Visions of the Dharma

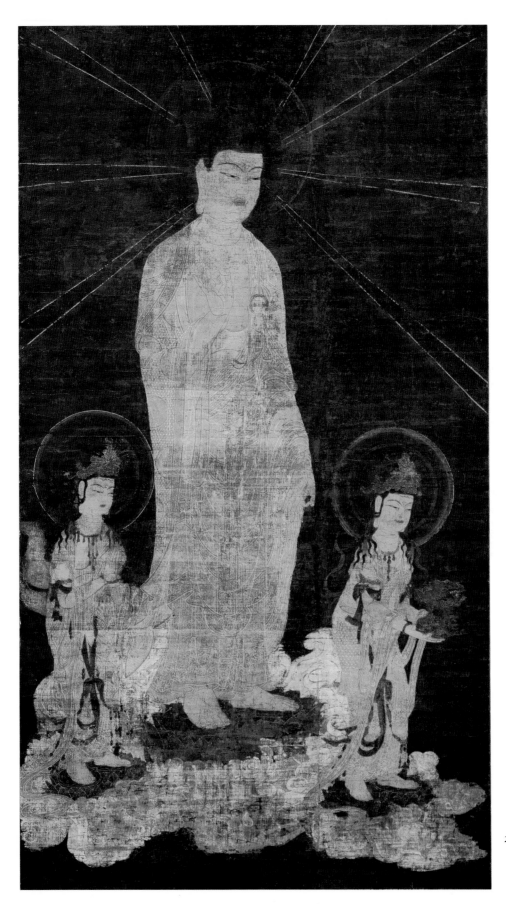

25

Visions of the Dharma

JAPANESE BUDDHIST PAINTINGS AND PRINTS
IN THE HONOLULU ACADEMY OF ARTS

Stephen Little

The Honolulu Academy of Arts
Honolulu, 1991

This catalogue has been made possible in part by generous grants from the Andrew W. Mellon Foundation and the State Foundation on Culture and the Arts.

Published by The Honolulu Academy of Arts, Honolulu
George R. Ellis, Director

Photography: Tibor Franyo
Design: Barbara Pope
Composition: The Stinehour Press
Printing: Toppan Printing Co. Inc., Japan

Library of Congress Cataloging-in-Publication Data
Honolulu Academy of Arts.
Visions of the Dharma: Japanese Buddhist paintings and prints in the Honolulu Academy of Arts.
[compiled by] Stephen Little.
Includes bibliographical references and index.

1. Art, Japanese—Catalogs.
2. Art, Buddhist—Japan—Catalogs.
3. Art—Hawaii—Honolulu—Catalogs.
4. Honolulu Academy of Arts—Catalogs.
I. Little, Stephen, 1954–. II. Title.

N7352.H66 1991 760'048943'095207496931–dc 20
CIP 91–20301

ISBN 0–937426–14–8

Printed on acid-free paper.

COVER AND FRONTISPIECE: *Catalogue number 25*

Art is what reveals to us the state of perfection.

KŪKAI 774–835

Contents

FOREWORD

THE HONOLULU ACADEMY OF ARTS houses an excellent Asian collection, including one of the finest groupings of Japanese Buddhist paintings and prints in the United States. Each major school of Buddhism in Japan is reflected in these works, which have never before been exhibited or published as a single unit. Although the collection includes examples dating from the twelfth to the nineteenth centuries, the majority of the works were produced between the thirteenth and fifteenth centuries during the Kamakura, Nambokuchō, and Muromachi periods. Forty-four paintings and thirteen woodblock prints constitute the Academy's holdings at this time.

This catalogue includes an essay on the development of Buddhism in Japan and on Japanese Buddhist art; provides documentation of the iconography, techniques, styles, and provenance of each of these works; and includes translations of all major inscriptions. Also discussed is the function and art historical significance of each work. A glossary of all Japanese and Chinese words appearing in the text is included. Many of the works illustrated and described in this catalogue have not been previously published.

This publication represents the first in a planned series which will focus on specific aspects of the Academy's Asian holdings. Many of the Academy's works have appeared in various catalogues, books, and articles published over the years. Aside from a number of fine contributions dealing with particular aspects of the James A. Michener Collection, authored principally by Dr. Howard Link, specific areas of strength in our Asian holdings have not been discussed in depth. By illustrating and discussing each work held by the Academy, this volume and succeeding ones will render these objects more accessible.

Stephen Little has acknowledged the many individuals who have played a role in the creation of this catalogue. To these friends I also offer my sincere thanks. Special acknowledgment should also be extended to certain members of the Academy staff who worked diligently to mount the exhibition that accompanies this publication. Fujio Kaneko and his crew have once again created an exciting installation, and the duties of the Registrar's Office have been ably carried out by Sanna Deutsch and her assistant, Stephanie L'Heureux.

Finally, I would like to congratulate Stephen Little for producing a well-researched and well-written publication of great value to scholars and the general public. Dr. Little has worked diligently and enthusiastically to realize the project, and the quality of his effort is readily apparent.

GEORGE R. ELLIS
Director

ACKNOWLEDGMENTS

THERE ARE MANY INDIVIDUALS to whom thanks are due for having helped make this catalogue possible. First and foremost I would like to thank George R. Ellis, the Academy's director, for having given me the opportunity to conduct the research for this book. I also owe a great debt of gratitude to Marion Campbell, secretary of the Asian Art Department, who typed much of the manuscript and helped locate many research materials. Dr. Howard A. Link, former senior curator of Asian Art at the Academy and now consultant to the James A. Michener Collection, was very helpful in providing his own research on the paintings and prints, and suggesting several avenues of investigation.

I am grateful to Takeshi Katsuki, Joseph Seubert, and Ron Tessler for their translations of the texts on or relating to the Yūzū Nembutsu (no. 27), Kōbō Daishi (no. 31), and Zegaibō (no. 34) handscrolls, respectively. Fred Cline, librarian of the Asian Art Museum of San Francisco, kindly sent me a copy of Terukazu Akiyama's 1966 paper on the now-dispersed handscroll depicting legends of the Jin'ō-ji (no. 33), and Jean Cassill was very helpful in sending me research materials on the early Yūzū Nembutsu handscroll in the Cleveland Museum of Art. In addition, Lily Kecskes and Andrew Knapp of the Arthur M. Sackler Gallery, Washington, were most helpful in granting permission to include Takeshi Katsuki's translation of the Yūzū Nembutsu handscroll inscription. I am especially grateful to Mr. and Mrs. Frances Takahashi for the generous loan to the Academy of the Nyoirin Kannon hanging scroll (no. 13) from the estate of the late Harry Shupak.

My thanks to Gratia Williams Nakahashi, curator of the Mary and Jackson Burke Collection, New York, for showing me related paintings in the Burke Collection; and to Dr. Barbara Ford, associate curator of Japanese Art at the Metropolitan Museum of Art, New York, and her assistant, Masako Watanabe, for sharing their thoughts on many of the exhibits. I am grateful to Dr. Mimi Yiengpruksawan of Yale University for her insights on numerous entries and for access to her forthcoming article on the deity Ichiji Kinrin (no. 18), and to Dr. Marian Ury of the University of California, Davis, for her correspondence on the "Tale of Zegaibō" handscroll (no. 34). For their illuminating comments on paintings in the catalogue I would like to thank L. Benji Nerio, David Kidd, Y. Morimoto, Peter Morse, Klaus Naumann, and Anne Morse.

The majority of the paintings and prints in this catalogue entered the Academy's collection in the 1950s and early 1960s. Many of the finest works were gifts, and the museum has many generous donors to thank for the treasures included here. Beginning with his gift in 1952 of the Kamakura period handscroll depicting scenes from the life of Kōbō Daishi (cat. no. 31), Robert Allerton (1873–1964) donated many important works of Japanese Buddhist art to the collection; among his gifts included in this publication are the Heian-period illuminated *sūtra* from the Jingo-ji (cat. no. 1), a section of Kanō Tan'yū's

copy of the Kōzan-ji *Chōjū Giga* handscroll depicting animals in the guise of Buddhist pilgrims and monks (cat. no. 39), and the outstanding fourteenth-century *Taima Mandala*, depicting Amida's Western Paradise (cat. no. 24).

Other major donors to the Academy whose gifts of Japanese Buddhist paintings and prints are included here are the Hawaii collectors Mr. John Gregg Allerton, Mrs. Philip E. Spalding, Mrs. Theodore A. Cooke, Mrs. Carter Galt, Mr. George Kerr, Miss Renee Halbedl, Ms. Aileen Miyo Ichijo, and Mrs. L. Drew Betz. In addition, the Academy is indebted to Mr. James A. Michener, Mr. Jiro Yamanaka, and Mr. Samuel Hammer for their generous gifts of paintings and prints. Without the enlightened patronage of these donors this publication would not have been possible.

Many thanks are due to the Academy's publications editor, Joy Kitamori, for overseeing the production of this book; Tibor Franyo, photographer, for his excellent color plates; Barbara Pope for her superb design; Lys Ann Shore for editing the text; and Michael MacMillan for his expertise in computer-program translation. Finally, I would like to thank my wife, Nadine, for providing the initial idea for this catalogue and for her encouragement throughout its preparation.

S.L.

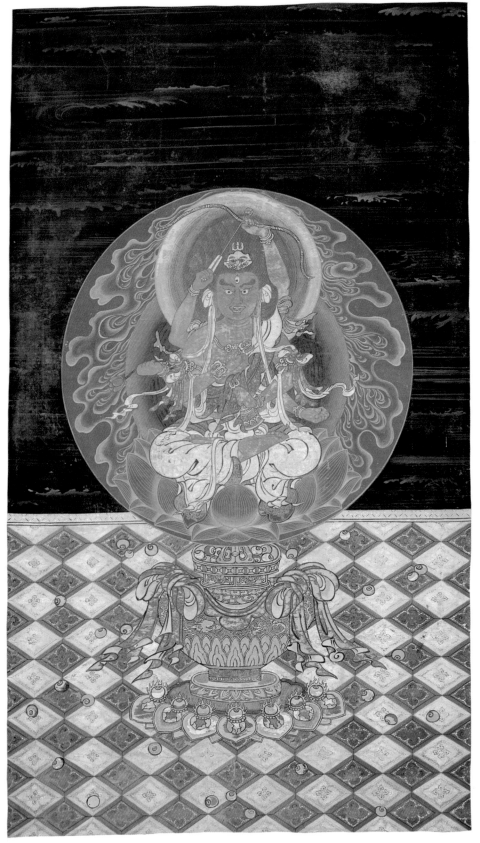

15 detail

VISIONS OF THE DHARMA

Japanese Buddhist Paintings and Prints in the Honolulu Academy of Arts

STEPHEN LITTLE

Buddhism was introduced into Japan from Korea in the sixth century A.D., and within a century had taken root as a major force in Japanese society and cultural life. The Asuka and Nara periods witnessed the wholesale importation of Buddhist philosophy and art from China and Korea, and the ensuing production of Buddhist images by Japanese artists and craftsmen. Under the enthusiastic patronage of the imperial family, and particularly with the support of such figures as Prince Shōtoku (574–622) and the eighth-century rulers Emperor Shōmu and Empress Shōtoku, Buddhist temples and ideology spread throughout Japan. By the Heian period, a syncretic accommodation of this foreign religion and the indigenous Shintō worship of nature spirits and deities had occurred. Buddhism had a profound impact on the Japanese ruling aristocracy, and for centuries after its introduction the imperial family played a key role in its propagation.

The historical Buddha Śākyamuni lived in India during the sixth century B.C. Buddhist belief holds that in his life the Buddha discovered a means to escape the endless cycle of death and rebirth determined by an individual's *karma* (the accumulated weight of a person's thoughts and actions). Through meditation the Buddha attained a state known as *Nirvāṇa*, literally "blowing out"—analogous to the extinguishing of a candle flame. The attainment of *Nirvāṇa* signified a merging of the inner spirit that characterizes all sentient life with the Void out of which all reality emerges. Śākyamuni taught that by cultivating awareness and mindfulness of the illusion of duality, through meditation and a heightened sensitivity to the fundamental truths that define the nature of being, one could attain the state of *samādhi* (mental concentration) that would lead to *Nirvāṇa*. The Buddha taught his followers the doctrine of the Four Noble Truths: that all life is inevitably sorrowful; that sorrow is due to craving; that sorrow can only be relieved by the cessation of craving; and that this can only be achieved through carefully disciplined and moral conduct, culminating in the life of concentration and meditation led by the Buddhist monk.[1]

The bonds of this existence could be transcended, according to Śākyamuni, through self-discipline and by following the Eightfold Noble Path, which consisted of

Right Views, Right Resolve, Right Speech, Right Conduct, Right Livelihood, Right Effort, Right Mindfulness, and Right Concentration.

In the centuries following Śākyamuni's death, or *Parinirvāṇa*, Buddhism in India gradually developed into two branches. The first and earliest is known as Theravāda or Hīnayāna. This tradition emphasized ascetic practice and self-denial as the most direct means to enlightenment. In later centuries the Theravāda tradition became the dominant form of Buddhism in Southeast Asia. The second branch is the Mahāyāna, or "Great Vehicle." This tradition evolved in northern India in the first and second centuries A.D., and was the form of Buddhism ultimately transmitted to China, Korea, and Japan. The Mahāyāna Buddhists taught that all beings could become enlightened through their own faith and the assistance of bodhisattvas. The bodhisattvas were beings who had attained enlightenment, but had vowed to defer their own entry into *Nirvāṇa* in order to help all other beings to attain enlightenment. In Mahāyāna Buddhism a complex pantheon of innumerable Buddhas and bodhisattvas evolved; every eon of time and every universe had its own Buddha. The principal bodhisattvas venerated in the Mahāyāna tradition were Avalokiteśvara (J. Kannon), Manjusrī (J. Monju), and Samantabhadra (J. Fugen), symbolizing compassion, wisdom, and benevolence, respectively.

With the consecration of the first Buddhist temples in China in the late Han Dynasty (first century A.D.) and the translation of such classic texts as the *Lotus Sūtra* in the early Six Dynasties period (third–sixth centuries), Buddhism emerged in China as a powerful religion that coexisted with the native Chinese Daoist religion and Confucian philosophy. The introduction of Buddhism to Japan in the sixth century occurred as the religion was undergoing a period of astonishing growth and development on the Asian continent.

Several key changes characterized the development of Japanese Buddhism during the Heian period, an era of striking cultural richness in Japanese history. In the four centuries of the Heian period, Buddhism witnessed the introduction into Japan of the Esoteric or Tantric sect. Brought from China by the monk Kūkai (Kōbō Daishi, 774–835) in the early ninth century, Esoteric Buddhism taught that enlightenment could be achieved only through an understanding of the absolute teachings of the Cosmic Buddha Vairocana (J. Dainichi Nyorai), which transcend all sects of Buddhism. The secret teachings of the Esoteric Shingon sect founded by Kūkai were transmitted orally from master to student. Esoteric rituals involved meditation on and recitation of sacred *mantras* (seed syllables) and the practice of *mudrās* (sacred hand gestures). Esoteric Buddhism introduced into Japanese Buddhist practice the *maṇḍala*, or psycho-cosmic diagram of both human consciousness and the spiritual universe. It is significant that Kūkai, like his Chinese teacher Huiguo (746–805), stressed the efficacy of art in religious teaching; Kūkai himself was a gifted artist and calligrapher. In his *Memorial on the Presentation of the List of Newly Imported Sūtras*, Kūkai wrote:

> The law [*dharma*] has no speech, but without speech it cannot be expressed. Eternal truth [*tathāta*] transcends form, but only by means of form can it be understood. Mistakes will be made in the effort to point at the truth, for there is no clearly defined method of teaching, but even when art does not excite admiration by its unusual quality, it is a treasure which protects the country and benefits the people.

In truth, the esoteric doctrines are so profound as to defy their enunciation in writing. With the help of painting, however, their obscurities may be understood. The various attitudes and *mudrās* of the holy images all have their source in Buddha's love, and one may attain Buddhahood at the sight of them. Thus the secrets of the *sūtras* and commentaries can be depicted in art, and the essential truths of the esoteric teachings are all set forth therein. Neither teachers nor students can dispense with it. Art is what reveals to us the state of perfection.[2]

Another major development in Buddhism during the Heian period was the belief in the advent of the age of *mappō*, or the "decline of the *Dharma* (the Buddhist law)." According to Buddhist clerics in both China and Japan, ancient *sūtras* (holy texts) predicted that the year 1052 would mark the beginning of a long period of decline of moral and religious virtue, culminating in the coming to earth of Maitreya (J. Miroku), the Buddha of the Future. Coupled as it was with the decline in influence of the Heian court and increased lawlessness in Japan in the eleventh and twelfth centuries, belief in the *mappō* age led to the widespread popularization of Buddhism in Japanese society. The clergy, formerly closely tied to the imperial household, the aristocracy, and military leadership, now shifted its focus increasingly toward the middle and lower classes. Directly linked to belief in the decline of Buddha's law was belief in the potential for easy rebirth in the Western Paradise or Pure Land of the Buddha Amitābha (J. Amida), with its jeweled palaces, lotus ponds, and orchestras of heavenly musicians.

By the beginning of the Kamakura period, the Pure Land (Jōdo) and Esoteric Shingon and Tendai sects were the leading schools of Buddhism in Japan. All three employed the arts of painting, sculpture, and architecture to greatest advantage in their teachings and rituals. The influence of these sects continued into the Nambokuchō and early Muromachi periods. In the latter era, however, the philosophy of Zen gradually emerged as a leading school of Japanese Buddhism. Zen had appeared in China in the sixth and seventh centuries as the Chan (meditation) sect. One of its primary teachings was that enlightenment could occur suddenly, without the intervention of *sūtras*, rituals, or bodhisattvas. The Zen sect held that all creatures had the fundamental Buddha-nature within themselves. Through discipline, physical labor, and the use of special techniques such as the *kōan*, or metaphysical riddle, the individual could attain a state of mind in which the strictures of logical, quotidian thought that impeded enlightenment could be transcended. Like the other major schools of Buddhism, Zen used words and images to point the way to a higher reality.

The primary schools of Buddhism in Japan were thus the early Mahāyāna sects, such as the Kegon (Flower Garland), the Esoteric (particularly Tendai and Shingon), the Pure Land, the Zen, and the Shugendō. The last-named was a sect of "mountain monks" (*yamabushi*) or ascetics who wandered all over Japan and had a tremendous influence on Buddhist faith at the popular level. In addition, there were numerous doctrines that taught a syncretic blend of Buddhist and Shintō belief. The emergence in the Heian period of Shintō shrines in which the native *kami* (spirits) were perceived as manifestations (*suijaku*) of Buddhist deities (*honji*) was the result of a long period of acculturation. Few countries in Asia experienced such a successful adaptation of Buddhism to preexisting native traditions.

Painted and sculpted images played a central role in the teachings and rituals of each of these Japanese schools and systems of Buddhism. In the *Lotus Sūtra* itself, the Buddha Śākyamuni preached that the creation of sacred images would bring merit to their creator. Buddhist art proliferated from the moment Buddhism first took hold in Japan, and over the centuries it developed in an extraordinary range of doctrinal and stylistic directions. In the Esoteric school, for example, paintings often served as the most direct means of comprehending a hidden truth—a reflection of the power invested in visual images in the Japanese Buddhist tradition.

The works in this catalogue represent each of the major schools of Buddhism outlined above. They had many different functions, often dictated or conditioned by their format: *sūtra* scrolls, which combine sacred text with illuminated frontispieces; images of the life of the Buddha Śākyamuni; hanging scrolls bearing images of primary deities, such as Amida, Buddha of the Western Paradise, and Jizō, bodhisattva of the underworld, descending from heaven; maps of Shintō shrines indicating the Buddhist deities that are the original forms of their *kami*; lively narrative handscrolls that relate tales surrounding the lives of famous priests or the founding of temples; portraits of monks and Buddhist saints; detailed views of the Pure Land of Amida; iconographical sketches used in the transmission of the correct proportions and coloring of finished paintings; and even satirical images of the Buddha in the guise of a frog or a *daikon* radish. In these paintings and prints the historical development of the Japanese Buddhist tradition is brilliantly reflected in images imbued with a profound faith and which exemplify the highest levels of artistic creation.

1 William de Bary, ed., *The Buddhist Tradition in India, China and Japan* (New York: Vintage Books, 1969), p. 9.
2 Ibid., p. 292.

CATALOGUE

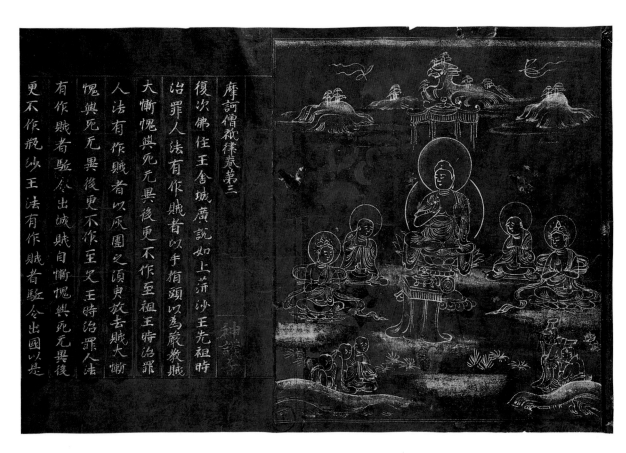

摩訶僧祇律卷第三

復次佛住王舍城廣說如上沙王先祖時
治罪人法有作賊者以手捐頭以為嚴教賊
大慚愧與死無異後更不作至祖王時治罪
人法有作賊者以灰圍之頂更放去賊大慚
愧與死無異後更不作至又王時治罪人法
有作賊者駈令出城賊自慚愧與死無異後
更不作乃沙王法有作賊者駈令出國以是

I

MAHĀYĀNA IMAGES

Illustrated Frontispiece to the *Mahāsāngha Vinaya* (*Great Canon of Monastic Rules*), chapter 3

Late Heian period, twelfth century
Handscroll; gold ink on indigo paper; with seal of the Jingo-ji, Kyoto
26 x 1550 cm
Gift of Robert Allerton, 1952 (1673.1)

This handscroll is an excellent example of a late Heian illuminated *sūtra*. It begins with a frontispiece illustration and continues with the text written in the standard format of seventeen characters per line. This example consists of the third chapter only of the *Great Canon of Monastic Rules (Mahāsāngha Vinaya)*, a work outlining the proper organization of a Buddhist monastic community. The text was originally brought to China from India by the monk Faxian in the early fifth century, and it was translated by Faxian and Buddhabadhra.[1]

The outer cover (*hyōshi*) of the scroll is painted with floral arabesques in gold and silver pigments (fig. 1a). At the upper left corner of the cover is a rectangular cartouche containing the title of the *sūtra* in Chinese (*Mohe sengzhi lü*). The inner surface of the scroll begins with a square frontispiece (*mikaeshi*), also painted in gold and silver, which depicts the Buddha preaching on a lotus throne. Seated on the ground around him are two monks and two bodhisattvas, with three monks listening at the lower left, and two officials listening at the lower right. The officials are dressed in Chinese court dress and hold symbols of rank in their hands. The inclusion of these Chinese-style details is characteristic of Japanese *sūtras* painted in gold and silver.[2] In the background is a landscape dominated by Vulture Peak (Sk. Gṛdhrakūta) located near the Indian city of Rājagṛha, where the Buddha often preached. This painting is similar in format to many surviving late Heian *sūtra* frontispieces.

While the earliest known example of Japanese Buddhist painting in gold and silver pigments dates to the Nara period, frontispiece illustrations in gold and silver on indigo paper are first recorded in the tenth century.[3] The earliest surviving blue-and-gold *sūtras* with illustrated frontispieces date to the eleventh century; these are known in Japan as *konshi kinji kyō*. The majority of surviving examples illustrate the *Lotus Sūtra*.

The technique for making the materials for such illustrations has been described by Willa J. Tanabe: "The dark blue paper (usually *gampi* paper) was dip-dyed by repeated soakings in the dye vat. After the seventh or eighth dipping, the sheets were beaten with mallets to produce a sheen, and then were glazed with an alum and glue sizing. The re-

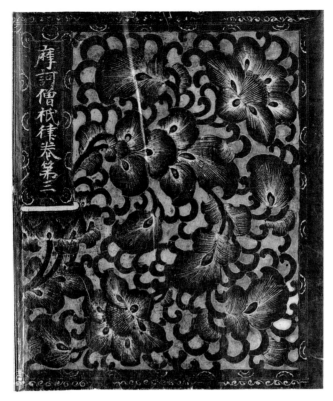

1a

1b

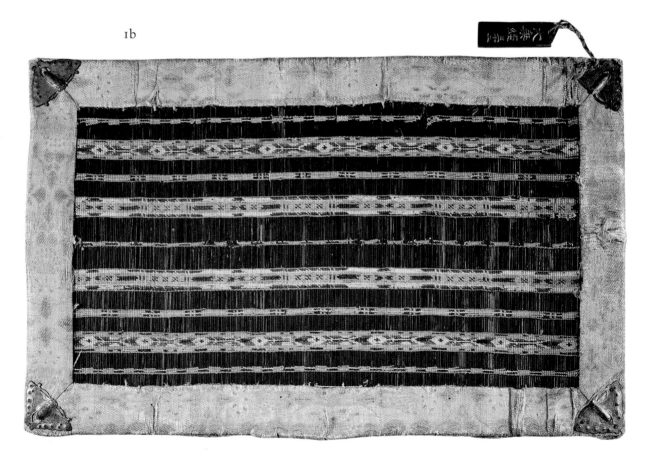

sulting depth of color suggested lapis lazuli which, along with gold and silver, was one of the seven precious jewels or treasures mentioned in the *Lotus Sūtra* and other scriptures."[4]

Following the frontispiece is the text, inscribed in gold characters in a grid outlined in silver ink. The style of the calligraphy, written in standard script, is derived from Chinese prototypes of the Tang Dynasty (618–906).

Below the title of the manuscript, at the head of the text, is a red seal, reading "Jingo-ji." The presence of this seal indicates that the *sūtra* was originally one of a large set consisting of the entire *Tripitaka*, or Buddhist *Canon*, kept at Jingo-ji, a Shingon monastery founded during the Heian Enryaku reign period (782–805) and located in the hills west of Kyoto. According to a history of the temple, the copying of the *Tripitaka* was initiated by the retired emperor Toba just before his death in 1156.[5] The project was completed in 1185 under the direction of Toba's son, Emperor Goshirakawa, who lived at the Jingo-ji following his abdication in 1158. The set once comprised 5,048 scrolls; today, 2,317 of them remain at the temple.[6] The presence of the Jingo-ji seal on the Honolulu Academy's scroll indicates that it can be dated between 1156 and 1185. The scroll is accompanied by its original *sūtra* wrapper of silk and bamboo strips (*fude-maki*, fig. 1b).

1 Kenneth Ch'en, *Buddhism in China: A Historical Survey* (Princeton: Princeton University Press, 1964), pp. 89–93.
2 Willa J. Tanabe, *Paintings of the Lotus Sutra* (New York and Tokyo: Weatherhill, 1988), p. 80.
3 Ibid, p. 79.
4 Ibid.
5 Miyeko Murase, *Japanese Art: Selections from the Mary and Jackson Burke Collection* (New York: Metropolitan Museum of Art, 1975), p. 42.
6 *A Selection of Japanese Art from the Mary and Jackson Burke Collection* (Tokyo: Tokyo National Museum, 1985), no. 68.

LITERATURE
Sherman E. Lee, *Japanese Decorative Style* (Cleveland: Cleveland Museum of Art, 1961), pl. 2.
Mayuyama Junkichi, *Japanese Art in the West* (Tokyo: Benrido, 1966), pl. 73.
Merrill C. Rüppel, *Masterpieces of Japanese Art* (Dallas: Dallas Museum of Art, 1969), no. 13.

PROVENANCE
Mayuyama and Company, Tokyo; Robert Allerton, Kauai.

大般若波羅蜜多經卷第四百五十四

三藏法師玄奘奉　詔譯

第二分增上慢品第六十之三

復次善現於意云何假使於此南贍部洲諸

有情類皆得人身得人身已發心修學諸菩

薩行皆證無上正等菩提有善男子善女人

等盡其壽量以諸世間上妙樂具供養恭敬

尊重讚歎此諸如來應正等覺復持如是

集善根與諸有情平等共有迴向無上正等

菩提是善男子善女人等由此因緣得福多

Illustrated Frontispiece to the *Mahāprajñāpāramitā Sūtra*　　2

Heian period, late twelfth century
Handscroll; gold ink on indigo paper
25.7 x 975.9 cm
Purchase, 1965 (3338.1)

This scroll consists of one chapter of the *Mahāprajñāpāramitā Sūtra*, one of the classic scriptures of Mahāyāna Buddhism in the Far East. The *sūtra* was translated into Chinese by Xuanzang (c. 596–664) during the early Tang Dynasty. In structure and technique this illumination is similar to the Academy's *Mahāsāngha Vinaya* chapter from the Jingo-ji (cat. no. 1). In this case, however, the illumination at the beginning of the scroll belongs to chapter 397 of the text, while the text is that of chapter 454 (the correct chapter of the illumination is specified in a cartouche on the back of the painting). The date when this frontispiece was attached to the text is unknown, but comparison with other known examples of the late twentieth century indicates that the painting and text are roughly contemporaneous.

The distinctive cross-hatching along the right border of the illumination links this painting with a large group of *sūtra* scrolls dedicated in 1176 to the Chūson-ji in Hiraizumi, Iwate Prefecture, in northern Honshu. The donor of the Chūson-ji *sūtras* was a Heian aristocrat, Fujiwara no Hidehara (d. 1187); the *sūtras* were dedicated on behalf of his mother, Motohina, who died in 1157. The entire group can be dated to c. 1175. In addition to the typical cross-hatching along the border, this scroll shares with others from the Chūson-ji a distinctive manner of outlining the upper edges of rock surfaces and earthforms with a single line.

In the Academy's frontispiece a monk is depicted shaving his head, on a ledge at the left. Two already ordained monks witness this act, while two bodhisattvas descend on clouds at the upper right. The landscape itself is painted in the characteristic manner of Heian *sūtra* illumination, in washes of gold and silver pigment on indigo paper. The back is painted with floral scrolls very similar in style to those on the back of the Jingo-ji scroll (cat. no. 1). The Academy also owns another *sūtra* illumination from this set (HAA 3337.1).

LITERATURE
Academy Album (Honolulu: Honolulu Academy of Arts, 1968), p. 114.
Zaigai Nihon no Hiho, vol. 2: *Emakimono* (Tokyo: Mainichi Shimbunsha, 1980), pl. 110.

PROVENANCE
Dawson's Book Shop, Los Angeles.

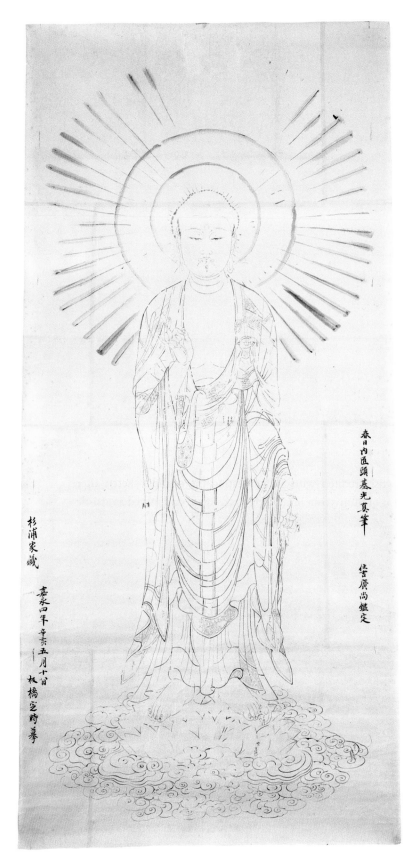

春日内匠頭基光真筆

佐竹廣尚鑑定

杉浦家藏

嘉永四年辛亥五月十日

板橋定蔚摹

3

Iconographical Sketch of a Buddha

<div style="text-align:right">3</div>

Edo period, dated 1851
Ink on paper
127.8 x 60.5 cm
Purchase, 1991 (6062.1)

This drawing is a classic example of a *zuzō*, an iconographical sketch used as a model for paintings of Buddhist deities on paper and silk. The figure depicts a Buddha, most likely either Shaka (Sk. Śākyamuni) or Amida (Sk. Amitābha). The figure is painted in very fine lines, using both black and brown ink. The overall proportions of the Buddha are carefully articulated, with numerous notations in the image concerning choice of colors and the use of gold in the finished painting. Among the notations, for example, are the words "Gold ground" and "*renge* [lotus]." In certain areas, for example in the hems of the robe, the artist has included detailed depictions with floral scrolls or geometric embroidered patterns.

The drawing is inscribed along both the right and left borders. The inscription on the right reads: "The true brush of Kasuga Naishōzū Motomitsu, authenticated by Sumiyoshi Hironao." The inscription on the left reads, "Treasure of the Sugiura family; the eighteenth day of the fifth month of the fourth year of the Kaei reign [1851], the cyclical year *shingai*, copied by Itabashi Sadatoki." Kasuga Motomitsu (active c. 1086–1099) was a Heian period painter attached to the Kasuga shrine in Nara (cat. no. 28); he is also recorded as having worked at the Kongōbū-ji on Mount Kōya in Wakayama Prefecture.[1] He has traditionally been considered the founder of the Tosa school of painting. Sumiyoshi Hironao (1781–1828), the artist credited with authenticating the original sketch after which this is copied, was a son of Sumiyoshi Hiroyuki (1755–1811) and served as artistic advisor to the Tokugawa *bakufu* (military government).[2] Both Hironao and his father were famous as connoisseurs of ancient paintings. Itabashi Sadatoki (1810–1868), the painter who copied Motomitsu's sketch, is better known by the name Tsurao; he was a pupil of Sumiyoshi Hironao's younger brother, Hirotsura (1793–1863).[3] The inscriptions on this sketch thus suggest that the original drawing from which this was copied dated to the eleventh century, in the Heian period.

1 Laurance P. Roberts, *A Dictionary of Japanese Artists* (Tokyo and New York: Weatherhill, 1976), pp. 113–114. The famous depiction of the Buddha's death (Nehan) dated 1086 at the Kongōbū-ji has traditionally been attributed to Motomitsu.

2 Ibid., p. 44.

3 Ibid., p. 190.

PREVIOUSLY UNPUBLISHED

PROVENANCE
Eli Jaxon-Bear, Maui.

南無娥顏色光佛
南無無勝軍佛
南無無終光佛
南無勝月上佛
南無懷智慧佛
南無道華香佛
南無　今上佛

南無滅慈佛
南無諦覺佛
南無常忍辱佛
南無象步佛
南無懷諦佛
南無香上自在佛
南無等幢佛

Fragment of the *Sūtra of Three Thousand Names of Buddha (Butsumyō-kyō)*

4

Early Muromachi period, c. late fourteenth–fifteenth century
Woodblock print with calligraphy, ink on paper
30.7 x 29.6 cm
James A. Michener Collection (L 25,654)

This fragment was originally part of a longer text known as the *Butsumyō-kyō*, or *Sūtra of Three Thousand Names of Buddha*, which was translated into Chinese from Sanskrit by an unknown translator of the Liang Dynasty (502–557).[1] The text consists of three separate *sūtras*, which include one thousand names each of Buddhas of the past, present, and future, respectively. The *sūtra* promises that men and women who hear the names of the three thousand Buddhas and who "read, copy and explain them, paint their images, offer them incense, flowers and music, praise their blessing power and with a heart full of devotion worship them," will be reborn in a Buddhist paradise.[2] Emphasis is placed on the name of Amitābha, Buddha of the West, and rebirth is promised to all those who repent their transgressions and repeat the Buddhas' names. The recitation of this text, in a ritual known as Butsumyō-e, was often accompanied in the Heian period by the display in temples of paintings depicting three thousand Buddhas.[3]

On the Academy's fragment, images of Buddhas have been repeatedly stamped with a wooden block in two horizontal registers, one at the top and one across the middle of the page. The remainder of the page was divided into grids drawn with brush and ink using a ruler; the names of the Buddhas were then written with a brush underneath the images. The name of each Buddha is preceded by the word *namu* (hail), from the Sanskrit *namah*. The same block was used to print the Buddha images on a similar fragment in a Japanese private collection.[4] The composition and text of these Japanese versions are based directly on Chinese originals in which the Buddha images were painted instead of printed. An example from the Dunhuang caves, datable to the Five Dynasties period (tenth century), survives in the Shanghai Museum.[5]

1 M. W. de Visser, *Ancient Buddhism in Japan*, 2 vols. (Leiden: E. J. Brill, 1935), vol. 1, pp. 379–380. The full title of the *Butsumyō-kyō* is *Sankō sanzen butsumyō-kyō*, or *Sūtra of Three Thousand Names of Buddha of the Three Kalpas*.
2 Ibid., p. 380.
3 Ibid., p. 381.
4 Ishida Mosaku, *Japanese Buddhist Prints* (Tokyo and Palo Alto: Kodansha, 1963), no. 143, p. 159.
5 Published in *Cultural Relics from Dunhuang and Turfan* (Hong Kong: Art Gallery, Chinese University of Hong Kong, 1987), no. 29.3.

PREVIOUSLY UNPUBLISHED

5 Nehan: The Parinirvāṇa of Śākyamuni

Edo period, c. eighteenth century
Hanging scroll; ink, colors, and gold on silk
39.1 x 53.1 cm
Bequest of Mrs. C. H. Lauru, 1991 (6243.1)

This painting from the mid-Edo period depicts the death of the historical Buddha Śākyamuni. The episode is described in early accounts of the Buddha's life, for example, the *Buddhacarita* (The Acts of the Buddha). The Buddha asked his follower Ananda to arrange a couch between two *Sal* trees and said, "In the course of this night the Tathagata will enter *Nirvāṇa!*" When he had settled himself, all his followers began to weep, but he admonished them to be calm. The scene that ensued is described as follows:

> When the Sage entered Nirvāṇa, the earth quivered like a ship struck by a squall, and firebrands fell from the sky. The heavens were lit up by a preternatural fire, which burned without fuel, without smoke, without being fanned by the wind. Fearsome thunderbolts crashed down on the earth, and violent winds raged in the sky. The moon's light waned, and, in spite of a cloudless sky, an uncanny darkness spread everywhere. The rivers, as if overcome with grief, were filled with boiling water. Beautiful flowers grew out of season on the *Sal* trees above the Buddha's couch, and the trees bent down over him and showered his golden body with their flowers. Like as many gods the five-headed Nagas stood motionless in the sky, their eyes reddened with grief, their hoods closed and their bodies kept in restraint, and with deep devotion they gazed upon the body of the Sage. . . . The kings of the Gandharvas and Nagas, as well as the Yakshas and the Devas who rejoice in the true Dharma—they all stood in the sky, mourning and absorbed in the utmost grief.[1]

In this hanging scroll the Buddha is shown lying on a platform at the center of the composition. The platform is situated in a grove of *Sal* trees. The Buddha's body and robes are painted in gold. Around him, seated on the ground, are the figures of his disciples and other followers, all of whom are grieving and weeping. Included among these are several deities, for example, a three-headed Esoteric figure in the background and the Dragon King in the foreground. In addition, numerous mythological and real animals have joined the weeping multitude. Among these are an elephant, phoenix, tiger, water buffalo, lion, tortoise, camel, boar, horse, deer, monkey, and hare, and numerous smaller birds, insects, and frogs. The painting thus represents the sorrow expressed by beings of each of the Six Realms of Existence at the Buddha's final passage into *Nirvāṇa*.

The human figures and animals are delicately executed in fluid lines and mineral colors. Gold paint has been added in certain details among the figures. The grove of *Sal* trees is less finished in execution. Beyond the scene in the foreground the waves of an

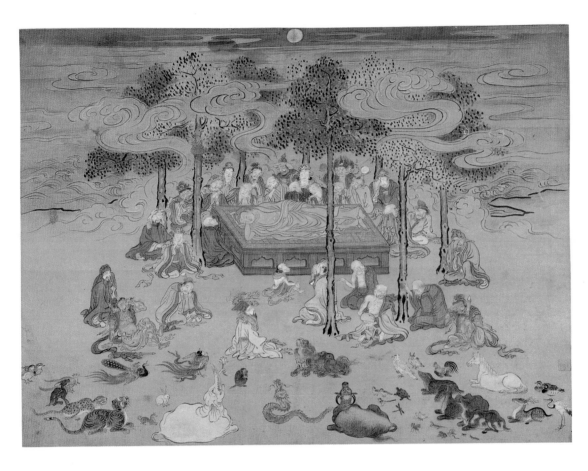

5

ocean are visible, with clouds and a moon in the sky. The painting has no signature, but it bears a small square intaglio seal of the artist along the lower right border, reading "Sefuku." This artist has yet to be identified. The painting derives from earlier compositions, some as early as the Heian and Kamakura periods.[2]

1 Edward Conze, trans., *Buddhist Scriptures* (Harmondsworth: Penguin, 1969), pp. 63–64.
2 See the discussion of this theme in John Rosenfield and Elizabeth ten Grotenhuis, *Journey of the Three Jewels: Japanese Buddhist Paintings from Western Collections* (New York: Asia Society, 1979), no. 2.

PREVIOUSLY UNPUBLISHED

6 Nehan: The Parinirvāṇa of Śākyamuni

Nishimura Shigenaga (1697–1756)
Edo period, late 1720s
Hand-colored woodblock print, *ōban*
45.2 x 27.7 cm
Gift of James A. Michener (13,866)

This woodblock print depicts the same scene as the mid-Edo painting of the preceding entry (cat. no. 5). In the print, however, many more figures are represented, and many of these are identified by name in small cartouches. Among them is the Buddha's mother, Maya, shown descending on a cloud in the moonlit sky at the upper right. She is accompanied by two servants and a monk. The similarities between this print and early painted versions of the scene suggest that the print is based on a painting.[1]

Nishimura Shigenaga was an eighteenth-century painter and print designer. He worked in Edo (Tokyo), and was one of the early masters of the *Ukiyo-e* (Floating World) style. Known for his popular depictions of *Kabuki* actors and *bijin* (beautiful women), he also created a number of Buddhist prints, of which this is an excellent example. The pigments applied to the finished print include yellow, ocher, red, and gold.

1 See John Rosenfield and Elizabeth ten Grotenhuis, *Journey of the Three Jewels: Japanese Buddhist Paintings in Western Collections* (New York: Asia Society, 1979), no. 2.

LITERATURE
Howard A. Link, *Primitive Ukiyo-e* (Honolulu: University of Hawaii Press, 1980), p. 154.

PROVENANCE
James A. Michener.

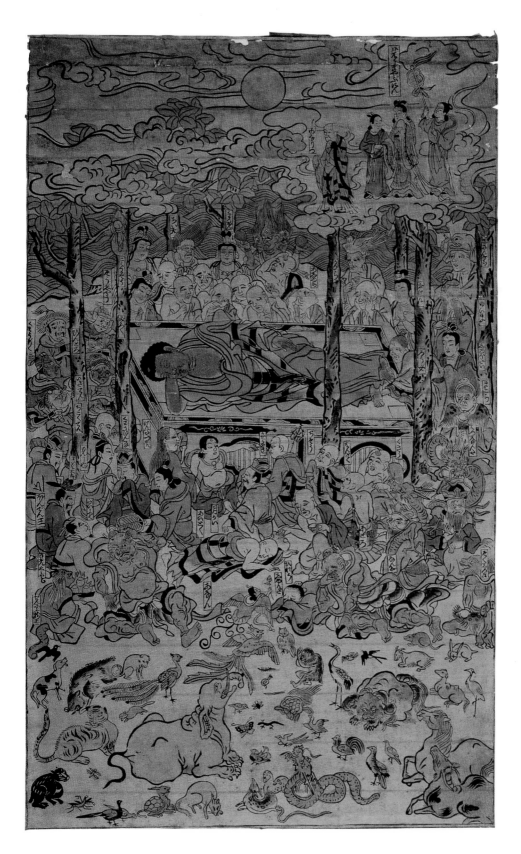

6

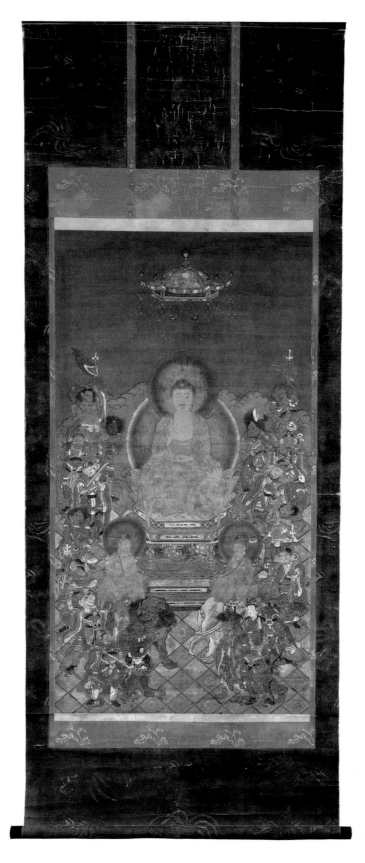

7

Shaka Triad with the Sixteen Good Spirits of the *Mahāprajñāpāramitā Sūtra*

7

Muromachi period, c. 1400
Hanging scroll; ink, colors, and gold on silk
212 x 87 cm
Purchase, 1991 (6060.1)

This large painting depicts the historical Buddha Shaka, or Śākyamuni, with a large number of attending deities. The Buddha is shown seated in meditation on a lotus flower which rests on a throne symbolizing Mount Sumeru (the Indian *axis mundi*). A lion is sculpted into the throne, as a symbol of the Śākya clan into which the Buddha was born. A jeweled canopy floats in the air above the Buddha's head, topped by a flaming jewel (*cintāmaṇi*).

In front and on either side of the Buddha's throne are his two principal attending deities, the bodhisattvas Monju (Sk. Mañjuśrī) on a lion and Fugen (Sk. Samantabhadra) on an elephant. Monju and Fugen are the bodhisattvas of Wisdom and Benevolence, respectively. Arranged along either side of the painting is a host of lesser deities, including guardian kings, devas, and monks. These figures include the Sixteen Good Spirits (*jūroku zenjin*), mentioned in the *Dhāraṇī-saṅgraha Sūtra*.[1] The Good Spirits comprise Yaksa generals, Naga kings, and devas who protect the *sūtra*. In addition, one of the Buddha's favorite monks, Kāśyapa, is depicted, along with Xuanzang, the Tang Dynasty monk who traveled to India in the seventh century and brought back many key Buddhist texts to China; he is shown at the lower right with a backpack full of *sūtras*. The presence of Xuanzang is significant because he translated the *Mahāprajñāpāramitā Sūtra* into Chinese.

The painting is executed in flowing lines of ink, over which washes of green, blue, red, and white have been applied. Many details in the figures' drapery, hair, armor, and jewelry are painted in gold. The style of the painting derives from similar paintings of the late Kamakura period.[2]

An unusual aspect of this scroll relates it to the Academy's painting of Aizen Myō-ō (cat. no. 15); this is the replacement of the usual brocade mounting by painting that imitates the brocade in a *trompe-l'oeil* effect. The artist has included in this scheme the *fu-tai*, or loose strips of silk that hang down from the upper mounting.

The scroll has suffered from abrasion and pigment loss over the centuries, but the ink outlines and much of the gold painting are preserved.

1 M. W. de Visser, *Ancient Buddhism in Japan*, 2 vols. (Leiden: E. J. Brill, 1935), vol. 2, pp. 493, 515–516.
2 See *Hieizan to Tendai no bijutsu* (Tokyo: Tokyo National Museum, 1986), pls. 73, 74.

PREVIOUSLY UNPUBLISHED

PROVENANCE
Eli Jaxon-Bear, Maui.

8　Kannon with a Willow Twig

Edo period, c. late seventeenth century
Woodblock print; ink on paper
81.4 x 28.5 cm
Purchase, 1954 (13,444)

This woodblock print depicts the bodhisattva Kannon (Sk. Avalokiteśvara) standing on two lotus flowers. The bodhisattva is dressed in flowing robes and scarves and wears a crown and elaborate jewelry. The androgynous figure holds in its hands a small container and the twig of a willow tree. The technique in which this woodblock print is executed is known in Japanese as *ishizuri-e;* it imitates the appearance of ink rubbings taken from wood or stone engravings.

The iconography of Kannon with a willow twig can be traced back as early as the Sui and Tang dynasties in China.[1] The role of this manifestation of Kannon was specifically to cure illness. One of the earliest known images of this form of Kannon exists among the Buddhist banners on silk found at Dunhuang in Central Asia.[2] It is clear from surviving stone engravings in China that this image originated on the mainland. A stele, dated 1618 at the Shaolin Temple on Mount Song, Henan Province, has a nearly identical image of Guanyin (Kannon) as that seen in the Academy's print. An inscription on the stele states that the original image was painted by the great Tang Dynasty painter Wu Daozi (active c. 710–760).[3]

At the top of the print is a poem written with a brush directly on the paper. This poem, inscribed by a Buddhist monk named Gi'ō (Ch. Yiying), describes Kannon as a manifestation of Amida and mentions the "expedient methods" (Sk. *upāya*) through which Kannon touches all beings in the "Buddha's ocean." The poem is preceded by a seal reading "Nembutsu go ro" ("Nembutsu is my refuge"), and followed by two seals reading, "Gi'ō shi shō" ("Seal of Gi'ō") and "Suzan" ("Mount Su").

1 Alicia Matsunaga, *The Buddhist Philosophy of Assimilation: The Historical Development of the Honji-Suijaku Theory* (Rutland and Tokyo: Charles E. Tuttle, 1969), pp. 129–130. The willow-twig Kannon is one of the traditional "thirty-three manifestations of Kannon," derived from the *Lotus Sūtra.*

2 An example is in the Avery Brundage Collection, Asian Art Museum of San Francisco (B62 D10).

3 See *Shaolin si Shike Yishu Xuan* (Beijing: Wenwu Chubanshe, 1985), p. 45.

PREVIOUSLY UNPUBLISHED

PROVENANCE
Raymond E. Lewis, San Francisco.

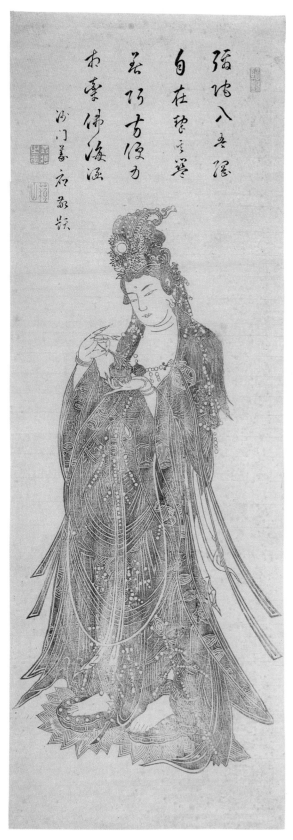

強指八葉蓮
自在碧空中
善巧方便力
示現佛海涯

沙門善知鄙跋

8

9 Eleven-Headed Kannon (Jūichimen Kannon)

Muromachi period, c. sixteenth century
Woodblock print; ink on paper
67 x 26 cm
Purchase, 1954 (13,432)

This print depicts the Eleven-Headed Kannon, known in Japanese as Jūichimen-Kannon (Sk. Ekadaśamukha). The figure is depicted in fluid, elegant lines that vary slightly in width and end in gently tapering points. Kannon stands on a high support in the form of a lotus flower resting on a hexagonal base. The deity has four arms, which hold a rosary, a *kundika* (holy-water bottle), a priest's staff with rings, and a lotus flower. Behind the figure is a circular halo. The figure's face is serene, while the ten small faces above are all benevolent in expression. At the center of the bodhisattva's headdress is a standing figure of the Buddha Amida, the Buddha of which this deity is an emanation.

The earliest images of the Eleven-Headed Kannon appeared in China during the late Six Dynasties period (sixth century). As an icon the image is based on the *Foshuo Shiyimian Guanshiyin Shenzhou Jing* (J. *Bussetsu-jūichimen-Kanzeon-jinju-kyō*), translated into Chinese by Yaśogupta during the Northern Zhou Dynasty (557–581).[1] In some forms of this deity, several of the eleven heads are portrayed as angry, but this is more often the case in Esoteric interpretations. The eleven heads symbolize the ability of the bodhisattva of Compassion to be aware of the needs and cries for help of all sentient beings.

In the upper right corner is a seal which reads *Missei sō* (Esoteric orthodox lineage). In the lower left corner is a seal of the late-nineteenth century collector, Hayashi Tadamasa (1853–1903).

1 Alicia Matsunaga, *The Buddhist Philosophy of Assimilation: The Historical Development of the Honji-Suijaku Theory* (Rutland and Tokyo: Charles E. Tuttle, 1969), pp. 123–124.

PREVIOUSLY UNPUBLISHED

PROVENANCE
Raymond E. Lewis, San Francisco.

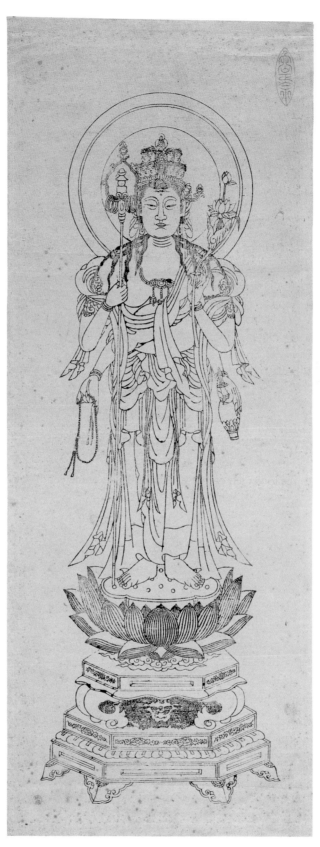

9

10　Ichiyō Kannon: Kannon on a Lotus Leaf

Muromachi period, c. fifteenth century
Woodblock print; ink on paper
31.4 x 23 cm
James A. Michener Collection (L 25,644)

This woodblock print depicts the bodhisattva Kannon (Ch. Guanyin, Sk. Avalokiteśvara) floating on a lotus leaf on the ocean. The graceful figure of Kannon is seated in the posture of "royal ease" (*mahārājalīlāsana*). The figure is depicted in fluid lines that vary only slightly in width. The lotus leaf and the swirling ocean waves are also executed in lines of great elegance.

According to tradition, the inscription at the top of the print was composed by the Kamakura-period Zen monk Dōgen during his return to Japan from Southern Song China.[1] When Dōgen's ship ran into a storm, the priest began chanting the *Kannon Sūtra* (*Kannonkyō*), upon which the bodhisattva appeared floating on a lotus leaf. The storm then subsided, and Dōgen's ship made its way safely back to Japan. When he arrived, he made a print of the image of Kannon he had seen, along with the eulogy that appears at the top of the print:

> From one flower, five petals opened,
> On one petal was a Tathagata [Buddha or bodhisattva].
> His great oath was as deep as this ocean,
> Returning, returning, he transported Sudhana.

ON THE FIRST DAY OF THE NINTH MONTH OF THE YEAR *NIN-IN* OF THE
NINJI REIGN, EULOGIZED BY THE MONK DŌGEN.

Sudhana was a disciple of the Buddha, and by analogy here refers to Dōgen himself. The date given in the inscription corresponds to the year 1242, fifteen years after Dōgen's return from China. This print, however, can be dated to the early Muromachi period by its style and the similarity of its composition to early Muromachi paintings of Kannon. A very similar print, now in the MOA Museum, Atami, differs only slightly in its lineament and in the fact that it is hand-colored with pigments and gold leaf.[2] The existence of two different versions suggests that the original image was copied several times after the composition first appeared in the mid-thirteenth century. Furthermore, it is likely that the original image was actually a painting; a hanging scroll in ink and colors on paper, now in a private collection in Japan, provides an early model for the woodblock prints. The hanging scroll, tentatively ascribed by Japanese scholars to an anonymous Southern Song artist, bears the same poem and note as the prints, but written with a brush at the top of the scroll in Dōgen's original calligraphy.[3] That the image of Kannon on a lotus leaf originated in China is further suggested by a similar image on a stone stele dated 1304 at the Shaolin Temple on Mount Song, Henan Province.[4]

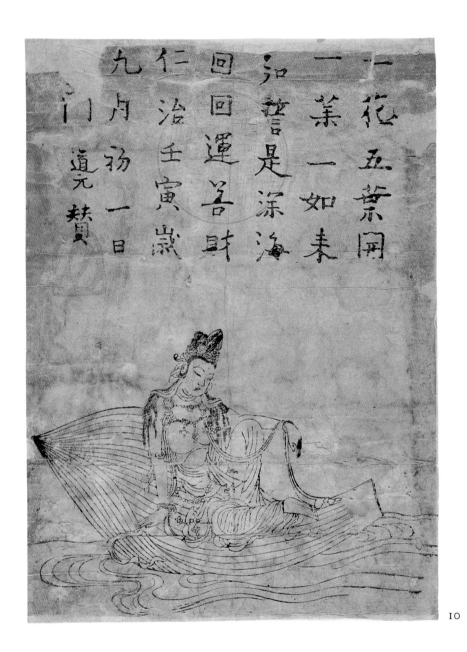

一花五葉開
一葉一如来
知音是深海
回回運菩旺
仁治壬寅歳
九月初一日
門真元賛

10

1 Ishida Mosaku, *Japanese Buddhist Prints* (Tokyo: Kodansha, 1963), p. 40.

2 Illustrated in color in Ishida, *Japanese Buddhist Prints*, color pl. 5. See also *Masterpieces of Japanese Prints—From the Origin to the Emergence of Nishiki-e* (Machida: Machida City Museum of Graphic Arts, 1987), no. 96.

3 This hanging scroll is published in *Kannon no Kaiga* (*Exhibition of Kannon Paintings*) (Nara: Yamato Bunka-kan, 1974), p. 9.

4 *Shaolin si Shike Yishu Xuan* (Beijing: Wenwu Chubanshe, 1985), pl. 32.

PREVIOUSLY UNPUBLISHED

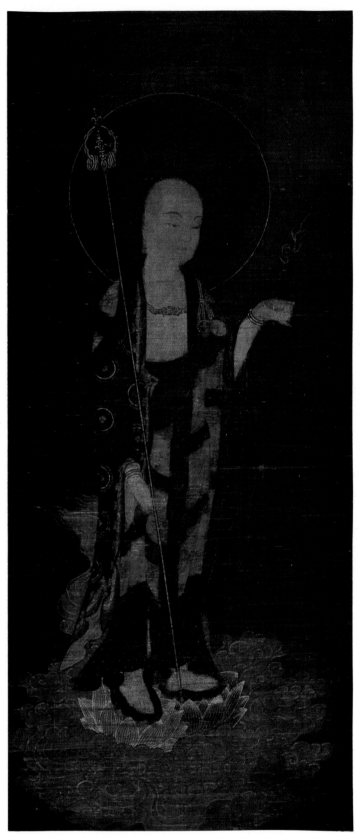

The Descent of Jizō

Nambokuchō period, 1333–1392
Hanging scroll; ink, colors, and gold on silk
81.5 x 36 cm
Gift of John Gregg Allerton, 1952 (1659.1)

This painting depicts the bodhisattva Jizō, descending from heaven on a swirling cloud. The painting is executed in fine lines on dark, reddish-brown silk. Jizō appears in the guise of a monk with shaved head and is dressed in a monk's robe (*kesa*) painted with red, dark green, and gold pigments. He wears a simple band of jewelry around his chest and bracelets on both wrists. He stands on two open lotus flowers, which rest on swirling clouds; the edges of the clouds are outlined in gold. In his left hand Jizō holds a transparent wish-granting jewel (*cintāmaṇi*) from which a wisp of gold flame emerges, and in his right hand he holds a gold priest's staff, or *khakkhara* (J. *shakujō*) with six dangling rings. Around Jizō's head is a halo, painted in gold. The details of the face, which wears a gentle, benign expression, are painted in fine lines of white and red pigment.

The painting is in good condition, although the surface is somewhat abraded and has apparently darkened from long exposure to incense smoke. Only the outlines and veins of the lotus petals on which Jizō stands have been retouched in recent times with gold ink.

The name *Jizō* (Ch. Dicang, Sk. Kṣitigarbha) means "Matrix of the Earth." The origins of this deity, which became one of the most popular bodhisattvas in Japanese Buddhism, can be traced to the Indian goddess Pṛthivī, a personification of the earth.[1] The worship of Jizō (Dicang) in China appears to have begun in the Six Dynasties period; the earliest text describing the deity was translated from Sanskrit into Chinese during the Northern Liang Dynasty (397–439).[2] The most important *sūtra* associated with Jizō, however, was translated into Chinese by the Khotanese monk Śikṣānanda in the late seventh century (early Tang Dynasty).[3] This text, the *Jizōbosatsu-hon-gankyō* (Ch. *Dicang Pusa Benyuan Jing*, Sk. *Kṣitigarbha-bodhisattva Pūrvapraṇidhānasūtra*), consists of thirteen chapters and includes a sermon given by the Buddha at the request of the bodhisattva of Wisdom, Mañjuśrī (Ch. Wenshu, J. Monju), in which the vow taken by Jizō is quoted: "Throughout immeasurable eons until the very boundaries of the future, I will establish many expedient devices for the sake of suffering and criminal beings in the Six Paths. When they have all been liberated I myself will perfect the Buddha Way."[4]

The Six Paths of Jizō's vow correspond to the Six Realms of Transmigratory Rebirth, into which all sentient beings are born and reborn. From the lowest to the highest these consist of the realms of hell, the hungry ghosts (*pretas*), beasts, angry demons (*asuras*), human beings, and heavenly beings (*devas*). Jizō's vow to assist sentient beings in each of the Six Realms (*rokudō*), and particularly his ability to save souls in hell, helps explain his great popularity in Far Eastern Buddhism. The Six Realms are symbolized in Jizō's imagery by the six rings on his staff.

The worship of Jizō in Japan was established by the Nara period.[5] So popular was

Jizō during the Heian period that the twenty-fourth day of each month was considered a holy day in his honor; this practice is corroborated by a tale in the twelfth-century anthology *Konjaku Monogatari-shū*.[6]

With the rise of the cult of the Buddha Amida and belief in the Western Paradise during the late Heian and Kamakura periods, worship of Jizō as a savior also spread. As one of the major bodhisattvas, Jizō was associated with the Trāyastriṃśa Heaven of the thirty-three gods (Tōri-ten) atop Mount Sumeru, the Buddhist *axis mundi*.[7] At the same time, Jizō became one of the twenty-five bodhisattvas in Amida's retinue, whose function was to lead souls to the Western Paradise. Jizō thus often appears as a subsidiary figure in depictions of the *raigō* or "descent" of Amida.[8] The format of the Academy's painting imitates images of the *raigō* of Amida (see cat. no. 25).

In addition, Jizō was a major figure in Japanese Esoteric Buddhism, and with the bodhisattva Kannon was one of the deities of the northern quadrant of the mystical *Taizōkai Mandara* (Sk. *Garbhakosadhātu Maṇḍala*).[9] Known as the Womb Mandala, in Esoteric Buddhist ritual this symbolized the realm of reason or logic out of which the Diamond World of wisdom and knowledge (J. Kongōkai, Sk. Vajradhātu) arises. At the center of the *Taizōkai Mandara*, which symbolizes the realm of potentiality (as opposed to actuality), was the cosmic Buddha Dainichi Nyorai (Sk. Mahāvairocana). Jizō's name (Matrix of the Earth) helps explain his role as one of the principal deities of the Womb Mandala. "The great earth (*Tai ji*) is indestructible and capable of rising and sustaining all that exists, hence it is an immeasurable treasure. The depth and infinity of the earth, as well as its other attributes, symbolize the virtue of the mind seeking Enlightenment."[10]

Jizō was associated with certain Shintō deities through the philosophical transformation known as *honji suijaku*, in which Buddhist deities were seen as manifestations of native Shintō gods.[11] This is apparent in certain syncretic Shintō-Buddhist shrine paintings, for example, the well-known *Kasuga Mandala* type (cat. no. 28), in which Jizō appears as the *honji* (original form) of the Shintō *kami* of the third Kasuga shrine.

1 Alicia Matsunaga, *The Buddhist Philosophy of Assimilation: The Historical Development of the Honji-Suijaku Theory* (Rutland and Tokyo: Charles E. Tuttle, 1969), p. 235.

2 Ibid.; see also Young-Sook Pak, "Kṣitigarbha as Supreme Lord of the Underworld," *Oriental Art*, 23 (7) (Spring, 1977), p. 96.

3 Matsunaga, *Buddhist Philosophy*, p. 235.

4 Heng Ching, trans., *Sūtra of the Past Vows of the Earth Store Bodhisattva* (New York: Institute for Advanced Studies of World Religions, 1974), p. 74, quoted in Pak, "Kṣitigarbha," p. 98.

5 Matsunaga, *Buddhist Philosophy*, p. 236.

6 Ibid; see Marian Ury, trans., *Tales of Times Now Past: Sixty-two Stories from a Medieval Japanese Collection* (Berkeley and Los Angeles: University of California Press, 1979), pp. 114–117. The tales of miracles of Jizō in the *Konjaku Monogatari-shū* highlight the close relationship in the Heian period between the worship of Amida and that of Jizō.

7 Bruce Darling, *The Transformation of Pure Land Thought and the Development of Shintō Shrine Mandala Paintings: Kasuga and Kumano* (Ph.D. dissertation, University of Michigan, 1983), p. 158; see also W. M. de Visser, *Ancient Buddhism in Japan*, 2 vols. (Leiden: E. J. Brill, 1935), vol. 1, p. 15. Jizō was, in addition, one of the Eight Great Bodhisattvas in Amida's service; see de Visser, *Ancient Buddhism*, vol. 2, p. 554.

8 For a painting of the *raigō* of Amida that incorporates Jizō, see Jōji Okazaki, *Pure Land Buddhist Painting*, trans. Elizabeth ten Grotenhuis (Tokyo and New York: Kodansha, 1977), pl. 135. As Okazaki points out, occasionally Amida was shown descending from the Pure Land surrounded by six images of Jizō, representing the Six Realms from which he could save lost souls.

9 Matsunaga, *Buddhist Philosophy*, p. 202.

10 Ibid., pp. 202–203.

11 Ibid., pp. 236–237.

PREVIOUSLY UNPUBLISHED

PROVENANCE
Mrs. Alice Spalding Bowen, Honolulu; John Gregg Allerton, Kauai.

12 The Sixteen Rakan (Arhats)

Nambokuchō or early Muromachi period, c. 1350–1400
Set of 16 hanging scrolls; ink and colors on silk; with seal of the Byōdō
Shinō-in, Saimyō-ji, Kyoto
Each approximately 105.5 x 40 cm
Gift of Mrs. L. Drew Betz, 1982 (5008.1–5008.16)

This set of paintings depicts the sixteen arhats (Ch. *luohan*, J. *rakan*). The arhats were believed to be original followers of the Buddha Śākyamuni in India and became the focus of a cult in Mahāyāna Buddhism. Traditionally arhats occurred in groups of sixteen, eighteen, and five hundred. In Japan sixteen arhats was the most prevalent number. In the Academy's set of sixteen paintings, each depicts a single arhat, occasionally with a human or animal attendant. Each scroll bears in the lower left corner a rectangular seal of the Byōdō Shinō-in, a subtemple of the Saimyō-ji in Kyoto.

The arhats were conceived as beings of exceptional *prajña* (transcendent wisdom), who had attained enlightenment by their own efforts but had not yet entered the state of *Nirvāṇa*. Thus they were believed to exist in the phenomenal world, but to have transcended all worldly bonds and freed themselves from the cycle of birth and rebirth. Their function in Mahāyāna Buddhism was to protect and maintain the Buddhist Law, or *Dharma*. In ancient India the arhats were believed to be endowed with six types of transcendent knowledge (*Abhijñā*):[1] the power to work miracles; the Divine Ear, by which all things in the Universe could be heard; knowledge of the thoughts of others; memory of former existences; the Divine Eye, by which all things in the Universe could be seen; the knowledge that caused the destruction of defiling passions.

The sixteen arhats were worshiped as a group in China as early as the Six Dynasties period, and they are mentioned in the *Ru Dacheng Lun* (*Mahāyānāvatāraka Śāstra*), translated by Daotai during the Northern Liang Dynasty (357–439).[2] This text, however, mentions only two of the arhats by name: Piṇḍola and Rahula. The earliest text in which all the sixteen arhats are named and discussed in detail is the *Da a Luohan Nandimiduoluo Suo Shuo Fazhu Ji* (*Record on the Duration of the Dharma, as Explained by the Great Luohan Nandimitra*), translated by Xuanzang in 654.[3]

While the first depictions of arhats in Chinese art may have been executed in the late fifth century, the first record of all sixteen arhats in art is associated with the Tang painter Lu Lengjia (eighth century).[4] Among the earliest surviving depictions of the sixteen arhats in Chinese art is the set of hanging scrolls attributed to the tenth-century Chan (Zen) monk-painter Guanxiu, now in the Imperial Household Collection, Tokyo; another set, attributed to Lu Lengjia, now in the Palace Museum, Beijing, may be even earlier.[5] The worship of the sixteen arhats appears to have been strongly associated with the Zen sect, both in China and Japan. The cult of the sixteen arhats became increasingly widespread in China from the tenth century onward, during the Five Dynasties period and the Song Dynasty. Worship of the sixteen arhats was introduced to Japan from China by the seventh

12.1

century.[6] Most surviving arhat paintings in Japan, however, date to the Kamakura, Nam-bokuchō, and Muromachi periods, when the worship of arhats had become a standard part of Buddhist ritual.[7]

Close comparison of the Academy paintings to surviving sets of arhat paintings in Japanese collections reveals that the Academy's set is derived from a set painted by the fourteenth-century artist Ryōzen. A signed set of sixteen paintings by Ryōzen in the Kennin-ji, Kyoto, most closely resembles the Academy's paintings. A very similar set in the Freer Gallery, Washington, which has been firmly attributed to Ryōzen, provides another possible model.[8] It is likely that Ryōzen himself used as a model a set of Chinese arhat paintings dating to the Yuan Dynasty (1260–1368). There exist today in Japanese temples at least fifteen sets of arhat paintings, all of which derive from the same basic

model.[9] One is signed by Ryōzen, and five are traditionally attributed to Chinese painters of the Yuan Dynasty (two to Yan Hui, one to the obscure painter Caishan). It is uncertain, however, whether any of these are actually Chinese. The remaining sets in Japan are considered to be the work of anonymous painters of the Nambokuchō or early Muromachi periods; two of these are traditionally attributed to the early Muromachi painter Minchō.

Piṇḍola Bhāradvāja (J. Binzuru Batsuradaja), 5008.1

Piṇḍola is one of the first arhats to be mentioned by name; he is recorded in the *Mahāyānāvatāraka Śāstra*, which was translated into Chinese by Daotai during the Northern Liang Dynasty (357–439), and is also mentioned in the *Sukhāvatīvyuha* (*Sūtra Spoken by the Buddha on Amitābha*).[10] Many stories relating Piṇḍola's miracles and magical powers appear in the early Theravāda canon, telling, for example, how he had the ability to fly through the air. According to one source he once offended the Buddha Śākyamuni by accidentally killing a woman, so he was made to stay in the world and propagate the *Dharma* until the coming of the Buddha of the Future (Maitreya), at which point he would be allowed to enter *Nirvāṇa*.[11] By the fifth century, Piṇḍola had become something of a cult figure in China.

Piṇḍola appears in this painting seated on an embroidered cloth placed over a rock (fig. 12.1). A steep cliff at the right ends in an overhang; pine trees grow out of the rock surfaces. In the background are the churning waves of a lake or ocean. Piṇḍola is shown with gaunt features, and is dressed as an Indian monk in a robe and sandals. His expression is one of intense concentration. In his hands he holds a miniature *stūpa* (reliquary shrine), inside which is a small statue of the Buddha Śākyamuni. An attendant in the guise of a crippled beggar appears in the lower right corner, dressed in tattered robes and holding a wooden crutch.

The brushwork of the arhat's body and robes is fluid, with the lineament characterized by fluid, elastic lines of varying width. In contrast, the attendant's robes are painted with sharp, hooked brushstrokes. As in the other paintings in this set, the figures have been backpainted with white pigment, applied to the back surface of the silk. After the outlines had been painted, colors were applied to the front surface. Gold pigment has been added in the *stūpa*, the halo, and the arhat's jewelry. The brushwork of the rocks and cliff is derived from the modified "axe-cut" texture strokes seen in thirteenth-century paintings by Chinese artists such as Liu Songnian and Yan Hui.

Kanakavatsa (J. Kadakkabassa), 5008.2

Kanakavatsa may be the same as the monk Vatsa, mentioned in the Pali text *Ekottarāgama Sūtra*: "He who tortures his body and sits in the dew, and who does not flee wind and rain, is the *bhikshu* Vatsa."[12] This arhat appears as a monk, although he does not have the emaciated features of Piṇḍola Bhāradvāja (fig. 12.2). He is depicted instead as a well-fed figure dressed in a Chinese priest's robe. In his right hand he holds a fly-whisk. He is accompanied by an attendant at the lower left who is dressed as a Chinese scholar of the Song Dynasty. A steep cliff rises up the left side of the painting, with an overhang above the arhat's head.

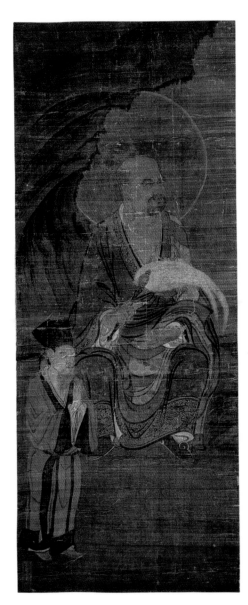

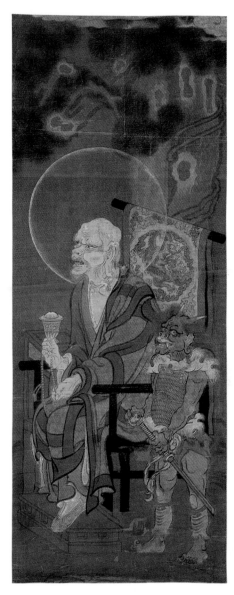

12.2

12.3

Kanaka Bhāradvāja (J. Kadakka Batsuridaja), 5008.3

This arhat is seated in a Chinese-style armchair; he is dressed in a priest's robe, and has the intense expression of an ascetic (fig. 12.3). In his hands he holds a Buddhist rosary. His feet rest on a low footstool. A narrow table appears behind him, on which is a covered cup. A cloth embroidered with a dragon among clouds is hung over the back of the armchair. In the upper background are two pine trees, with highly stylized knots in the trunks and branches. The arhat is accompanied by a horned demon attendant, who glowers with his three eyes toward the viewer. This muscular demon wears a jacket of chainmail and grips the handle of a sword with both hands.

Subinda (J. Sohinda), 5008.4

The arhat Subinda is depicted as a Buddhist priest of the Esoteric sect (fig. 12.4). Seated on a low bench, he holds in his hands the two main ritual implements of Esoteric Buddhism, the *vajra* (thunderbolt) and *ghaṇṭā* (bell). He is portrayed with his mouth open, as if in the midst of chanting a sacred *mantra*. His feet rest on a footstool; to the right is a circular stand with a box. The arhat's attendant appears at the left, in the guise of a *lokapāla*, or guardian figure. The attendant wears armor and has his hands clasped in prayer; a halo of green flames encircles his head. These two figures appear in front of a wooden temple, with an ornate fence and a flagstone pavement visible at the right. Behind Subinda is an open doorway, with the door carved in decorative floral scrolls. At the upper left is a view into an interior, where we see an ornate table with cabriole legs, bearing an incense burner and a miniature *stūpa*.

Nakula (J. Dakura), 5008.5

According to the Theravāda text *Ekottarāgama Sūtra*, Nakula was the oldest of the arhat followers of Śākyamuni, and was destined to live forever.[13] This arhat appears here as a wizened Indian monk dressed in a red robe and holding a fan (fig. 12.5). He is accompanied by a Chinese youth holding a bundle of *sūtras*. The arhat's most notable features are his long eyebrows, which hang down to his chest. A cliff along the right border of the scroll terminates in an overhang that suggests the entrance to a cave. A willow tree grows out of the cliff over the arhat's head. Clouds drift along the upper rock surfaces, while a pond takes up the background. Two Mandarin ducks swim in the water, and bamboo grows on a spit of land.

Bhadra (J. Batsudara), 5008.6

The arhat Bhadra is recorded as having been a great magician. He is mentioned in the Theravāda text *Ekottarāgama Sūtra*: "He whose eloquence rises at once and dissolves the hindrance of doubt of mankind, is the *bhikshu* Bhadra."[14] He is shown here seated on a low stool and chanting as he rotates a rosary in his hands (fig. 12.6). His legs are crossed under him on the seat, and his shoes are placed on a low footstool. He is accompanied by a sleeping attendant, shown with the Tang-style coiffure of a young boy. The attendant holds a partially unrolled scroll covered with Sanskrit writing. This, together with the arhat's clearly foreign features, reinforces awareness of Bhadra's Indian origin.

In the background are several pieces of furniture, the most prominent of which is a large screen with a wooden base carved with floral scrolls and a mythical beast. The screen frame encloses a monochrome ink painting on silk depicting a snowy landscape (fig. 12.6a). To the right is a table that holds a covered cup, a vase with a flowering branch, and a small table screen.

The ink landscape on the large screen is a significant feature, as it provides information that helps us to date this entire set of arhat paintings. It depicts a landscape with earthen banks and trees in the foreground, a steep hillside with several trees in the middle distance, and snow-covered mountains beyond a river in the background. The landscape is executed in pale ink, with subtly modulated washes. The hills and earthen banks are

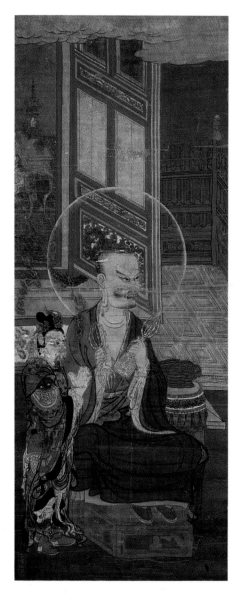

12.4

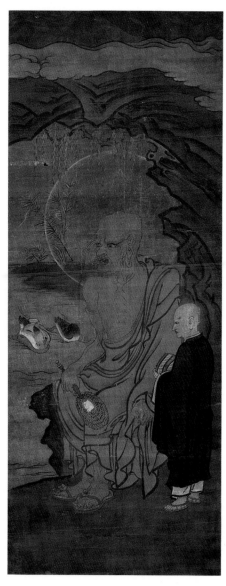

12.5

outlined with broad, fluctuating strokes of ink, with an occasional lighter ink wash used for texture and modeling. The distant mountains are merely outlined with thin lines of ink accentuated along their outer borders with broader strokes of pale wash. The trees in the fore- and middle grounds have trunks painted in one or two strokes, and foliage consisting of soft blobs and dots of ink.

The overall technique is impressionistic and owes a debt to the styles of such Southern Song Zen artists as Muqi and Liang Kai (mid-thirteenth century). The distant mountains are ultimately derived from Northern Song painting, although the overlapping of their forms is a detail filtered through stylized landscape paintings of the Jin and Yuan dynasties in the tradition of Li Cheng and Guo Xi.[15] In style the landscape on this screen is similar to paintings by the fourteenth-century Japanese artists Ka'ō (first half of the

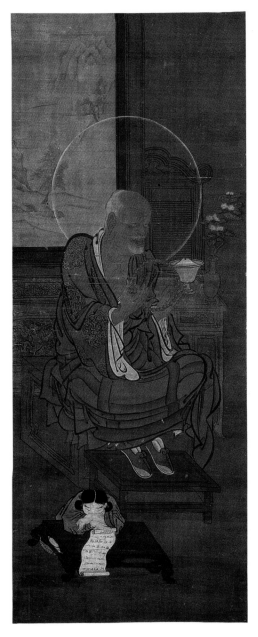

12.6

fourteenth century), Ue Gukei (fl. 1361–1375), and Minchō (1352–1431).[16] The style is especially close to that of Ue Gukei, whose rare surviving landscapes have been described as follows:

> They are defined with rather light washes of the brush on a rather loose wide-grained silk. The effect is that of creating a deliberately ephemeral world, almost as though one were looking at it through a thin, semi-transparent sheet of gauze. This effect is further reenforced by the subtle use of undefined areas which creates the illusion of bands of mists playing

in and out of grove and tree top, cliff and temple roof. The notion of a
tangible atmosphere, of misty distance is thus made apparent.[17]

The similarities in style between the ink landscape on the Academy's portrait of
Bhadra and late fourteenth-century paintings by Gukei and others suggest a late fourteenth-
century date for this entire set of arhat paintings. The style of the landscape screen reflects,
furthermore, a period in early Japanese ink landscape painting before the influence of the
great masters Josetsu and Shūbun in the early fifteenth century, who created the more
distinctively Japanese transformation of the Song and Yuan ink-landscape tradition.

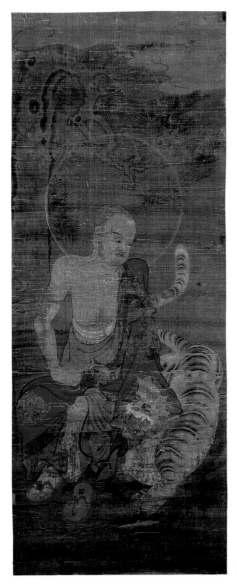

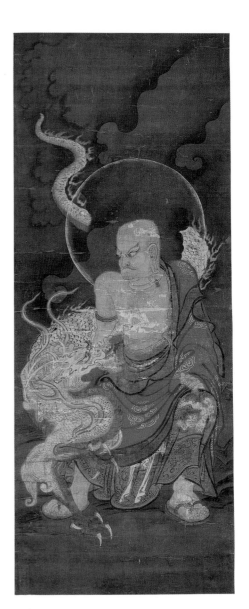

12.8

12.7

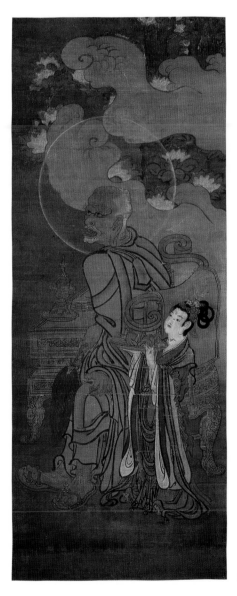

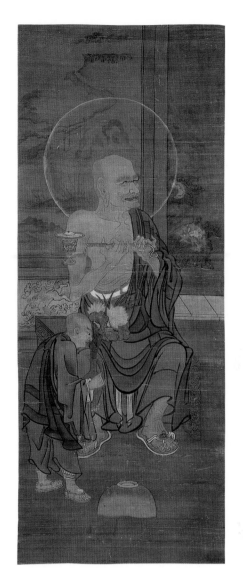

12.10

12.9

Kālika (J. Karika), 5008.7

Kālika appears as a young monk with Chinese features (fig. 12.7). He is seated on the ground under a pine tree, and is accompanied by a roaring tiger whom he pets with his left hand. It is significant that Kālika with the tiger appears in conjunction with the arhat Vajraputra, who is accompanied by a dragon (5008.8). The tiger and dragon in China respectively symbolized *yin* and *yang*, the two forces in the cosmos out of whose complementary interaction reality emerges. *Yin* represented dark, cold, and weakness; *yang* stood for light, heat, and strength. As symbols of the polarities in existence that could be overcome through Buddhist meditation and practice, the dragon and tiger were often depicted in paired hanging scrolls by Chinese Chan painters of the Song and Yuan dynasties, and in turn by Japanese Zen artists of the Kamakura, Nambokuchō, and Muromachi periods.[18]

Vajraputra (J. Bajarahotara), 5008.8

Vajraputra is shown seated on a rock; he is accompanied by a white dragon (fig. 12.8). The arhat has an intense and slightly malevolent expression, and appears to be subduing the dragon with his gaze. The dragon's tail disappears among the roiling clouds in the background.

Gopaka (J. Jubaka), 5008.9

Gopaka is shown as an old Indian monk, seated in an ornately carved Chinese armchair with a curved back (fig. 12.9). He holds a fly-whisk in his right hand. Accompanying him is a female attendant, dressed as a court lady of the Tang Dynasty (618–906). She holds a tray bearing two peaches. These fruits, in conjunction with the gold phoenix in her hair, suggest that she is a Daoist immortal portrayed here in a subsidiary position to the Buddhist arhat. Her supernatural status is indicated by the third eye on her forehead. Behind the arhat is a table carved in the same ornate manner as the chair, and bearing an incense burner and a low stand. Stylized clouds drift across the upper part of the scroll, where they partially obscure a flowering tree.

Panthaka (J. Handaka), 5008.10

The arhat Panthaka and his younger brother Cūḍa Panthaka (5008.16) are both mentioned in the Theravāda text *Ekottarāgama Sūtra*: "He who by means of his divine magic power can hide himself is the *bhikshu* Panthaka, and he who can transform his body and perform very many miracles (metamorphoses) is the *bhikshu* Cūḍa Panthaka."[19] Panthaka is shown seated on a low bench (fig. 12.10). He holds in his hands a gold incense burner. This ritual implement is similar in style to many surviving examples of the Kamakura period. Panthaka is accompanied by a young monk holding a vase of lotus flowers, which he appears to be setting into a hemispherical holder on the ground. The figures appear on a garden terrace, suggested by the flagstones at the right. Behind the arhat is a painted screen similar in type to that depicted in the portrait of the arhat Bhadra (5008.6). The lower frame of the screen is carved or painted with a design of a mythological beast chasing an embroidered

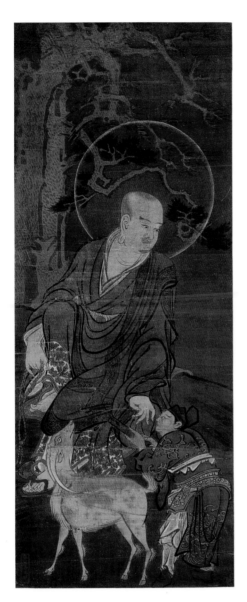

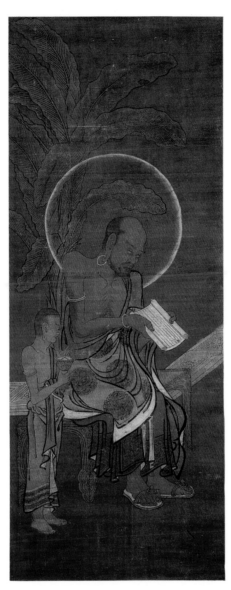

12.11

12.12

ball among clouds. The screen itself is painted with a monochrome ink landscape depicting low banks along a stream, a covered bridge, and a misty grove of trees. The landscape is executed in pale, loosely handled washes, and is characterized by a degree of spatial ambiguity in which areas of land and water merge in the mist.

Rāhula (Ragora), 5008.11

Like Piṇḍola (5008.1), Rāhula was one of the first arhats to be mentioned by name in early Buddhist texts.[20] Traditionally believed to be the son of the Buddha Śākyamuni and his wife Yasodhara, he gradually became the patron of novice monks and those who had not yet mastered the *Vinaya*, or rules of the monastic community.

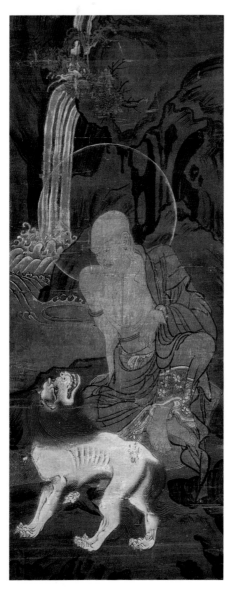

12.13

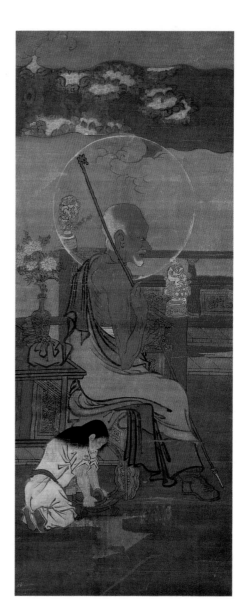

12.14

He is shown here as a young monk seated on a rock under a gnarled pine in a rugged landscape, holding a rosary in his right hand (fig. 12.11). In the foreground is an attendant dressed in the robe and hat of a Chinese scholar-official of the Tang Dynasty. The attendant's robe is embroidered with bats among waves; the bat is a symbol of good fortune in China. Next to the attendant is a white ram, also a symbol of good fortune, since the word for "ram" in Chinese (*yang*) is similar in form to a character meaning "good luck" (*xiang*).

Nāgasena (J. Nagasaina), 5008.12

The arhat Nāgasena is most closely linked with the text entitled *Milinda-Panha* (*The Questions of King Menander*). Menander was a Greek king who ruled a state in northwest India in the second century B.C. According to this text, he was converted to Buddhism by Nāgasena.[21] Nāgasena was known in China by the early fifth century A.D., when a very similar text, the *Nāgasena Bhikshu Sūtra*, was translated into Chinese.[22]

The arhat Nāgasena is depicted in this scroll as a monk with dark skin and pronounced Indian features (fig. 12.12). He is seated on a garden bench, reading a *sūtra* scroll. His robe is decorated with roundels depicting dragons. Accompanying him is an attendant dressed in a simple *dhoti* and holding an incense burner or cup. The carved flagstones in the background and the banana palm indicate that the locale is an aristocratic garden, of the type often depicted in Chinese court painting of the Southern Song Dynasty; an example is an arhat painting by the court painter Liu Songnian, dated 1207.[23]

Iṅgada (Angaja, J. Inkatsuda), 5008.13

This arhat is shown against a remote mountain landscape, seated on a mat placed over a rock (fig. 12.13). He is accompanied by a white lion, and like the arhat Vajraputra with the dragon (5008.8), he appears to be quelling the fierce beast with his gaze alone. Behind the arhat a waterfall descends from a cliff into a pool of water.

Vanavāsi (Banabashi), 5008.14

The arhat Vanavāsi is shown as an old man with a staff (fig. 12.14). He is seated on an ornate bench in a garden, suggested by the elaborately carved balustrade with gilded lion-shaped posts. The arhat is accompanied by a young male attendant with long hair, who kneels on the ground to work a rolling mortar and pestle. On a table is a stack of lacquer or ceramic cups, a vase of flowers, and a bundle covered with cloth. In the upper part of the painting are bands of clouds which partly obscure several flowering trees.

Ajita (Ashita), 5008.15

The arhat Ajita is seated on a rock under a tree (fig. 12.15). His monk's robe is embroidered with dragons and has a border of flowers. In his right hand he holds a wish-granting jewel (*cintāmaṇi*). He is accompanied by a bearded old man, who leans forward with his hands outstretched as if to receive the jewel. An incense burner hangs from the tree above.

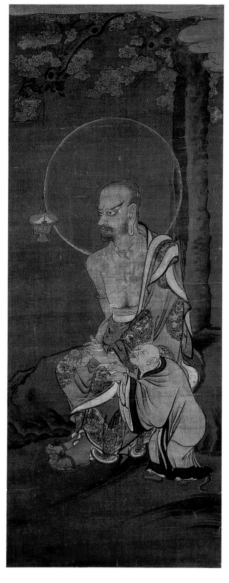

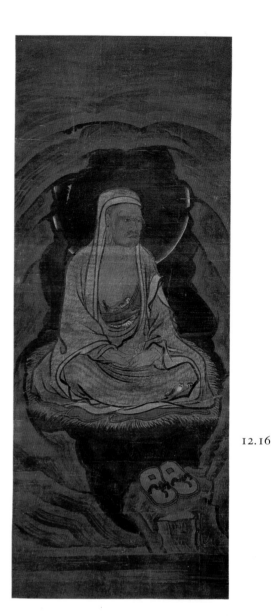

Cūḍa Panthaka (Chudahantaka), 5008.16

Cūḍa Panthaka was the younger brother of the arhat Panthaka (5008.10), and became an arhat in old age. When he was born he was extraordinarily stupid, so that he had difficulty learning even a single *gatha* (verse). Due to his great virtue, however, the Buddha "took away the obstacles of his mind."[24] Cūḍa Panthaka was also credited with miraculous powers, including the ability to fly, walk on water, divide his body into innumerable other bodies, and transform himself into other forms. This arhat is seated in meditation inside a cave (fig. 12.16). He wears a simple robe with a hood; his shoes are carefully placed on a rack in the foreground. Tucked into his robe, both at the lower hem and at his chest, are five sparrows which appear to be nesting. In his posture the arhat resembles the figure of Bodhidharma (J. Daruma), the first patriarch of Zen Buddhism.

1 M. W. de Visser, *The Arhats in China and Japan* (Berlin: Öesterheld, 1923), p. 8.

2 Ibid., p. 62.

3 Ibid., p. 58; the entire text is translated in Sylvain Levi and E. Chavannes, "Les seize arhat protecteurs de la Loi," *Journal Asiatique* (1916), pp. 5–50, 189–304.

4 De Visser, *Arhats*, pp. 104–105. The record of Lu Lengjia's paintings (a set of sixteen paintings) is contained in Deng Chun, *Hua ji* (1167).

5 Osvald Sirén, *Chinese Painting: Leading Masters and Principles*, 5 vols. (London: Lund Humphries, 1956–1958), vol. 3, pls. 114–115 (Guanxiu) and pl. 89 (Lu Lengjia).

6 De Visser, *Arhats*, p. 129.

7 See, for example, de Visser, *Arhats*, pp. 182–196, in which he describes the ceremony performed by the Sōtō Zen sect in honor of the sixteen arhats.

8 The Kennin-ji set is published in Suzuki Kei, *Chūgoku kaiga sōgo zuroku*, 5 vols. (Tokyo: University of Tokyo, 1982), vol. 4, no. JT5-001. The Freer set is published in *The Freer Gallery of Art, II: Japan* (Tokyo: Kodansha, 1972), pl. 19, pp. 158–159. See also Carla M. Zanie, "Ryōzen: From Ebusshi to Ink Painter." *Artibus Asiae* 40 (2/3) (1978).

9 The sets of arhat paintings in Japanese temple collections that are related to the Academy's set are illustrated in Suzuki Kei, *Chūgoku kaiga sōgo zuroku*, vol. 4: JT8-001 (Nambokuchō), JT11-001 (Muromachi), JT17-004 ("Yan Hui"), JT25-001 ("Yuan"), JT29-001 ("Minchō"), JT31-001 (Muromachi), JT34-002 ("Caishan"), JT81-002 (Edo), JT82-001 ("Minchō"), JT94-001 ("Minchō"), JT95-001 (Nambokuchō), JT101-005 ("Yuan"), JT110-004 (Muromachi), JT111-006 ("Yan Hui"), JT132-001 ("Li Gonglin").

10 De Visser, *Arhats*, p. 73.

11 Ibid., pp. 71–72.

12 Ibid., p. 89.

13 Ibid., p. 81.

14 Ibid., p. 87.

15 See, for example, Sirén, *Chinese Painting*, vol. 3, pl. 321, and vol. 5, pl. 82.

16 See Takaaki Matsushita, *Ink Painting* (New York and Tokyo: Weatherhill, 1974), pl. 29 (Ka'ō); and Richard Edwards, "Ue Gukei—Fourteenth Century Ink-Painter," *Ars Orientalis* 7 (1968), p. 174.

17 Edwards, "Ue Gukei," p. 174.

18 See the pair by Muqi in the Daitoku-ji, Kyoto, illustrated and discussed in Jan Fontein and Money L. Hickman, *Zen Painting and Calligraphy* (Boston: Museum of Fine Arts, 1970), no. 10.

19 De Visser, *Arhats*, p. 83.

20 Ibid., pp. 79–80.

21 William de Bary, ed., *The Buddhist Tradition in India, China and Japan* (New York: Vintage Books, 1969), pp. 21–24.

22 De Visser, *Arhats*, p. 88.

23 See *Kōkyu sōga seika*, 3 vols. (Tokyo: Gakken, 1975), vol. 2, pl. 56.

24 De Visser, *Arhats*, p. 84.

PREVIOUSLY UNPUBLISHED

PROVENANCE
Joseph Seo, New York; Mrs. L. Drew Betz, Honolulu.

ESOTERIC IMAGES

13 Nyoirin Kannon

Early Muromachi period, fifteenth century
Hanging scroll; ink, colors, and gold on silk
96 x 39.7 cm
On loan from the Estate of Harry Shupak

Nyoirin Kannon is an Esoteric or Tantric form of the bodhisattva of Compassion, Kannon (Sk. Avalokiteśvara). In this manifestation Kannon appears seated, and has six arms. The Sanskrit name of this deity is Cintāmaṇi-cakra Avalokiteśvara, meaning "Jewel-Holding, Wheel-Turning Avalokiteśvara." The earliest-known text to describe this form of Kannon is the *Cintāmaṇi-cakra Dhārani Sūtra* (J. *Nyoirin Darani-kyō*), translated into Chinese by the monk Bodhiruci in A.D. 709.[1] The sacred jewel enables Nyoirin Kannon to grant the wishes of those who invoke the deity, while the *cakra* is the wheel of the *Dharma*, or Buddhist Law, through the action of which sentient beings can attain Enlightenment. The six arms of this deity symbolize Nyoirin Kannon's ability to save beings in all six Realms of Existence (see cat. no. 11).[2]

While one recent study suggests that an early form of Nyoirin Kannon can be found in ninth-century Indian art, the earliest Far Eastern images are several late Tang Dynasty gilt bronze sculptures preserved in Japan.[3] The deity appears most often in Japanese art after the Heian period.

In this hanging scroll Nyoirin Kannon is seated in the pose known as "royal ease" *(mahārājalīlāsana)*. The figure's skin is painted in gold, and it wears a green, red, and brown robe with scarves; details and highlights are meticulously painted in gold. In its hands the figure holds a lotus flower, a group of three flaming jewels resting on a lotus, a rosary, and an incense burner. Its elaborate crown bears at the center a small image of the seated Buddha Amida. The gold details of the crown and the figure's jewelry are painted in the *moriage* technique, in which the gold pigment is raised slightly above the surface of the silk.

Nyoirin Kannon is seated on an open lotus throne with two halos, one behind its head and another behind its body. The lotus throne rests on a rocky ledge situated by the ocean; this suggests that the scene depicts Mount Potalaka (J. Fudaraku), Kannon's traditional abode in the eastern ocean. The ledge is surrounded by steep rocks, mountains, and waterfalls, all painted in a combination of green, brown, and gold pigments. The sky in the background is painted dark blue-green. The overall effect is of a strange, unworldly scene befitting an Esoteric deity. The use of the *moriage* technique in the jewelry and the highly expressive combination of gold and dark luminous pigments in the landscape suggest that this painting should be dated to the early Muromachi period.

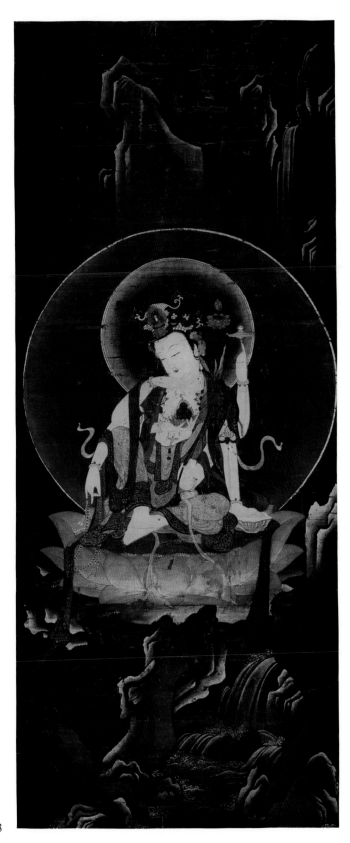

13

1 See Alicia Matsunaga, *The Buddhist Philosophy of Assimilation: The Historical Development of the Honji-Suijaku Theory* (Rutland and Tokyo: Charles E. Tuttle, 1969), p. 126; and Sherry Fowler, "Nyoirin Kannon: Stylistic Evolution of Sculptural Images," *Orientations* (December, 1989), p. 59.

2 Fowler, "Nyorin Kannon."

3 Ibid., fig. 2; see Pratapaditya Pal, "The Iconography of Cintāmaṇi Cakra Avalokiteśvara," *Journal of the Indian Society of Oriental Art* n.s. 2 (1976–1978), pp. 39–48.

PREVIOUSLY UNPUBLISHED

Zuzō (Iconographical Drawing): Kongō Zuishin Bosatsu

Kamakura period, thirteenth century
Hanging scroll; ink on paper; with seal of the Kōzan-ji, Kyoto
109.5 x 61.3 cm
Gift of Renee Halbedl, Mr. and Mrs. Robert P. Griffing, Jr.,
Mrs. Theodore A. Cooke, Mrs. Walter F. Dillingham, Robert Allerton,
Mrs. Alfred Tozzer, and Mr. and Mrs. William James, in memory of
Langdon Warner, 1956 (2201.1)

This impressive iconographical sketch, or *zuzō*, depicts the Esoteric deity Kongō Zuishin Bosatsu, or the "Bodhisattva Whose Mind Is in Accord with the Diamond." The deity is painted standing on a dais with one foot raised and holding aloft a *vajra* or thunderbolt. He has a terrifying expression and long, wild hair. The figure's posture is similar to that assumed by the Five Guardian Bodhisattvas of Esoteric Buddhism, and this may be a related deity.[1] The sketch is labeled in semicursive script at the upper right: "Kongō zuishin bo[satsu]."

Sketches of this type have survived in large numbers from the Heian and Kamakura periods. Many examples were produced by workshops at such temples as the Kōzan-ji in Kyoto. The Academy's *zuzō* bears the well-known rectangular seal of Kōzan-ji, stamped on the back side of the paper just below the inscription (fig. 14a). Sketches such as this were often drawn on both front and back sides of large joined sheets of paper.

14a

The lineament of this sketch is wonderfully vigorous, with great variations in the width of the lines. The figure has a dynamic posture; the smoothly curving lines of the muscles, hair, and drapery create strongly echoing patterns of movement. The emphasis on the diagonal line from upper left to lower right provides a powerful thrust that unifies the composition. The *zuzō* is made up of six joined pieces of paper. It has been suggested that the sketch is a Kamakura-period copy of a Heian original; this is based on the hole drawn and incorporated into the image between the proper left arm and the figure's side. The unusual presence of this lacuna suggests the reverence in which such iconic images were held. Proper attention to precision of the lines and proportions in such figures was critical to their ritual efficacy. Thus, the artist who transmitted the design may have decided not to fill in portions of the image that were missing in his model.

The Kōzan-ji seal is found on numerous surviving sketches and paintings from this famous temple. The best-known example may be the *Chōjū Giga* (*Frolicking Animals*) handscroll in the Kōzan-ji collection; this scroll provided the model for the Academy's copy by Kanō Tan'yū (cat. no. 39).[2] Scrolls of *Śākyamuni Descending the Mountain* in the Seattle Art Museum and the *White-Robed Kannon* in the Cleveland Museum of Art also bear this Kōzan-ji seal.[3]

1 See *Kōbō Daishi to mikkyō geijutsu* (Kyoto: Kyoto National Museum, 1981), pl. 119.
2 *Treasures of the Kōzan-ji Temple* (Kyoto: Kyoto National Museum, 1981), pl. 1.
3 Published respectively in Seattle Art Museum, *A Thousand Cranes: Treasures of Japanese Art* (San Francisco: Chronicle Books, 1987), no. 37; and Sherman E. Lee, *A History of Far Eastern Art* (London: Thames and Hudson, 1964), pl. 498.

LITERATURE
Archives of the Chinese Art Society of America, 9–12 (1955–1958), p. 91, fig. 16.
Junkichi Mayuyama, ed., *Japanese Art in the West* (Tokyo: Benrido, 1966), pl. 79.
Academy Album (Honolulu: Honolulu Academy of Arts, 1968), p. 118.

PROVENANCE
Mayuyama and Company, Tokyo.

金剛隠... 杵

15 Aizen Myō-ō

Early Muromachi period, c. 1400
Hanging scroll; ink, colors, and gold on silk
87.5 x 51 cm
Purchase, 1991 (6059.1)

This beautiful painting depicts the Esoteric deity Aizen Myō-ō (Sk. Rāgarāja Vidyārāja), or "Aizen the Wisdom King." His function is to transform human passions into a vehicle for Enlightenment. The primary *sūtra* related to this deity is the *Kongōburōkaku Issai Yugaya Gikyō*.[1] This text was translated into Chinese in the early eighth century by the Indian monk Vajrabodhi.[2] Worship of Aizen Myō-ō was introduced into Japan by Kōbō Daishi (see cat. no. 31) in the early ninth century. From the Late Heian period onward, Aizen was invoked to aid in emotional problems as well as to protect the state.

In the Academy's painting, Aizen Myō-ō appears seated on a lotus throne. The deity is depicted in the standard manner with red skin, six arms, and a terrifying expression. In his hands he holds two Esoteric ritual objects, the *vajra* (thunderbolt) and *ghanta* (bell), a lotus flower, and a bow and arrow. A lion mask appears in his hair. The figure is surrounded by a double halo, the inner circle painted in blue and green pigments and the outer circle with gold flames on a deep red ground. Details of the figure's robe and sash are painted with meticulous floral designs and geometric patterns in gold.

The throne on which Aizen sits is decorated in the *moriage* technique of raised gold painting. Among the details of this throne are stylized lotus petals and a fierce dragon swimming among swirling waves.

At the base of the throne is a series of flaming jewels (*cintāmaṇi*). Other jewels are shown scattered on the stylized and highly decorative floor or pavement on which the throne stands. The background behind the figure itself is painted with a highly abstract and mysterious scene of gold clouds or waves against deep blue-green.

An extraordinary aspect of this hanging scroll is that the mounting, which would normally consist of brocade strips and panels, is here painted in a *trompe-l'oeil* technique on the same piece of silk as the main image. This suggested mounting consists of a border of floral scrolls painted in blue, white, red, and gold pigments with an outer border of gold *cakra* wheels painted on a pale green ground. The upper wooden bar (*hassō*) of the scroll has its original gilt-bronze fittings; the knobs of the lower bar are decorated in cloisonné enamel on copper and appear to be additions of the late Edo period.

1 Alicia Matsunaga, *The Buddhist Philosophy of Assimilation: The Historical Development of the Honji-Suijaku Theory* (Rutland and Tokyo: Charles E. Tuttle, 1969), p. 252.
2 John Rosenfield and Elizabeth ten Grotenhuis, *Journey of the Three Jewels: Japanese Paintings from Western Collections* (New York: Asia Society, 1979), p. 88.

PREVIOUSLY UNPUBLISHED

PROVENANCE
Eli Jaxon-Bear, Maui.

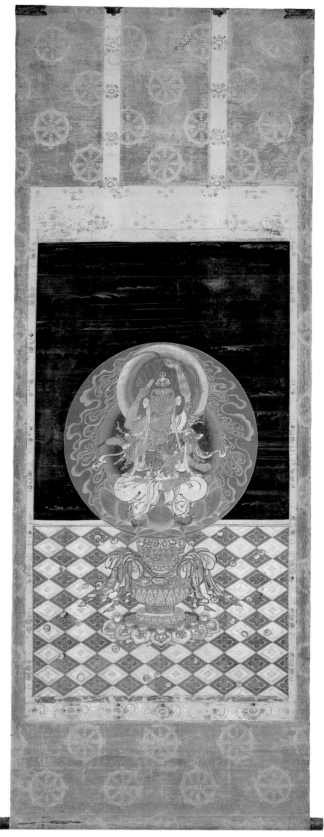

王明動不

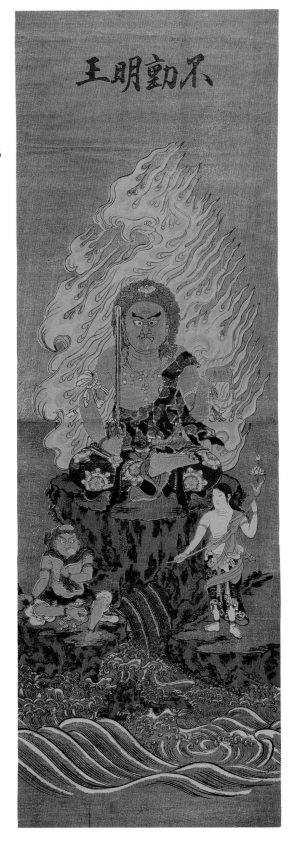

Fudō Myō-ō

Circa early seventeenth century
Hand-colored woodblock print
71 x 23.8 cm
Purchase, 1954 (13,434)

This woodblock-printed image of the Esoteric deity Fudō Myō-ō may be tentatively dated to the late sixteenth or early seventeenth century and is almost certainly based on an earlier painted image. Fudō Myō-ō (Sk. Acalanatha Vidyārāja, Ch. Budong Mingwang) is a deity of Indian origin. His name means "Immovable King of Wisdom," and in China and Japan he became one of the five Myō-ō, or Wisdom Kings (Vidyārāja).[1] The appearance and characteristics of these deities are described in a *sūtra* known as the *Ninnō-gokoku-hannya-haramitakyō-dōjō-nenjugiki.*[2] The earliest mention of Fudō Myō-ō appears in the *Fukū-ken-jaku-jimpen-shingon-kyō,* translated into Chinese by Bodhiruci in the early Tang Dynasty (707–709); he also appears in the *Dainichikyō,* translated about 724.[3] Worship of the Five Wisdom Kings was introduced into ninth-century Japan by Kōbō Daishi, founder of the Shingon sect. Fudō Myō-ō is seen as a manifestation of the cosmic Buddha Dainichi Nyorai (Mahavairocana), and appears in the southern section of the Jimyō-in (Wisdom Holder's Court) of the Womb Mandala (*Taizōkai Mandara*).

The print presents the image of the deity in fine black lines. Green, orange, and brown pigments were applied by hand over the printed image. Because of its size the image is printed on two pieces of paper, which have been joined together.

Fudō Myō-ō is shown as a terrifying deity, seated in "fire-producing" *samādhi* (meditation) on a rock in the ocean. Behind him is a halo of bright orange flames, and he is identified by his primary attributes, the noose and the sword. He is customarily shown with fangs. His function in the Esoteric pantheon is to destroy impediments that lie in the path to Enlightenment, and he was worshiped for his ability to control disease, to subdue enemies, and to assist in the acquisition of wealth and peace. Fudō Myō-ō is accompanied here by his two young assistants, Kongara-dōji and Seitaka-dōji.[4] At the top of the print are characters reading "Fudō Myō-ō."

1 Alicia Matsunaga, *The Buddhist Philosophy of Assimilation: The Historical Development of the Honji-Suijaku Theory* (Rutland and Tokyo: Charles E. Tuttle, 1969), pp. 248–249.
2 Ibid.
3 Ibid.
4 Hisatoyo Ishida, *Esoteric Buddhist Painting,* trans. E. Dale Saunders (Tokyo and New York: Kodansha, 1987), pp. 143–145.

PREVIOUSLY UNPUBLISHED

PROVENANCE
Raymond E. Lewis, San Francisco.

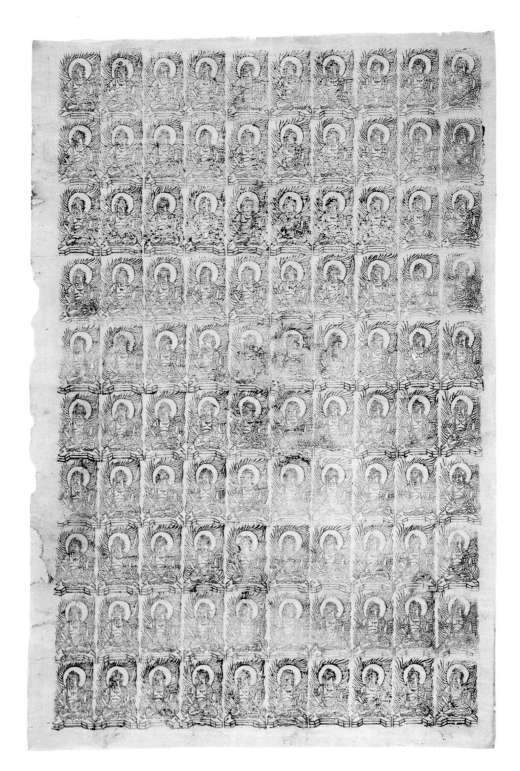

17

Multiple Images of Fudō Myō-ō 17

Muromachi period, c. late fourteenth–fifteenth century
Woodblock print
46 x 31.4 cm
Purchase, 1974 (16,522)

This remarkable print consists of one hundred images of the Esoteric deity Fudō Myō-ō, one of the Five Kings of Wisdom (*Myō-ō*) (see cat. no. 16). The print was made by stamping small images of Fudō in ten horizontal registers. The image was thus printed using a small block with repeated impressions. While the individual impressions vary in clarity, the overall effect is quite powerful. Each image depicts Fudō seated in meditation on a low platform. He carries a sword and a rope noose in his hands and has a terrifying expression. Behind the deity are swirling flames. It is likely that this image was inspired by either an iconographical drawing (*zuzō*) or a large-scale painting. The repeated impressions of the printed blocks were believed to increase the efficacy of the image. Several similar examples are known in Japanese collections.[1]

1 See, for example, *Masterpieces of Japanese Prints — From the Origin to the Emergence of Nishiki-e* (Machida: Machida City Museum of Graphic Arts, 1987), no. 93.

PREVIOUSLY UNPUBLISHED

PROVENANCE
M. Yoshida, Kyoto.

Ichiji Kinrin and the Bodhisattva Monju 18

Muromachi period, fifteenth century
Hanging scroll; ink, colors, and gold on silk
95.5 x 37.4 cm
Gift of Mrs. Philip E. Spalding, 1955 (2112.1)

The Academy's painting of Ichiji Kinrin (One Word Wheel King) is one of the few surviving images of this Esoteric deity outside of Japan. The deity's depiction in this scroll with Monju (Sk. Manjuśri), the bodhisattva of Wisdom, is unusual. Ichiji Kinrin was perceived as a manifestation of the cosmic Buddha Dainichi Nyorai (Sk. Mahavairocana). The worship of Kinrin began in the Heian period and continued into the Muromachi

period and later. He has been described as "one of the most formidable gods in the Japanese Buddhist pantheon," for he is the pure form of the Dainichi Nyorai of the Kongō-kai, or Diamond World Matrix.[1]

The image is based on a Buddhist text known as the *Jishoki*, in which Kinrin is described as being gold in color and wearing a five-faceted crown. He is depicted here in the guise of a bodhisattva, and his hands make the gesture known as "*Mudrā* of the Wisdom Fists" (*chiken-in*). The rituals associated with Ichiji Kinrin were so powerful that they were employed to control the effects of heavenly bodies, fight disease, and repel hostile military attacks. The rituals also enabled worshipers to visualize the Buddha Amida. Initially the Ichiji Kinrin rites were performed by high priests and members of the Heian aristocracy. Worship of the deity seems to have increased dramatically with the advent of the age of *mappō* (Decline of the *Dharma*) in the eleventh century.

In the Academy's painting, the figure of Kinrin sits on a lotus throne supported on the backs of seven gold lions. The figure, which has gold skin, is dressed in a white robe with flowing scarves and wears a gold crown. Behind his head is a multicolored halo, while his body has a white-and-red halo. This large central figure is surrounded by eight subsidiary images painted against a dark gray ground. In clockwise order from the lower left, these are the Wheel of the *Dharma* (*cakra*), a banner surrounded by sacred jewels (*cintāmaṇi*), a goddess, a white horse on a cloud, an elephant on two lotus flowers, the storehouse god Shuzōshimbō, the angry deity Shuheishimbō, and the deity Butsugen.[2] A painting of Kinrin with the same subsidiary figures, dated to the Kamakura period, is in the Henjōkō-in, Wakayama Prefecture.[3] The lower section of the scroll depicts the bodhisattva Monju seated on a lion with a white halo; he holds his usual attributes of the book on a lotus flower and the sword, with which he cuts through the bonds of ignorance.

The painting has suffered from abrasion of its pigments, suggesting that it may have been used frequently in Buddhist rituals. Surviving images of this type are rare.

1 For an excellent discussion of this deity, see Mimi Yiengpruksawan, "In My Image: The Ichiji Kinrin Statue at Chūsonji," forthcoming in *Monumenta Nipponica*. The present discussion relies greatly on this article. See also M. W. de Visser, *Ancient Buddhism in Japan*, 2 vols. (Leiden: E. J. Brill, 1935), pp. 481, 550, 570.

2 See the discussion of a similar painting in Hisatoyo Ishida, *Esoteric Buddhist Painting*, trans. E. Dale Saunders (Tokyo and New York: Kodansha, 1987), pp. 53–54.

3 *Kōbō Daishi and the Art of Esoteric Buddhism* (Kyoto: Kyoto National Museum, 1983), pl. 166. For a Heian image see the exhibition catalogue *Bi no bi* (Tokyo: Mitsukoshi, 1976), pl. 2.

PREVIOUSLY UNPUBLISHED

PROVENANCE
Mrs. Philip E. Spalding, Honolulu; Mrs. Alice Spalding Bowen, Honolulu.

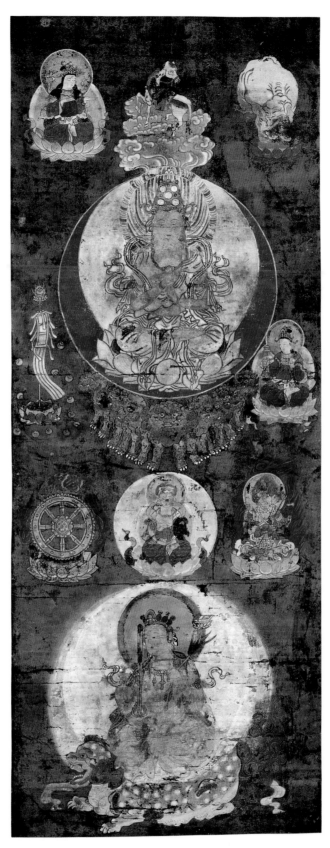

19 Niten and Gaten: Two of the Twelve Deva Kings (Jūni-Ten)

Early Muromachi period, fifteenth century
Hanging scrolls; ink, colors, and gold on silk
120.4 x 37.2 cm; 120.4 x 37 cm
Gift of Samuel Hammer, 1954 (1970.1, 1971.1)

These hanging scrolls depict two of the twelve deva kings (J. *Jūni-ten*). Of Hindu origin, these deities were absorbed into the pantheon of Far Eastern Esoteric Buddhism. The twelve figures symbolized forces of nature, and as a set they became images of worship in Japan. The deities and some of the aspects of nature they symbolized are: Indra (rain), Agni (fire), Yama (death), Rākṣasa (demons), Varuna (water), Vāyu (wind), Vaiśravana (wealth), Iṣāna (a form of Śiva), Brahma, Pṛthivī (earth), Sūrya (sun), and Candra (moon).[1] The deva kings were introduced into Japan during the Nara period, and by the Heian period sets of paintings depicting the twelve deities were worshiped in a ritual performed on the eighth day of the first month.[2] As subsidiary deities within the Esoteric pantheon, the deva kings were considered powerful protectors of the state. In an Esoteric context, the twelve deva kings were also deities of the outer section of the *Taizōkai Mandara*, or the Womb Mandala.[3]

The two paintings in the Academy's collection were originally part of a set of twelve scrolls. Both paintings have suffered from abrasion and loss of silk. In style they are derived from a Late Heian set of depictions of the deva kings dated A.D. 1191 by Takuma Shōga, now in the Kyōōgokoku-ji (Tō-ji) in Kyoto.[4] The Tō-ji paintings are mounted as panels in a pair of six-fold screens. The Academy's paintings also resemble a set of deva-king scrolls in the Art Institute of Chicago, which are in the form of hand-colored woodblock prints and are dated to 1407.[5]

The Academy's painting of the sun deity Niten (Sūrya) depicts the god standing on two lotus flowers (fig. 19a). Niten is shown with reddish-brown skin, dressed in the robes and jewelry of the type usually seen on bodhisattvas. He wears a crown, and his head is surrounded by a gold halo, itself surrounded by red flames. He holds a lotus flower in each hand. The lotus in his right hand supports a red disk outlined in gold and representing the sun; within this is a bird, a traditional sun symbol in the Far East. At the top of the scroll is a white disk outlined in gold, containing the Sanskrit *Siddham* character *Ā* on a lotus flower.[6]

The scroll depicting the moon deity Gaten (Candra) likewise shows the god standing on two lotus flowers, which float on stylized clouds (fig. 19b). Gaten is depicted in flowing robes and scarves, and wears an elaborate crown. Like Niten's, his head is surrounded by a gold halo with red flames. In his hands he holds an offering tray on which is a disk representing the moon. Within the disk is a white crescent moon and a seated hare. The hare is an ancient moon symbol in the Far East and is associated in Daoist myth-

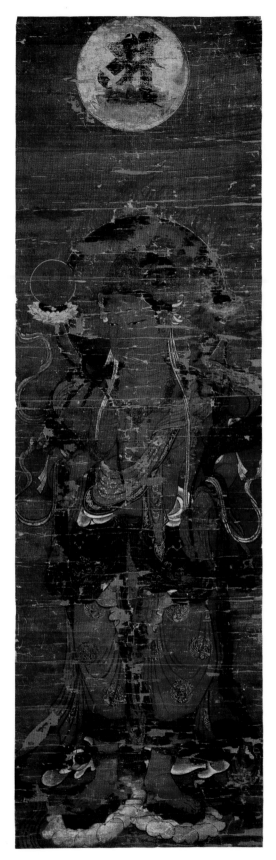

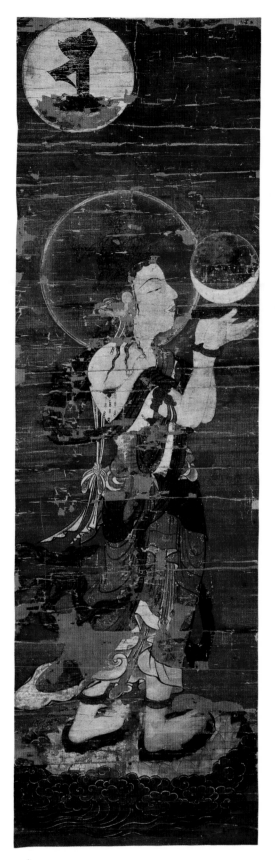

19a

19b

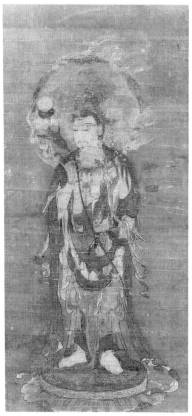

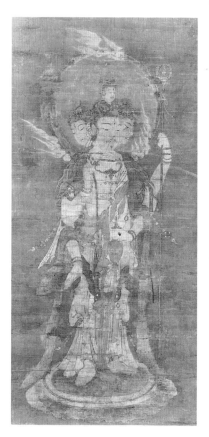

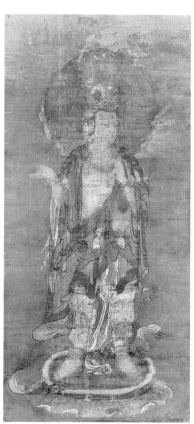

c. The Deva King Ishana-ten *d.* The Deva King Bon-ten *e.* The Deva King Emma-ten

Fig. 19 c–h
Muromachi period, c. sixteenth century
Hanging scrolls; ink, colors and gold on silk
Purchase, 1953 (1710.1a–f)

ology with the moon goddess Chang E. Within a white disk outlined in gold at the top of the scroll is the Sanskrit *Siddham* character *Ca* on a lotus flower.

The apparent lack of surviving sets of deva-king paintings in China suggests that the idea for them originated in Japan, most likely in the Nara period. The Tō-ji set by Takuma Shōga is one of the earliest surviving sets known. The Academy also owns a set of six slightly later deva-king paintings, which were originally mounted on a folding screen (figs. 19c–h).[7] A comparison of the figures of Niten in the two sets suggests that the set of six is derived from a different model than the Tō-ji set of 1191.

1 On the identity of the deva kings, see John Rosenfield and Elizabeth ten Grotenhuis, *Journey of the Three Jewels: Japanese Buddhist Paintings from Western Collections* (New York: Asia Society, 1979), no. 21, p. 95; and Alicia Matsunaga, *The Buddhist Philosophy of Assimilation: The Historical Development of the Honji-Suijaku Theory* (Rutland and Tokyo: Charles E. Tuttle, 1969), pp. 22–23.

2 Rosenfield and ten Grotenhuis, *Journey*, p. 95.

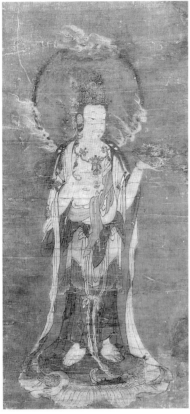

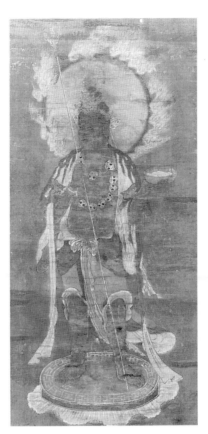

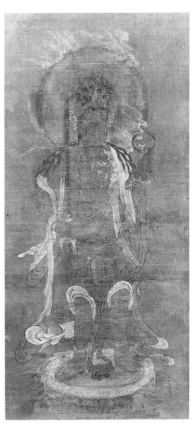

f. The Deva King Suiten *g.* The Deva King Niten *h.* The Deva King Chiten

3 Matsunaga, *Buddist Philosophy*, p. 201.

4 *Genshoku Nihon no Bijutsu, vol. 7: Butsu-ga (Buddhist Painting)* (Tokyo: Shogakkan, 1969), color pls. 94–97, figs. 4–15; see also Tanaka Ichimatsu, *Japanese Ink Painting: Shubun to Sesshu* (New York and Tokyo: John Weatherhill, 1972), p. 40.

5 Rosenfield and ten Grotenhuis, *Journey*, nos. 21–22.

6 On the use of such *Siddham* characters in Esoteric Buddhist paintings in Japan, see Robert Hans van Gulik, *Siddham: An Essay on the History of Sanskrit Studies in China and Japan* (New Delhi: International Academy of Indian Culture, 1956).

7 Honolulu Academy of Arts 1710.1 (a–f): *Six of the Jūni-ten.* Set of six hanging scrolls mounted on panels; ink, colors, and gold on silk. Muromachi period, c. sixteenth century. Purchase, Robert Allerton Fund, 1953.

PREVIOUSLY UNPUBLISHED

PROVENANCE
Samuel Hammer, New York.

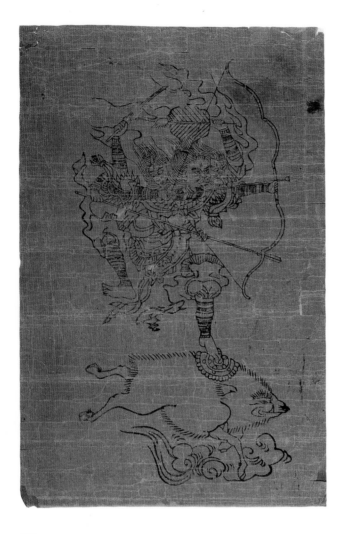

20

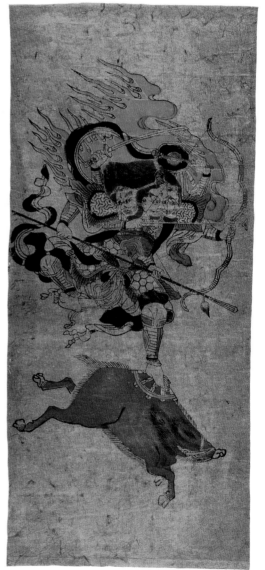

21

Marishi-Ten Riding a Boar

Muromachi period, 1392–1568
20 Woodblock print
30.9 x 20.4 cm
James A. Michener Collection (L 25,632)

21 Hand-colored woodblock print
40.3 x 17.9 cm
Purchase, 1954 (13,439)

Marishi-ten (Sk. Marici) is a deity of the Esoteric pantheon, and is considered a deva. He is sometimes included as one of the twelve Yaksha Generals associated with Yakushi, the Buddha of Medicine, in the *Yakushi-kyō* (*Sūtra of Yakushi* or *Bhaiṣajyaguru-sūtra*). This text was translated into Chinese in the fourth century, and again by Xuanzang in 650 during the Tang Dynasty.[1] Marishi-ten was worshiped as protection against fire, and as a guardian of warriors.[2] The deity may ultimately derive from the ancient Indian goddess Vajravarahi. While Marishi-ten rarely appears in Chinese Buddhist art, he often appears in the art of Japan and Tibet.[3] In both of the prints shown here, he is dressed in armor, riding on the back of a boar. He has three heads, all wearing a fierce expression, with a third eye in each forehead. Marishi-ten has six arms, which hold a sword, a fan, a bow and arrow, and a long spear. The figure's left foot rests on a *cakra* wheel on the back of the boar. A halo of flames appears behind the figure, and in the monochromatic print the boar runs above a stylized cloud.

The two prints in the Academy's collection are similar in size, composition, and style, and it is likely that they date to about the same period (c. fifteenth century). In the case of the colored print, the green, brown, and orange pigments were painted by hand over the printed image with the help of stencils.

1 M. W. de Visser, *Ancient Buddhism in Japan*, 2 vols. (Leiden: E. J. Brill, 1935), vol. 2, pp. 533, 551.
2 J. Hakin et al., *Asiatic Mythology* (New York: Crescent Books, 1963), p. 441.
3 Alice Getty, *The Gods of Northern Buddhism* (Oxford: Clarendon Press, 1914), pp. 117–118.

PREVIOUSLY UNPUBLISHED

PROVENANCE
Raymond E. Lewis, San Francisco (13,439).

22 | 23 Jūsambutsu-Mandara: Mandala of the Thirteen Buddhas

Muromachi period, 1336–1598
22 Hand-colored woodblock print
28.8 x 18.3 cm
Purchase, 1954 (13,440)

23 Hand-colored woodblock print
52.7 x 26.5 cm
Purchase, 1954 (13,442)

These two prints depict a grouping of Buddhas and bodhisattvas known generically as the Thirteen Buddhas. The figures comprise the Buddhist forms of the Ten Kings of Hell in addition to three other deities. The Ten Kings of Hell originated in China, where they were worshiped as Buddhist gods who presided in judgment in the underworld. The kings were codified as a group in the Mahāyāna Buddhist pantheon during the late Tang Dynasty on the basis of a forged text, the *Sūtra of the Ten Kings* (*Jū-ō-kyō*).[1] The cult of the Ten Kings was introduced into Japan in the late Heian period.

In Japan each of the kings was associated with a Buddhist deity, or *honji* (original form). The correlation between the Ten Kings of Hell and Buddhist *honji* was articulated in a forged text of the Heian period entitled *Jizō bosatsu hosshin innen jū-ō-kyō*.[2] The Ten Kings of Hell and their *honji* are as follows:

King of Hell	Honji
Shinkō-ō	Fudō Myō-ō
Shokō-ō	Shaka (Śākyamuni)
Sōtei-ō	Monju (Manjuśri)
Gokan-ō	Fugen (Samantabhadra)
Emma-ō	Jizō (Kṣitigarbha)
Hensei-ō	Miroku (Maitreya)
Taizan-ō	Yakushi (Bhaiṣajyaguru)
Byōdō-ō	Kannon (Avalokiteśvara)
Toshi-ō	Ashuku (Akṣobhya)
Godōtenrin-ō	Amida (Amitābha)

By the fourteenth century three more deities were added to make a group of thirteen. These were the Buddha Dainichi Nyorai (Mahavairocana) and the bodhisattvas Seishi (Mahāsthanaprāpta) and Kokūzō (Akāśagarbha).

Images of these deities were displayed during a seven-week mourning period after a person's death, and again during annual memorial services held three years after death. This practice appears to have spread during the Muromachi period. While the precise origin of the worship of the Thirteen Buddhas is unclear, it may have begun under the

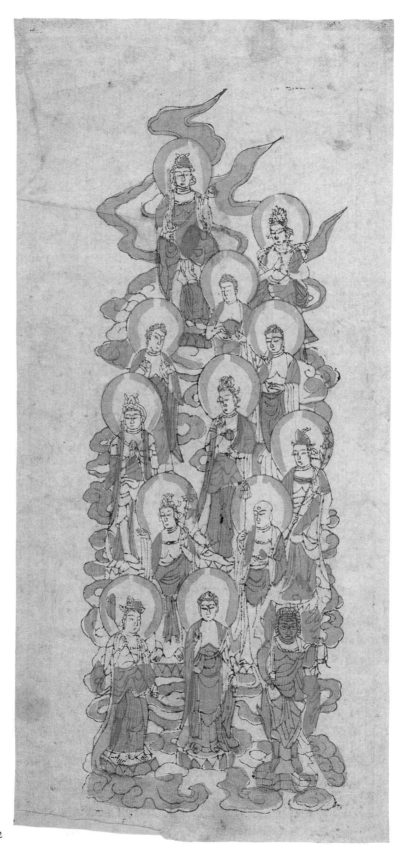

22

23

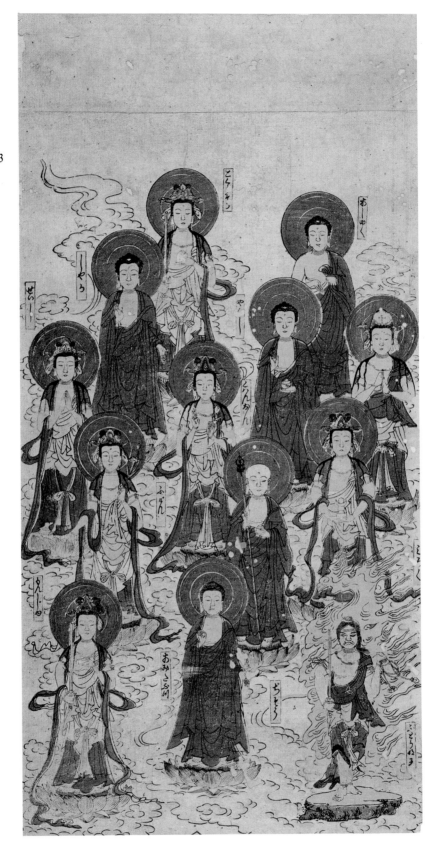

influence of the Esoteric Shingon sect; Alicia Matsunaga has pointed out the correspondence between the thirteen deities and the thirteen sections of the *Taizōkai Mandara* (Womb Mandala).[3]

It is likely that the Academy's woodblock prints are based on paintings of the type that survive from the Kamakura and Muromachi periods.[4] Numerous woodblock-printed depictions of the Thirteen Buddhas have survived from the Muromachi period, some of which are gilded as well as painted.[5] Both of the Academy's prints are hand-colored and depict the deities floating on swirling clouds. The smaller version (no. 22) is decorated with green, red, yellow, and purple pigments. The larger print (no. 23) has the deities' names inscribed in cartouches next to each figure in *hiragana* script; here the pigments are green, yellow, and purple.

1 John Rosenfield and Elizabeth ten Grotenhuis, *Journey of the Three Jewels: Japanese Buddhist Paintings from Western Collections* (New York: Asia Society, 1979), no. 47, p. 157.

2 Alicia Matsunaga, *The Buddhist Theory of Assimilation: The Historical Development of the Honji-Suijaku Theory* (Rutland & Tokyo: Charles E. Tuttle, 1969), pp. 233–234.

3 Ibid.

4 See, for example, the Kamakura-period hanging scroll published in Pratapaditya Pal et al., *Light of Asia: Buddha Sakyamuni in Asian Art* (Los Angeles: Los Angeles County Museum of Art, 1984), pl. 148, and the Muromachi scroll in the Jurin-in, Nara, illustrated in Jōji Okazaki, *Pure Land Buddhist Painting*, trans. Elizabeth ten Grotenhuis (Tokyo and New York: Kodansha, 1977), pl. 191.

5 Mosaku Ishida, *Japanese Buddhist Prints* (Tokyo and Palo Alto: Kodansha, 1963), color pl. 10.

PREVIOUSLY UNPUBLISHED

PROVENANCE
Raymond E. Lewis, San Francisco.

PURE LAND IMAGES

24 *Taima Mandala*

Late Kamakura or Nambokuchō period, fourteenth century
Hanging scroll; ink, colors, and gold on silk
107.9 x 106.7 cm
Gift of Robert Allerton in honor of the fiftieth wedding anniversary of
Mr. and Mrs. Walter F. Dillingham, 1960 (2726.1)

The *Taima Mandala* is the central icon in the worship of the Buddha Amida (Sk. Amitābha) in Japan. According to tradition, the first *Taima Mandala* was a woven image created in the eighth century by the daughter of an aristocrat named Yokohagi no Otodo.[1] What is believed to be the original is now preserved in the Taima-dera in Nara; it was first mentioned in literary records during the Kamakura period. From the thirteenth century onwards, many painted copies of this image were produced for use in the worship of Amida.

The *Taima Mandala* depicts the Western Paradise, or Pure Land, of the Buddha Amida. The scriptural source of this image can be found in two *sūtras*, the *Muryōju-kyō* (*The Teaching of Infinite Life*) and the *Amida-kyō* (*Sūtra of Amida*). Around the central scene depicting the Western Paradise are smaller scenes illustrating the Sixteen Contemplations of Queen Vaidehī and the story of Prince Ajātaśatru; these appear in a text called the *Kammuryōju-kyō* (*Sūtra on the Meditation of the Buddha of Infinite Life*). In addition, the iconography of the *Taima Mandala* is derived from the commentary on the *Kammuryōju-kyō* by the Chinese monk Shandao (613–681) entitled the *Guanjingsu*. The *Muryōju-kyō* and the *Amida-kyō* both describe the Paradise of Amida in detail. In the former, the historical Buddha Śākyamuni describes to the monk Ānanda the Pure Land, into which devout believers are reborn out of lotus flowers. In the *Amida-kyō*, Śākyamuni further discusses the Western Paradise, describing "the gorgeous palaces, parks and gardens; the gem trees made of gold, silver, crystal and coral; the fragrant flowers and luscious fruits; the rivers and lotus lakes with their perfumed water that is either hot or cold as desired for bathing; the delightful soothing sounds of birds and angelic singers."[2] The *Kammuryōju-kyō* also relates a sermon Śākyamuni preached to the Indian Queen Vaidehī in the city of Rājagṛha. In this sermon the Buddha lists nine stages of possible rebirth in Paradise; these are clearly illustrated in the border of the *Taima Mandala*.

The central image of the painting is derived from Chinese depictions of Amida's Western Paradise dating to the Tang Dynasty (618–918). Similar depictions survive among the Buddhist caves at Dunhuang in Central Asia.[3] At the center of the composition, the Buddha Amida appears seated on an elaborate lotus throne (fig. 24a). On either side of

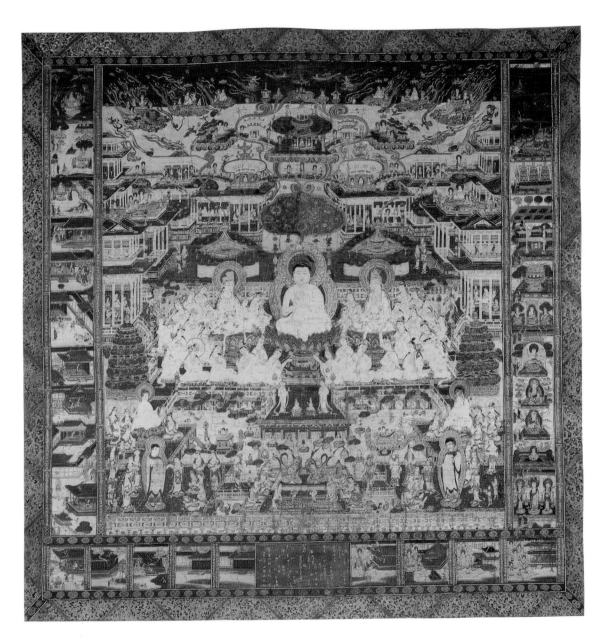

24

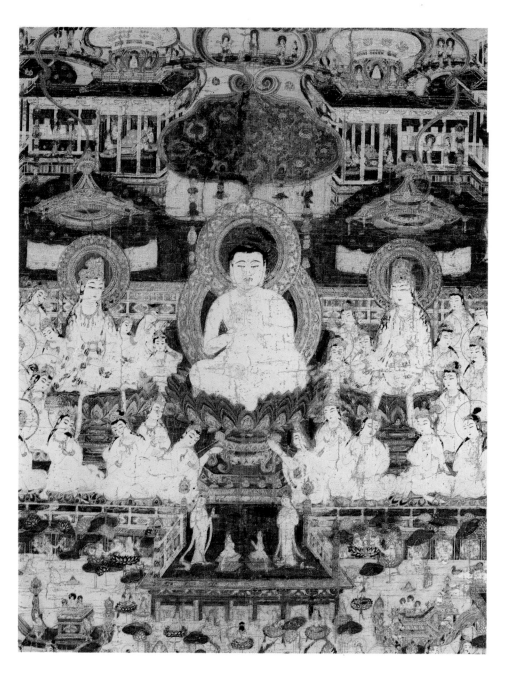

24a

Amida are the bodhisattvas Kannon (Sk. Avalokiteśvara) and Seishi (Sk. Mahāsthāna-prāpta), also seated on lotus thrones. These figures are painted in fine outlines of red ink and colored with gold pigment. On either side of this central trinity stand a host of bodhisattvas and lesser deities. In the foreground is an elaborate depiction of a lotus pond, with newborn souls being reborn out of the lotus flowers. Other figures float on the pond in boats or bathe in the golden water. In the lower left and lower right Amida is shown again standing and greeting newborn souls who have just entered the Pure Land (fig. 24b).

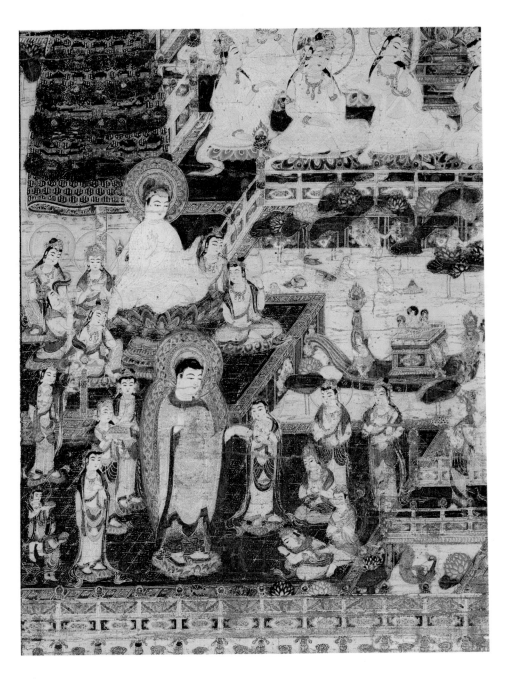

24b

The jeweled trees described in the *Amida-kyō* appear at either side, while a complex array of palatial buildings and pavilions appears behind the main trinity (fig. 24c). In the sky above are many bodhisattvas and *apsaras* (Buddhist angels); included among these are the bodhisattvas Monju on a lion and Fugen on an elephant.

The overall effect of the *Taima Mandala* is one of opulent splendor; such images created a convincing illusion of the Western Paradise. In addition to the use of gold and silver pigments, green, red, orange, and white are used throughout the composition to

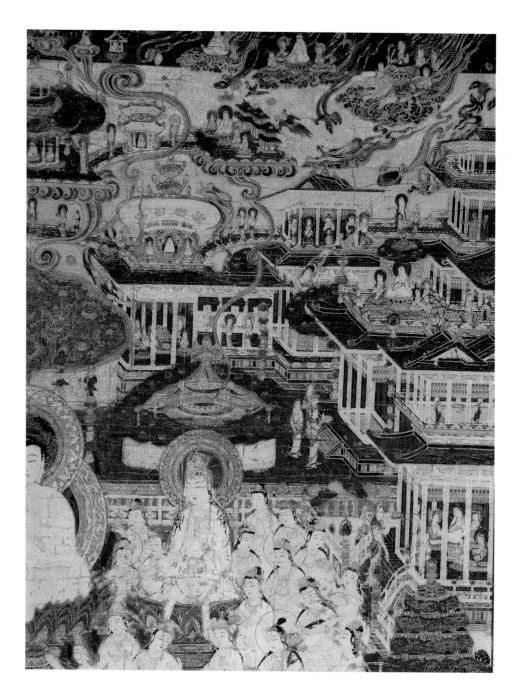

24c

create brilliant harmonies of color. These colors are also used in the outer border of the painting.

The small images in cartouches along the left border of the mandala depict the story of Prince Ajātaśatru as it is found in the *Kammuryōju-kyō*. In the course of this story the prince's family undergoes a miraculous transformation from concern with worldly deeds to a longing for rebirth in the Western Paradise. The prince's mother, Queen Vaidehī, plays an instrumental role in this narrative when she asks the Buddha Śākyamuni for a series of sixteen contemplations that will lead to rebirth. The panels on the right side of the mandala depict thirteen of the sixteen contemplations. These show different ways in which the believer can visualize the Pure Land. The lower border of the mandala depicts the nine stages of rebirth in Paradise, as explained in Shandao's commentary on the *Kammuryōju-kyō*. These stages range from the highest on the right to the lowest on the left. In the center of the lower panel is an inscription which reproduces the inscription on the original *Taima Mandala*.[4]

As Jōji Okazaki has pointed out, the images of the *raigō* (Welcoming Descent) of Amida originated in the smaller scenes found in the lower section of the *Taima Mandala*.[5] The Academy's painting is astonishingly well preserved, and includes lengthy inscriptions in gold ink identifying all of the scenes around the exterior.

1 For a detailed discussion of the history and format of the *Taima Mandala*, see Elizabeth ten Grotenhuis, *The Revival of the Taima Mandala in Medieval Japan* (New York: Garland Publishing, 1985).
2 Jōji Okazaki, *Pure Land Buddhist Painting*, trans. Elizabeth ten Grotenhuis (Tokyo and New York: Kodansha, 1977), p. 15.
3 For a discussion of these Tang images, see ten Grotenhuis, *Revival*, pp. 132–134.
4 The original inscription has been fully translated: ibid., pp. 84–86.
5 Okazaki, *Pure Land*, p. 53.

LITERATURE

Howard A. Link, "Japanese Buddhist Art," *Apollo* 109 (204) (February 1979), pl. 22.
Elizabeth ten Grotenhuis, *The Revival of the Taima Mandala in Medieval Japan* (New York: Garland, 1985), pl. 177.
Honolulu Academy of Arts: Selected Works (Honolulu: Honolulu Academy of Arts, 1990), p. 74.

PROVENANCE

Robert Allerton, Kauai.

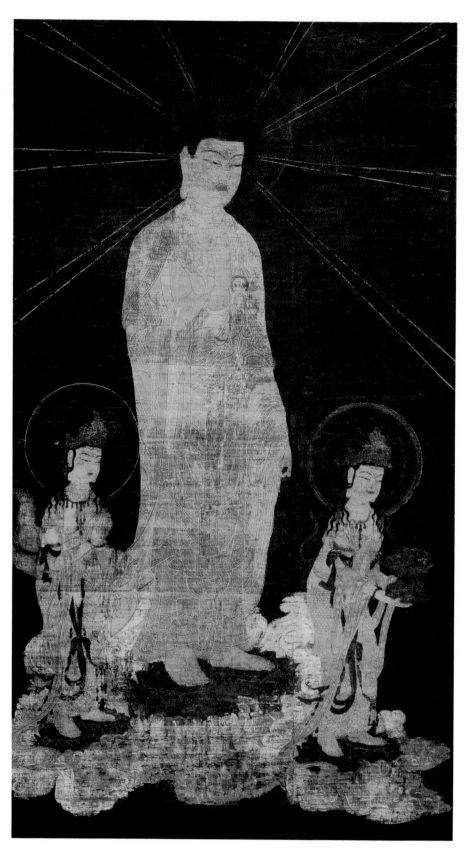

25

Amida Raigō: The Descent of Amida

Kamakura period, c. 1300
Hanging scroll; ink, colors, and gold on silk
106.6 x 59.8 cm
Gift of Jiro Yamanaka, 1961 (2904.1)

This elegant painting depicts the *raigō* or (Welcoming Descent) of the Buddha Amida (Sk. Amitābha) from the Western Paradise to earth. In the painting, the large figure of Amida is shown with his attending bodhisattvas Kannon (Sk. Avalokiteśvara) and Seishi (Sk. Mahāsthānaprāpta) descending from heaven. The three figures stand on lotus flowers that float on swirling white clouds. Amida and the two bodhisattvas are dressed in gold robes decorated in the *kirikane* (cut-gold) technique. In this technique, thin sheets of gold leaf were cut with decorative patterns which were then applied directly onto the surface of the silk. The figure of Amida alone contains eight different *kirikane* patterns, including key frets, starbursts, and floral scrolls. The figures' outlines are painted in fine lines of red ink. The Buddha Amida raises his right hand in the *mudrā* (gesture) of welcome (*semui-in*, Sk. *abhayamudrā*), one often associated with Amida. To the left, Seishi clasps his hands in prayer, while to the right Kannon leans forward, holding in his hands a lotus-shaped throne. Each figure has a halo, and eight double bands of light emerge from behind the head of Amida. The expression of all the figures is serene. The execution of the painting is meticulous, and great attention has been paid to the juxtaposed patterns of the *kirikane* decoration and the subtle harmonies of green, white, red, and gold pigments against the dark silk ground.

The textual source for *raigō* paintings of this type is the *sūtra* known as the *Sukhāvatīvyūha* (J. *Muryōju-kyō*; *The Teaching of Infinite Life*). In this text the historical Buddha Śākyamuni describes a vow taken by the primordial bodhisattva Dharmākara to establish a paradise in which all beings could find emancipation. Dharmākara is said to have made forty-eight vows in all, the eighteenth of which is considered the "Original Vow": "If, after my attaining Buddhahood, all beings in the ten quarters should not desire in sincerity and trustfulness to be born in my country, and if they should not be born by only thinking of me for ten times, except those who have committed the five grave offences and those who are abusive of the true Dharma, may I not attain the highest enlightenment."[1]

The belief in Amida and his Pure Land (Ch. Jingtu, J. Jōdo) can be traced to the Six Dynasties period in China (fourth–sixth centuries A.D.). The cult of Amida and the belief in easy rebirth in the Western Paradise, or Pure Land, found its visual expression in such early Chinese Buddhist cave-temples as Xiangtang Shan, carved during the Northern Qi Dynasty (550–575) in Hebei Province.[2] During the Tang Dynasty (618–906), belief in Amitābha's Pure Land was widespread, and it was given a strong impetus by the third patriarch of the Pure Land sect in China, Shandao (613–681). Shandao wrote a commentary on a major text entitled the *Sūtra on the Meditation of the Buddha of Infinite Life* (Ch. *Guanwu Liangshou Jing*, J. *Kammuryōju-kyō*). This commentary, entitled *Guanjingsu*, lists

certain ritual activities that would result in rebirth in the Western Paradise of Amitābha. Among these the most important was the recitation of the name of Amitābha. Some of the best-preserved paintings depicting the Western Paradise survive in the Tang Dynasty caves at Dunhuang in Central Asia.[3]

In Japan the cult of Amida (Amitābha) became widespread during the late Heian period (794–1185). This can in part be linked to the belief in the imminence of the age of *mappō*, or the "decline of the law (*Dharma*)." *Mappō* was seen as a lengthy period of increasing moral degeneracy that would end with the coming of the Buddha of the Future, Maitreya (J. Miroku). The year 1052 was calculated as the beginning of the *mappō* era, and thus it is not surprising that the tenth, eleventh, and twelfth centuries witnessed the growth of the Amida cult in Japan.

During the Late Heian period the practice of chanting Amida's name was popular and was given a special impetus by the writings of the Tendai-sect monk Genshin (942–1017). Genshin studied Buddhism at Mount Hiei, the monastic center to which the Early Heian monk Ennin had brought the practice of Amida worship from China. Genshin was the author of a highly influential text that outlined the advantages of Amida worship. This work, the *Ōjōyōshū* (*Essentials of Salvation*), was completed in the years 984–985.[4] In this text Genshin wrote of the inevitability of continual rebirth in ten realms of existence, and stated that escape from this cycle could be achieved by recitation of the name of Amida. It is significant that Genshin emphasized the importance of the visual arts in the transmission of his message. In particular, he stated that painting and sculpture were as important as literary texts in conveying descriptions of Amida's Pure Land.[5] This facilitated the development of *hensō* (transformed configurations), or visual images such as mandalas and *raigō* depictions that explicated Buddhist doctrines. Among other things, Genshin's text describes the glorious descent of Amida and his retinue to welcome a soul to the Pure Land. Genshin predicted that those who had faith in Amida would be guaranteed rebirth in the Western Paradise, since Amida had vowed to delay his own entrance into *Nirvāṇa* so that he could help all sentient beings attain rebirth in the Pure Land:

> The man who carries this teaching firmly in his mind for a long time feels a great rejoicing arise within him at the approach of death. Because of his great vow, Amida Nyorai, accompanied by many bodhisattvas and hundreds of thousands of monks, appears before the dying man's eyes, exuding a great light of radiant brilliance. And at this time the great compassionate Kanzeon [Kannon] extending hands adorned with the hundred blessings and offering a jeweled lotus throne, appears before the faithful. The Bodhisattva Seishi and his retinue of numberless saints chant hymns and at the same time extend their hands and accept him among them. At this time the faithful one, seeing these wonders before his eyes, feels rejoicing within his heart and feels at peace as though he were entering upon meditation. Let us know then, that at the moment that death comes, though it be in a hut of grass, the faithful one finds himself seated upon a lotus throne. Following behind Amida Buddha amid the throngs of bodhisattvas, in a moment's time he achieves birth in the Western Paradise.[6]

The Tendai monk Hōnen (1133–1212), considered the founder of the Jōdo or Pure Land sect (see cat. no. 32), held that the recitation of Amida's name just before death would result in Amida's appearance at the moment of death.[7] As Jōji Okazaki has demonstrated, Hōnen had an impact on the evolution of the type of three-figure *raigō* depiction exemplified by the Academy's hanging scroll: "Hōnen was largely responsible for the new emphasis on the simplified Amida Trinity *raigō*. In his most noted literary work, the *Senchaku hongan nembutsu-shū* (*Treatise on the Selected Nembutsu of the Original Vow*), he stated that *hensō* could be created with only one Buddha and two bodhisattvas."[8] In the same work, he notes that "Hōnen had stated that devotees should concentrate on Amida and his two chief attendants Kannon and Seishi in order to visualize and internalize the Pure Land of Amida."[9]

This type of image was considerably more abbreviated than the type that depicted the scene described in Genshin's *Ōjōyōshū*, exemplified by a Muromachi-period woodblock print in the Academy's collection (cat. no. 26). The earliest *raigō* paintings in Japan appeared in the eleventh century, although scenes of Amida's descent do appear in paintings of the *Taima Mandala* from at least the tenth century.[10] The Amida trinity scene, depicting only Amida, Kannon, and Seishi, appeared in the Kamakura period.[11] Depictions of deathbed scenes that include paintings of Amida's descent include the early fourteenth-century handscrolls *Hōnen Shōnin Engi* (*Pictorial Biography of Priest Honen*) and *Yūzū Nembutsu Engi* (*Illustrated Legends of the Yūzū Nembutsu Sect*) [see cat. 27].[12]

1 Jōji Okazaki, *Pure Land Buddhist Painting*, trans., Elizabeth ten Grotenhuis (Tokyo and New York: Kodansha, 1977), p. 15.

2 For a Northern Qi stone carving from the Xiangtang Shan caves depicting the Pure Land, see John Alexander Pope, *The Freer Gallery of Art, Vol. 1: China* (Tokyo: Kodansha, 1972), pl. 78.

3 For a discussion of Tang depictions of Amida's Western Paradise, see Elizabeth ten Grotenhuis, *The Revival of the Taima Mandala in Medieval Japan* (New York: Garland Publishing, 1985), pp. 132–134.

4 On Genshin's text, see Allan A. Andrews, *The Teachings Essential for Rebirth: A Study of Genshin's Ōjō Yōshū* (Tokyo: Sophia University, 1973).

5 William Theodore de Bary, ed., *The Buddhist Tradition in India, China and Japan* (New York: Vintage Books, 1969), p. 320.

6 Ibid., p. 325.

7 Ibid., p. 327.

8 Okazaki, *Pure Land*, p. 132.

9 Ibid., p. 104.

10 Leonard Bruce Darling, Jr., *The Transformation of Pure Land Thought and the Development of Shintō Shrine Mandala Paintings: Kasuga and Kumano* (Ph.D. dissertation, University of Michigan, 1983), p. 140; see also Okazaki, *Pure Land*, p. 53.

11 Okazaki, *Pure Land*, p. 132.

12 Ibid. See also John Rosenfield and Elizabeth ten Grotenhuis, *Journey of the Three Jewels: Japanese Buddhist Paintings from Western Collections* (New York: Asia Society, 1979), no. 40, p. 141.

PREVIOUSLY UNPUBLISHED

PROVENANCE
Jiro Yamanaka, Kyoto.

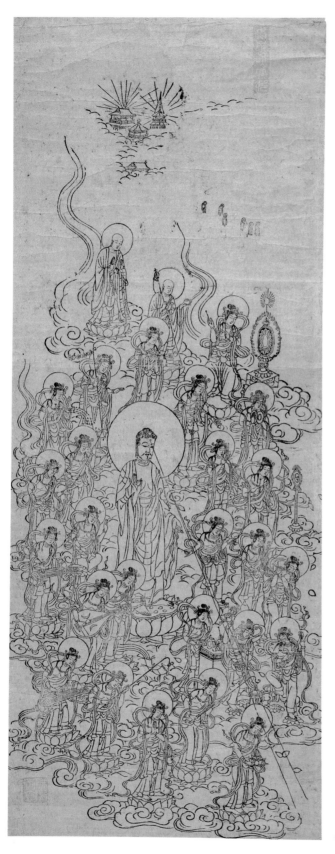

26

The Raigō of the Amida Triad and the Twenty-five Bodhisattvas

<div style="text-align: right;">26</div>

Muromachi period, c. fifteenth–sixteenth century
Woodblock print; ink on paper
74.5 x 29.6 cm
Purchase, 1954 (13,443)

This large monochrome print depicts a variation on the *raigō* theme, known as the Descent of the Amida Triad with the Twenty-five Bodhisattvas. The image is printed on three pieces of paper, which have been joined. In the central and lower sections of the print, Amida descends from the Western Paradise, accompanied by Kannon, Seishi, and twenty-five other bodhisattvas. A beam of light shines down from the *urna* (tuft of hair above the eyebrows) on Amida's forehead. The deities stand on open lotus flowers, which float on stylized clouds. The two lowermost figures can be identified as Kannon and Seishi. Many of the remaining bodhisattvas are shown with musical instruments and ritual implements; toward the top is the bodhisattva Jizō (see cat. no. 11) in the guise of a monk with a staff. At the top of the print, partially obscured by clouds, are the roofs of several heavenly pavilions and a pagoda of Amida's Pure Land. At the upper right are six tiny figures representing transformed Buddha images, or manifestations of Amida (*kebutsu*).[1] There are two very faint seal impressions on the print in red ink.

Jōji Okazaki has stated that the iconography of the *raigō* of the Amida trinity and the twenty-five bodhisattvas dates to about the time of the monk Genshin (942–1017). In his *Ōjōyōshū* of 984–985, Genshin referred to a late Chinese *sūtra* that presents the basis of this iconography (*Shiwangsheng Omituofoguo Jing*, J. *Jū Ōjō Amida Bukkoku-kyō*).[2] The well-known *Nijūgo Bosatsu Wasan* (*Hymn to the Twenty-five Bodhisattvas*), which is directly related to this theme, may date to the mid-Kamakura period.[3]

Numerous paintings of this subject can be found in Japan. The majority appear to date from the late Kamakura to the Muromachi period.[4]

1 Jōji Okazaki, *Pure Land Buddhist Painting*, trans., Elizabeth ten Grotenhuis (Tokyo and New York: Kodansha, 1977), p. 119.
2 Ibid., p. 114.
3 For a complete translation, see ibid., pp. 114–116.
4 For examples, see ibid., pls. 91–102.

PREVIOUSLY UNPUBLISHED

PROVENANCE
Raymond E. Lewis, San Francisco.

27 Yūzū Nembutsu Engi: Illustrated Legends of the Yūzū Nembutsu Sect

Early Muromachi period, fifteenth century
Two handscrolls; ink, colors on paper
33 x 1434 cm; 33 x 1371 cm
Gift of Renee Halbedl, 1961 (2828.1a, 2828.1b)

The Academy's pair of handscrolls depicting the legends of the Yūzū Nembutsu sect is a copy of a pair of handscrolls dating to the early fourteenth century (Kamakura period). Now in the Cleveland Museum of Art and the Art Institute of Chicago, these compositions provide the model for the Academy's handscrolls.[1] The paintings take as their subject the founder of the Yūzū Nembutsu sect, a monk named Ryōnin (1072–1132). Ryōnin, a priest of the Tendai sect, taught that individuals could attain rebirth in the Western Paradise of the Buddha Amida merely by chanting Amida's name (Nembutsu). *Yūzū Nembutsu* means "Nembutsu in communion" or "circulating Nembutsu," a reference to the belief that the chanting of Amida's name by one individual would affect all other sentient beings.

As the sect's name indicates, Ryōnin taught that all human beings and all other creatures are interrelated. He was known for his vocal talent and was a master of Buddhist liturgical music. Ryōnin became a famous evangelist; his converts to the Yūzū Nembutsu sect included both court aristocrats and common people. The founding of this sect paved the way for the activities of the monk Hōnen (1133–1212; see cat. no. 32) who founded the Jōdo (Pure Land) sect.

In the fourteenth and fifteenth centuries the original Yūzū Nembutsu paintings were copied many times. Toward the end of the fourteenth century the pair of handscroll compositions was also copied in the woodblock-print medium. A famous printed series of the legends, dated 1391, survives in several collections in Japan.[2] The original scrolls were painted in the *Yamato-e* technique, known for its free brushwork and use of bright mineral pigments, and this same technique was used in the Academy's scrolls. The somewhat derivative manner of the brushwork, however, suggests that the Academy's paintings should be dated to the early Muromachi period. Each painting is divided into individual narrative passages, with a section of text followed by an illustration.

Scroll One

The first scroll opens with a lengthy passage written in semicursive script (*gyōsho*) explaining the monk Ryōnin's Buddhist devotions. The text reads:[3]

> As we reflect upon the general teaching which Śākyamuni conducted during his lifetime, there come to mind various kinds of instructions such as Sanjō [Three Teachings], the Jūni-bunkyō [twelve divisions of the Mahāyāna Canon], the principles of the Gonkyō [including the Kegon,

Tendai, Shingon, Zen, and Jōdo schools], and the Jitsukyō [including the Shōjō, Sanrin, and Hossō schools] which were taught by many different sects in Buddhism. But the real purpose for the appearance of Śākyamuni in this world was to expressly provide all the people who were wandering the Three Worlds with an opportunity to attain the status of bodhisattvas, such as Jūji (Sk. Daśabhūmi) and Tōgaku (Sk. Samyaksaṃbodhi). Therefore, the discussion of good or bad concerning the teaching of the Buddha and the Buddhist sects should not be allowed.

Since the sermons which the Buddha delivered during his lifetime were intended to meet the requirements of the individual, it will be beneficial to the people if the teaching of the Buddhist sects, large and small, be given according to the acceptability of the people.

It would be difficult to satisfy the need of all the souls with the teaching advocated by a single sect. People should be able to attain the good fortune of being reborn without delay in Paradise just through the act of calling on Buddha's name, not having to rely on their inborn nature, or the keenness or dullness of their ability to embrace the Buddha's teaching.

Even if people cannot wake up from their delusion and cannot prove that they were wrong, they can still reach the Sacred Land if they call on the Buddha's name as was directed by the transcendental benevolence of Amida. This is mentioned in Buddha's life-long teaching, including the sermons. Who will doubt it?

Therefore, men and women, lay and clergy, at the present time as well as in the past, have always believed in the Buddha's teaching. This teaching eventually spread as far as China and Japan, proving that it was superior to all others.

There was a priest known as Ryōnin of Ōhara. He used to live on Mount Hiei, and was a man of unrivaled virtue both in Kengyō and Mikkyō Buddhism. In earnest search of the real knowledge of the Buddha, Ryōnin Shōnin visited the Mudō-ji every day for one thousand consecutive days. The Shōnin always had had a desire to live in seclusion from the world, and at age twenty-three he finally forsook the world and retired in Ōhara [near Kyoto]. There the Shōnin showed an aversion to all kinds of pleasure in his ardent pursuit of rebirth in Paradise. He devoted himself to reciting the *sūtras* twelve hours a day until he reached the age of forty-six.

In the painting, we see Ryōnin studying Buddhist texts inside the Mūdo-ji, accompanied by an elderly priest holding a rosary and two young attendants seated on a veranda. An interesting detail of this section is the inclusion in the painting of sliding *fusuma* doors in the temple's interior; these are painted with ink landscapes that are stylistically consistent with early Muromachi ink paintings. Beyond the temple is a short landscape section of hills painted in green pigment, stylized clouds painted in white, and foliage of both pine trees and autumnal deciduous trees. This section ends with a depiction of a separate shrine

building in which Ryōnin is shown meditating before a gilded standing image of the Buddha Amida.

The next section of text describes a dream in which the Buddha Amida appeared to Ryōnin and instructed him to spread the Yūzū Nembutsu teaching. The text reads:

> One day during the summer when Shōnin had just turned forty-six years old, he was swiftly put to sleep by the will of Buddha. In his sleep the Shōnin heard Amida tell him:
>
> *"Your behavior is unusual and you may be the most qualified man of Japan, the territory where jambu trees grow. Yet, you may find it not easy to be reborn in Paradise because our Land is absolutely immaculate and is founded on the 'good roots' as is instructed in Mahāyāna Buddhism. It is impossible for you to expect to be reborn in the Buddha's land by virtue of the 'good roots' as is taught in the Hīnayāna Buddhism. In spite of your dedicated pursuit of the Buddha's teaching, it would not be sufficient to provide you with the cause enabling you to enter the Buddha's Land—even if you die and are reborn many times and broaden your karma. However, let me teach you the means of winning the rebirth in the celestial world. It is through none other than the Ēnyu Nembutsu [Yūzū Nembutsu]. In the teaching of the Yūzū Nembutsu, the karma of the individual is considered that of the people and vice versa. The benefit, therefore, will be extensive and to be reborn in the Buddha's Land would be in order. If one person is reborn, then all people must be reborn."*
>
> This was Amitābha's explanation, but there is not time to go into detail.

In the painting, Ryōnin appears resting on the veranda of a temple building. The gilded figure of Amida is shown at the left descending from heaven on a cloud. Rays of golden light emerge from Amida's head and shine toward the resting priest. The location of the temple building at Ōhara is indicated by two characters inscribed above the building.

The third section of text describes events in the year 1124, when Ryōnin began to solicit pledges to recite Amida's name from many different classes of people, including members of the clergy and laymen. This text reads:

> Startled at the announcement of Amitābha, Ryōnin Shōnin felt the need to abandon self-reliance and to lead the people into the faith of the Yūzū Nembutsu. The Shōnin, therefore, became a devotee who recited Buddha's name as the only means of reaching the goal of rebirth.
>
> On the ninth day of the sixth month in 1114, the Shōnin began to solicit everyone whom he came across in Kyoto, from the emperor on down to the ordinary citizens, the clergy and the laymen, men and women, rich and poor, old and young.
>
> The Shōnin wrote their names down on the book and stored the books in the Nyoraidō [Tathagata Treasury], but their full names were registered only on the ledger because they were too long to jot down each time.

In the painting, Ryōnin is shown soliciting a pledge from the emperor himself in the palace in Kyoto, with the palace building labeled at the upper left. Three golden Buddha images appear above Ryōnin's head. The face of the emperor is not shown: all that we see are the lower part of his robe and his hands. The last part of this section depicts Ryōnin in a street in Kyoto soliciting Nembutsu pledges from men and women of all classes. Included in this illustration are depictions of lords and ladies, priests, samurai, and beggars. Several inscriptions appear in the painting, indicating the numbers of people in different classes who made Nembutsu pledges. Among these, for example, are "one thousand Heian women" and "one hundred nuns."

The fourth section of text describes the appearance at Ryōnin's retreat of a young priest who requested to inscribe his name in Ryōnin's Nembutsu registration book. The priest is described as wearing a blue-green robe. After he had left, Ryōnin looked at the book and saw that the name inscribed was actually that of the guardian King of the North, Bishamon-ten. The text reads:

> While Shōnin was engaged in the Nembutsu mission, a priest in the prime of life, blue-robed, suddenly appeared at the Shōnin's abode in Ōhara in the early morning. The priest expressed his desire to enter his name in the soliciting book. No sooner had he opened the book and written his name than he vanished.
>
> Becoming suspicious, the Shōnin opened the book only to find the following entry: "I pray to the Buddha reciting his holy name one hundred times; I, the Bishamon of the Kurama-dera, being the defender of Buddhism, came here in order to protect the people by dint of reciting the holy name and by good fortune."
>
> The Bishamon was the 513th person among those who signed their names on the book. This was the most extraordinary thing to happen under the imperial reign, to say nothing of India.

In the painting, Ryōnin and the young priest are shown on the veranda of a temple building. In the clearing beyond, a worker collects water from the basin. At the end of this section, Bishamon-ten appears on a cloud in the sky dressed in his usual garb of armor and flowing robes. Adjacent to this deity is the figure of the young priest in a green robe, labeled "Bishamon-ten." Beyond this is a depiction of another temple, the Kurama-dera, including a pagoda and a main hall. This is a prelude to the following section of text, which describes Ryōnin's visit to the shrine in 1125:

> Ryōnin Shōnin visited the Kurama-dera on the fourth day of the fourth month of 1125, and he recited the *sūtra* there all night. Again around the Tiger hour the Bishamon appeared like a ghost and told the Shōnin:
>
> "I recited the Buddha's name one hundred times before and since then I have been guarding you as closely as your shadow follows you. I also asked each soul following our Buddha's teaching in Hell to recite the Buddha's name a hundred times. I, herewith, am presenting a soliciting list with their names to you, who joined the Yūzū Nembutsu group. Pray enter their names on the main list."

Feeling as though he had awakened from a dream, the Shōnin suddenly noticed a scroll lying in front of him. As the Shōnin unfolded the scroll in reverence, there appeared a passage such as may be seen on the attached paper.

In the painting following this text, we see Ryōnin seated in the main hall of the Kurama-dera surrounded by laymen and -women. The temple name is inscribed at the top of the building. The figure of Bishamon-ten appears on the altar just visible through a window, illustrating the scene in which Bishamon-ten tells Ryōnin of the many deities he had convinced to enroll their names in the Nembutsu registration book. The following section of text lists all the categories of these deities as they appeared in Ryōnin's scroll. They include both Buddhist and Shintō deities. The text is significant as a reflection of the adaptation of Buddhist beliefs to preexisting Shintō beliefs in Japan. Immediately after the list comes the following text:

> The Heavenly beings and the souls in Hell had registered their names on the soliciting list through the good offices of the Yūzū Nembutsu. This was attested to by the fact that Śākyamuni in ancient times in India spoke about the wondrous reward resulting from reciting the name of Amida. Śākyamuni taught that a multitude of Buddhas would spare the people from being deported to the nether world; even those who had committed sins after Śākyamuni's death would be reborn in the Buddha's Land if they recited his holy name.
>
> Long after Śākyamuni departed, Ryōnin Shōnin urged people in Japan to rely on the Buddha by reciting Buddha's name, though Japan is a small and remote country. All the Heavenly Kings of the Three Worlds highly praised the Shōnin's devotion and joined the cause of the Yūzū Nembutsu.
>
> The Buddhas in this world also praised his devotion. Included among these Buddhas were the bodhisattvas and Shintō Gods. It is interesting to know that they encouraged people to join the Yūzū Nembutsu faith though they were Buddhas and Shintō Gods.

The next section of this painting illustrates some of the many deities included in Ryōnin's list. These deities, who appear floating on clouds, include Niten and Gaten (see cat. no. 19), the red Esoteric deity Aizen Myō-ō (cat. no. 15), the Hindu god Brahma, the Ten Kings of Hell, the Seven Stars, and the Dragon King who lives under the ocean. Following this are labeled illustrations of important Buddhist and Shintō shrines in Japan—included, like the Shintō deities, as representations of the amalgamation of Buddhist and Shintō beliefs. Among these are the Kasuga Shrine in Nara (cat. no. 28), the Kumano Shrine on the Kii Peninsula (cat. no. 30), and the Gion Shrine in Kyoto.

The final section of text of the first scroll describes the beneficial effects of the Nembutsu practice:

It has previously been mentioned that the Heavenly Beings joined the

Nembutsu believers. As to why they joined the Nembutsu believers, it is explained in the *Hanju-sammai-kyō*: "It was because the Buddhas of the Three Periods attained wisdom by means of earnestly reciting the Buddha's name. This was proclaimed by Bonten (Brahma), Taishaku (Indra) and the four Heavenly Kings as they assembled."

The celebrated Yūzū Nembutsu, therefore, is a law enabling people to be reborn in the Buddha's Land, which was bestowed upon Ryōnin Shōnin by Amida who personally made an appearance before the Shōnin. Extensive is the benefit and magnanimous is the virtue. The good men as well as the wicked may be reborn equally. Making no difference between the great saint and the lesser, their daily conduct will not be disturbed so long as they rely on the strength of a prayer.

Let us support the Great Goodness and deliver ourselves from the affliction that even the Heavenly Beings suffer before they expire. We shall reach the Pure Land which is peaceful and free of worries, and at last we shall receive the wisdom of Buddha.

Here as a saint of the promoter of the new faith Yūzū Nembutsu, the Tamonten, defender of the teaching of Buddha, made all the Heavenly gods join the Yūzū Nembutsu group, who held everything in the universe in their possession. On the fifth day of the fourth month of 1124, the Tamonten [Bishamon-ten] began to recite the Yūzū Nembutsu a million times daily. The Yūzū Nembutsu sect was the one all the Heavenly Kings had joined and the Tamonten made them promise not to go astray in the future.

Even the celestial beings with unlimited supernatural powers deeply believe in reciting the Buddha's name as much as people do. Then, how is it possible for the ignorant and perplexed mediocre people not to join the Nembutsu group in order to be reborn in Paradise? If, therefore, we enroll in the Nembutsu group we shall be united with the Heavenly Beings. Indeed, the Heavenly Beings are as much a part of the Nembutsu group as we. By dint of the Nembutsu offered by the Heavenly Beings, we may become able to be reborn in Paradise; likewise, the Heavenly Beings may be released from the concern with the mundane world through the Nembutsu recited by us.

Thus, the believers are helped by each other through the Buddha to attain rebirth. This is not the act conducted by his own will, word, or behavior, but is the act directed by means of the Yūzū Nembutsu.

Looking back upon these events (as mentioned before), we have become convinced that our country is a Divine Country, particularly in view of the fact that all those who were born in Japan became Buddhists and praised the Buddha's name. This is the country blessed by the Nembutsu.

If we pray even once our prayer will be heard by the Divinities. Therefore, all the Heavenly Beings in the universe praise and admire Amida by reciting his name. This is a rare thing among the numerous

こゝに四十六の誓に就すゝく最似の儀らゝく
浄土極楽の々地尺猛利メて日ゝゝ一同
のゝゝ・ひまたゝ頭行ゝ、後あり

上人生年四十六いいう今る夏目中に佛
方便をゝゝ為や志けゝゝの程瞟眠
浄ゝ阿弥陀や末文松と現〱ゝ承梅しての
浴ゝ汝ゝ〱不可思議なよ一聞浴のゝ日拭
ゝ聞と二人ゝゝゝゝ荒誠ゝ七愛なよ一〱志
かもとゝ沙順沁の浄生すゝゝ事ゝ投ゝ
我去ゝ一向清浄ゝゝゝひゝ大衆菁狼々圀や
小菁槪福迦の圀源をゝゝ〱〱持佛去生
〱ゝゝ沁ゝゝ紫のとゝ妃をゝ妃五生廣
知と佛ゝゝ〱順沁生せ菁圀まゝ〱〱ゝ速
圀融念佛ゝゝ釙通念佛ゝゝ〱今行と
浚浄生せ緣圀浚行ゝ〱てゝゝゝゝゝを
ゝゝゝ妃次に切遲を廣大を妃ゝゝゝゝ生
乃約とゝ終ゝゝ礼に切遲を廣大ゝゝゝ生
を順江た乃圀〱一人浄生ゝよゝゝ沁ゝ
徒生とゝ志し〱ゝた、ひあゝ、へゝとゝゝ
阿弥渓め来乃末現からのゝゝゝゝゝゝゝゝ
浄まちにと圀あゝゝ

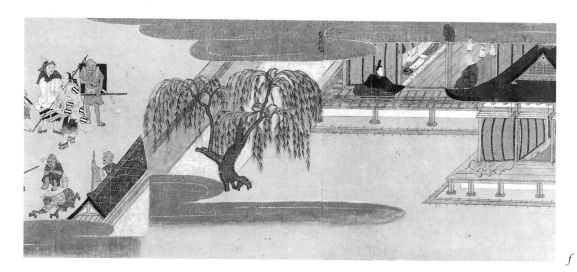

夫釋尊一代の蔵教をひろふるに三乗
十二分教大小権實の家有り其をしき
しくなりにけり、しかは梁業先世の
業縁をたつねしれに、三事迷倒の
群類としてあとをくらく士地寺賢の妙果に
いてこそ先とてあるまて代に大小にとてて
宗に頻湖とわらちの偉者を論すへきに
あれとも一代の説教する對機の湯なから
おのくくの湯毒をあめかしきにち一宗たり
をてそわくく一切の合霊小宗よけり
のおくきえよはくくされ宗よけるり大小の宗宗
の行カもあれそ根の大ときよはき機の利
鈍によてすひとく功出くひとく速疾
住生民實国を運さまたそわ動威登運
せ五こくと練佐難世の懸紀にとて他力縹あ
幼葉にさる速く不運常楽の地からさそ
しこくえ佛念佛の統カく八方寛義の中に号
てそて、かまちうつくをつけるいまや那震
たの、それひ日威桜棠の圓まくく疾健速来
道俗男女教徒のく信せしぬにいそれ
事人参の義浄にあへなるくや養ては中に
大乗の奥志上へ至人こるちりことては
教山の信佐頻寄教の積逗まそくこへ
千日頃とくくに薔提んと新章逗道の
こひ徒てくく至きゃ三ことくかり
三千の気ふを禅と大へ引和を禅祐に

今さき力阿弥陀如来の代事に、おそみきて年来
自力鉞会の功とすくくひら、く讀通念佛勧
進の志ともて此力稀んのの幻若とよりくく
天治元年甲六月九日より始て振済て
まくけそ上くに人より下賎民にいそまて
通俗男女貴賎沽かるへいかにたもよこきく
あきゃ称くく仍代とく、をそろの性名と称くて
やこ来産とたへしはー、の名とよるよて
八本悔小、ゆうて毛威くくるとよく也

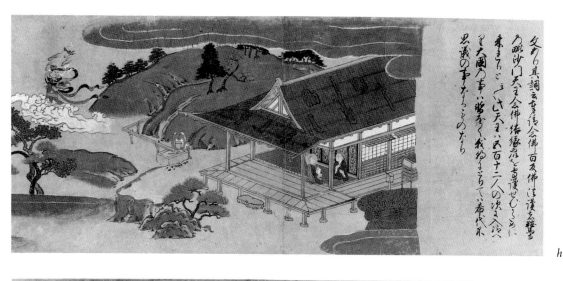

父より其調云其送念佛百万佛は護法鞍馬
の毘沙門天王会佛結縁なと勧せしるに
来まりこゝ八天王八百十二の次入念
また大國の事に當をく我ぬるとうて八希代不
思議の事なりつらのゝたち

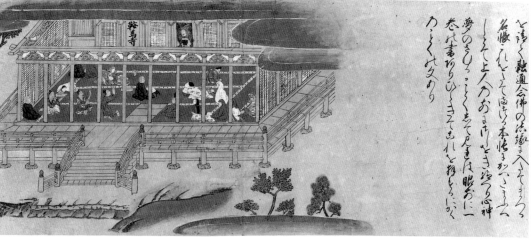

と諸らく鞍通念佛の法纈す入をまいる
名帳これよと願ける本恊をかきさまへ
しくて上人かおもみ中とき詮る忠神
夢のうひゝこくとく志て夕くに眠おに一
巻此書とりひくきこよ見れと誰もらいく
かよくなめり

鞍馬寺

寮成王部類眷属　　　　　百戻
太山王部類眷属　　　　　百戻
平等王部類眷属　　　　　百戻
都市王部類眷属　　　　　百戻
五道轉輪王部類眷属　　　百戻
府君司命部類眷属　　　　百戻
司禄部類眷属　　　　　　百戻
賀茂下宮部類眷属　　　　百戻
賀茂上部類眷属　　　　　百戻
伊勢内宮部類眷属　　　　百戻
伊勢外宮部類眷属　　　　百戻
宇佐八幡部類眷属　　　　百戻
春日四所部類眷属　　　　百戻
日吉七社部類眷属　　　　百戻
熊野本宮部類眷属　　　　百戻
熊野新宮部類眷属　　　　百戻
祇園部類眷属　　　　　　百戻
那智飛瀧部類眷属　　　　百戻
熱田八劔部類眷属　　　　百戻
北野天神部類眷属　　　　百戻
伊豆走湯部類眷属　　　　百戻
白山部類眷属　　　　　　百戻
稲荷三所部類眷属　　　　百戻
虎嶋部類眷属　　　　　　百戻
金峯山蔵王部類眷属　　　百戻
大社部類眷属　　　　　　百戻
三嶋部類眷属　　　　　　百戻
廣田南宮部類眷属　　　　百戻
香取部類眷属　　　　　　百戻
諏訪南宮部類眷属　　　　百戻
富士浅間部類眷属　　　　百戻
多度部類眷属　　　　　　百戻
安房須口部類眷属　　　　百戻
住吉四所部類眷属　　　　百戻
笠嶋部類眷属　　　　　　百戻
大原野部類眷属　　　　　百戻
大多年知部類眷属　　　　百戻
気比部類眷属　　　　　　百戻
伊吹部類眷属　　　　　　百戻
朝氣山下部類眷属　　　　百戻
伊都伎鳴部類眷属　　　　百戻
三尾部類眷属　　　　　　百戻
兵主部類眷属　　　　　　百戻
小一頭二大六十餘別大小一切神祇冥通各
欲界所有一切天衆各　　　百戻
色界所有一切天衆各
无色界所有一切天衆各
惣三千大千世界乃諸塵数所有一切藐天神祇各
已上摠微塵数億百万通已訖沙門天勅通文
北野天神鞍通念佛行者有示現文
天神本地身十一面菩提　爲度衆生故　示現天神體

g

i

天治二年四月四日大原上人鞍馬寺通夜之時
本尊多聞天王勧一切冥衆入融通念佛
帳其名帳現在上人傍其文云

梵天王部類諸天　百通
帝釈天王部類諸天　百通
持國天王部類諸天　百通
増長天王部類諸天　百通
廣目天王部類諸天　百通
吉祥天女部類諸天　百通
輝幢天王部類諸天　百通
天部類諸天　百通
水天部類諸天　百通
地天部類諸天　百通
火天部類諸天　百通
風天部類諸天　百通
閻魔天部類諸天　百通
愛染王部類諸天　百通
妙見菩薩部類諸天　百通
龍樹菩薩部類諸天　百通
大黒天神部類諸天　百通
北斗七星部類諸天　百通
月天子部類諸天　百通
日天子部類諸天　百通
摩利支天女部類諸天　百通
氷迦羅天部類諸天　百通
迦樓羅天部類諸天　百通
尊星王部類諸天　百通
韋駄天首羅大将部類諸天　百通

三部子
持世天等部類眷属　百灰
九曜等部類眷属　百灰
沙竭羅龍王等諸龍衆　百灰
十二神将等八万四千類　百灰
廿八宿等部類眷属　百灰
奈廣王部類眷属　百灰
善女龍王等諸龍衆　百灰
五官王部類眷属　百灰
宗帝王部類眷属　百灰
初江王部類眷属　百灰
閻羅王部類眷属　百灰
衆成王部類眷属　百灰
太山王部類眷属　百灰

k

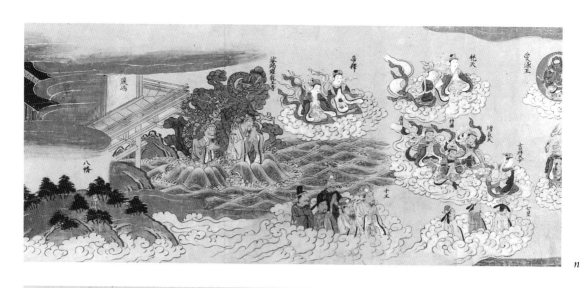

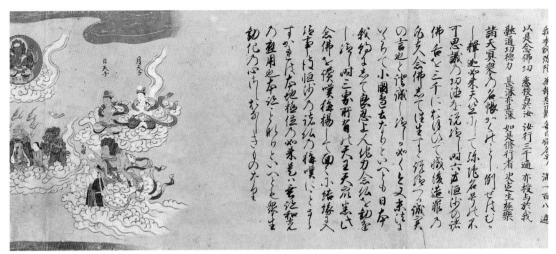

我等阿弥陀仏 無邊光勢 令片指念八 満一百八遍
以是念佛功 憲授与於我 汝行三千通 亦授与於我
馳通功德力 甚深不思議 如是修行者 史之生極藥

諸天見念佛の名號かくのことくせられむ。
一釋迦如来天竺に説給て弥陀名号の誅
不思議の功德を三千にあまねひて懺悔逸罪の
名を久念佛志て住生す經後つ滅實
の言とも讃滅して。かくのごとくと又来は
むらくて小園色たちといへとも日本に
我紛心志て是恩上人念力念佛と動靈
して一向三界所首此天主天流志を入
念佛を讃嘆して。如く小結塚を入
すよまて本地極伝乃如来若宮泛和光
力復用是本記と助りのといくとを界生
動化乃心内むむきさるものなり

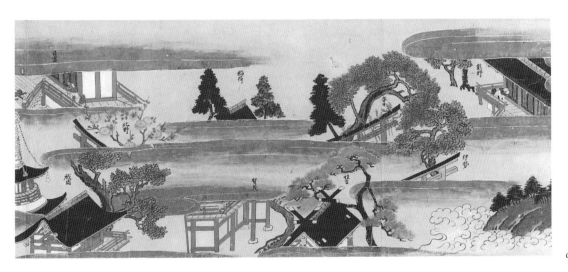

日吉 北野 稲荷 熊野 祇園 賀茂 伊勢 春日

沙人一諸天も念佛流等り我本も念佛意文
諸天の上々仏志ーうこる遁ーて數の
注志民約とある。我志心申会佛文章っ
天読への書離のりやなる志くはいと法
志たちかくはよろくと乃力約そこ志れ共に
してりかりいてそ心国をして生す成自信百万遍約
そろたて弥散取約きる心ーの境力私道念佛志と
中也もよくと先眼てよ日本に志義
うあたし人はけるす弥院に神多くと
常へ一流とて涼と云やて我れ則日本に
沖国むり又是戊神伪綱変とれ給し約ー
なよてそもまと弥伪納文をこよと給しそ
上天々る弥散天看こよして一回す弥陀乃
多くを揃く株事讃嘆ひたろ事弥氏乃
中ーともきく教するなき事せ然則日本に
弥陀義乃ひろまちいずむハくて先標ずるそ弥と
えて一切弥道に於け心く思て人之

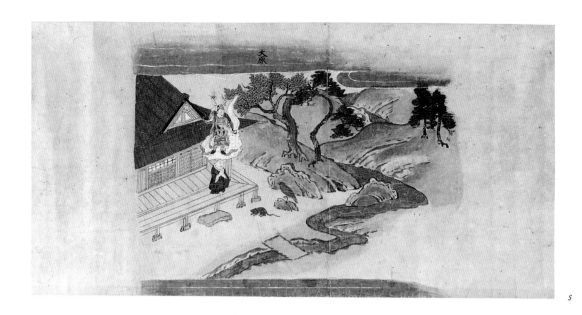

Buddhist sects. Is this not an indication that the Amida Sects in particular should be widespread in Japan?

If those who wish to live in accordance with the will of Buddha visit the shrines and recite the Nembutsu in which they exercise belief the most, then even the mist of suffering will lift and the flames of the Triple Heat will be reduced and they will finally attain enlightenment. Bearing this in mind, by praying for all that you desire, both in the present and the future life, your prayer will promptly be heard.

If one slights or abuses the Nembutsu, though born in Japan, the Divine Country, in which the Heavenly beings have faith, then one invites all kinds of misfortunes in the present life and odious consequences in the future life because there may be no protection from the souls in Hell. All the heresy, failure to attain the Buddha-hood, or conversion must have reasons. Therefore, those who committed these things may still have a chance to enter the Pure Land. People, therefore, should engage more enthusiastically in soliciting on behalf of the Yūzū Nembutsu sect, hoping that they may receive the protection from the souls in Hell. It is a good thing that people with a moral sense should be given the chance. It is odd that even such thoughtless beings as birds and animals appeared to have joined in offering prayers.

This text is followed by a painting showing the monk Ryōnin seated in prayer on the veranda of Mudō-ji at Ōhara. Above his head is the standing figure of Bishamon-ten on a cloud. Approaching Ryōnin on the ground are a bird and a rat, illustrating the statement in the text that even "birds and animals appeared to have joined in offering prayers."

Scroll Two

The second scroll begins with a description of the death of the monk Ryōnin, which took place in the year 1132. The text reads:

> Shōnin was sixty years old on the first day of the second month in the first year of Chōshō (1132), the year of the Mouse, when he foresaw his approaching death seven days away. At the last moment before death, an auspicious spiritual omen occurred.
>
> His abode was filled with an unusual fragrance and purple clouds settled along the moss-grown stone slabs. A voice was heard from the wind-whipped mountaintop on that clear day. It sounded like the music of flutes and harp, and seemed to harmonize with the muffled sound of the waterfall.
>
> The solemnity of the rite of being reborn, which was conducted on behalf of Shōnin, was beyond words, and when his body was lifted into the coffin, it was said to have been light as a feather.

This section of the painting is important because it illustrates the efficacy of belief in the Nembutsu theory. Ryōnin is shown as an old priest preparing for his death. To the left, a heavenly host of bodhisattvas descends from the Western Paradise on white clouds. Closest to the temple building in which Ryōnin is shown seated in prayer is the bodhisattva Kannon, who presents to the monk a gilded lotus throne on which he is to ascend to the Pure Land (see cat. no. 25). Red and green lotus flowers fall on the ground from heaven in this miraculous scene. Among the other deities shown here are the bodhisattvas Seishi, who clasps his hands in prayer behind Kannon, and Jizō, who appears as a Buddhist monk at the far left holding a staff. Most of the heavenly figures appear as musicians playing such instruments as a *koto*, a *biwa*, flutes, mouth organs, and drums.

In the second section of this scroll, Ryōnin appears to a sleeping monk of Ōhara, named Kakugen. The text reads:

> Priest Kakugen of Ōhara dreamed about Shōnin, who declared that:
> "I am already sitting on the flowery platform in Paradise where I had always hoped to be reborn. This is due entirely to the benefit of the Yūzū Nembutsu."

In the painting Kakugen appears asleep in one of the temple buildings at Ōhara, while Ryōnin descends from the Pure Land on a white cloud at the right.

The third section of text tells how the retired emperor Toba attended a Nembutsu service in which the name of Amida was recited one hundred times. The text reads:

> The ex-Emperor Toba [1108–1123] received the Nembutsu in which the name of Buddha was first recited one hundred times, and later was increased to several thousand times. He attended the service all day long and ordered the religious authorities to have his name joined with those of the Nembutsu people.

In the painting a building of the imperial palace appears next to a lake. The lower part of the emperor's red robe is visible just beyond an opening in the palace building. On

the veranda outside, two priests dressed in white are seated, one of whom inscribes characters on a handscroll. The other figures in this scene include palace attendants and aristocrats who gaze from the veranda at fish in the lake.

In the fourth section, a group of women associated with a temple called Kōryū-ji are shown reciting the name of Buddha. The accompanying text reads:

> The Nyoin [high-born women] of the Kōryū-ji who accepted the Nem-butsu rite were engaged in reciting the name of Buddha for one hundred consecutive days at the temple Hōkongō-in. At the same time, they asked six priests to offer the Nembutsu prayer day and night in order to make their pleas for rebirth heard.

In the painting the women appear in front of the main hall of the temple, with Buddhist priests and aristocrats in the building itself.

The fifth section of text tells the story of the daughter of a governor of Izumi Prefecture who became a nun and consequently was reborn in the Western Paradise after death:

> One day a daughter of Michitsune, the former governor of Izumi, called on Ryōnin Shōnin. On that very same day she became a nun. She slipped on a *kesa* [robe] and now she looked like a nun. She adopted for herself the Buddhist name Jojo and received the Nembutsu rite.
>
> At her death, her face was turned to the West and her hands were held together, palm to palm, and thus she achieved rebirth in paradise.

In the painting the woman appears on the veranda of a temple. She has taken the vows and is having her head shaved by several monks. At the end of this scene she is shown just before her death praying inside a temple building before an image of the *raigō* (Welcoming Descent) of the Buddha Amida and bodhisattvas Kannon and Seishi. The composition of the hanging scroll is nearly identical to that of the Academy's fourteenth-century *raigō* (cat. no. 25). Beyond the building, the feet of the Buddha Amida and the lower hem of his robe can be seen on a cloud floating down from heaven, while lotus petals fall to the ground.

The sixth section of text tells of a priest who dreamed that his parents were reborn in the Pure Land thanks to his practice of Nembutsu:

> Priest Shingen of Jōnan-ji dreamed that his parents had been reborn in the Buddha's Land because a prayer in the form of reciting Buddha's name three thousand times had been said for their well-being in this world.

In the painting the priest Shingen appears at the left asleep in a temple building. On a pair of *fusuma* doors behind him is an ink painting of geese and reeds. To the right the images of Amida, Kannon, Seishi, and the monk's parents appear on a cloud—the vision the priest saw in his dream.

The text of the seventh section reads:

The nun of Aoki who had joined the Nembutsu believers was success-
fully reborn in the Buddha's Land.

In the painting the nun is shown praying at the moment of her death, while white
clouds, lotus petals, and rays of golden light descend toward her from the Pure Land. A
landscape painted in monochrome ink appears on the interior walls of the room in which
she is seated.

The eighth section relates the story of the wife of a cowherd of Ki-dera, who
recovered from a difficult childbirth due to the Nembutsu practice:

A wife of a cowherd in the service of Priest Genkaku of Ki-dera, who
had a brush with death in childbirth, was saved only because she joined
the Nembutsu group. Upon learning this, those who embraced the
Nembutsu faith rose to 272 in number.

In the painting the woman is shown supported by a female attendant inside a
house. The presence of a black ox at the right indicates that this is the home of the cowherd.
In front of the woman, a priest inscribes her name in a Nembutsu registration scroll. The
figure of Bishamon-ten appears on a cloud above the roof. Genre scenes make up the rest
of the painting; these include a samurai on horseback with his attendant carrying a long
sword, and the figures of a monk, a crippled man, and a dog in the street.

The ninth section of text tells how a woman was rescued from Hell through the
practice of Nembutsu:

A wife of a lowly priest of Kitashirakawa was released and returned
safely from the court of Emma-ō [Yama-rāja, the King of Hell] because
people recite the Yūzū Nembutsu three thousand times on her behalf.

Therefore, one who wants to pray for the repose of the soul of
his parents, masters, wives, children, and friends should register their
names in this book and recite the name of Buddha.

One gets the blessing of the Buddha, which is infinite according
to the "good roots" acquired through his own efforts.

It is possible that even the lotus flowers open in Hell, man is
reborn in Heaven, and he reaches Paradise. As stated in the *sūtra*, to
provide the solicitors (of the Yūzū Nembutsu) credit is the supreme aim
in the sacred work of many Buddhas in the past. This, according to the
commentary of the *sūtras*, is believed to have been the real desire of
numerous Buddhas.

It is said in the *Ryūjo Jōdobun* that if one solicits two people, one's
efforts are tantamount to seeking the faith enthusiastically for himself. If
more than ten were solicited, the happiness and virtue which are certain
to come to him will be immeasurable.

If the number reaches one hundred or even one thousand, it is
the work of the bodhisattva and if it exceeds the ten thousand mark, it
is of Amida.

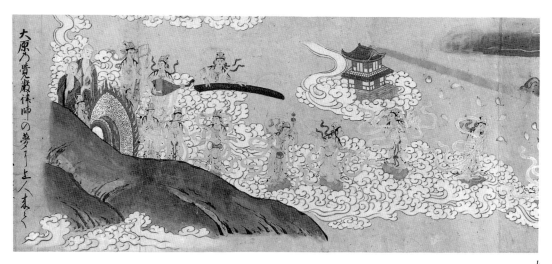

大
原
ノ
覚
厳
律
師
ノ
夢
ニ
上
人
ヲ
ヲ
ス

b

い
ら
う
め
ん
う
ち

d

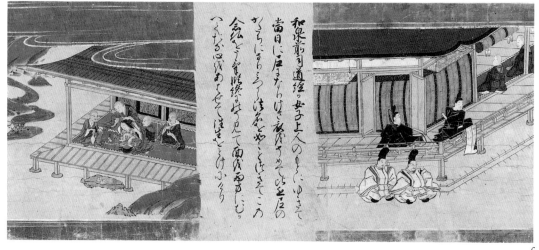

和
泉
前
司
道
経
ノ
女
子
上
人
の
も
と
に
ゆ
き
て
当
日
に
居
ま
ち
け
る
に
秘
経
す
め
て
此
上
の
か
く
に
ほ
る
こ
そ
法
名
な
や
と
ま
さ
こ
の
会
ん
と
さ
官
際
縁
く
出
て
見
つ
雨
戻
雨
す
し
む
つ
く
な
る
四
代
あ
さ
せ
て
法
せ
と
け
ふ
る

f

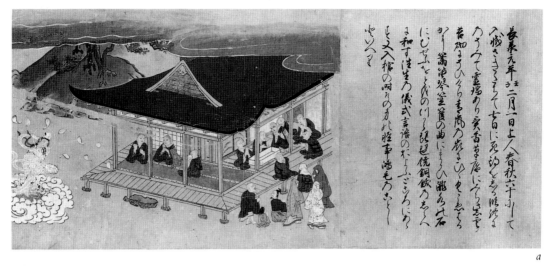

建久元年十二月一日上人春秋六十にして
入滅ましましき事は古に思ひ合を者いと
たうとく實相夢幻の妙を知るべし若
若わつひろまさか書寫乃妙にをよべる
かり編帙奇筆者誰の巧にまうひ瀧乃石
にむすぶと乃川のうつれは瀧てひ石
廣和す生の儀式言語のたよふ給心にあ
まれ生の儀式言語のたよふ給心にあ
と又八幅の陣のかた柩車嶋毛乃おさ
やうへき

a

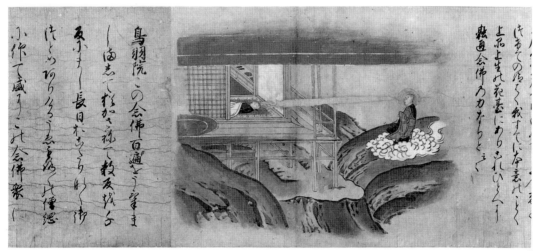

鳥羽院この会備百通とうて筆ま
し一両志てそがや禄一教友我子
原小まし長目おつ乃り御
忙とめのり乃ろこ志秀此僧都
小作て歳りてれ会備衆

てその座しく我すでに年寄れしく
上品上生乃花處にあり乃れひしてす
數通会佛乃かたちをとくこ

c

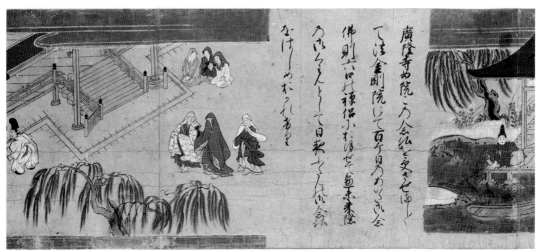

廣隆寺か院に万会仏を安き乃ねし
て注金剛院にて百ケ日のめくる会
佛則六仕礼褓小おゝゝ乍乍本来院
のれゝゝえをて日教てん乃此会
なけしめおくれあり

e

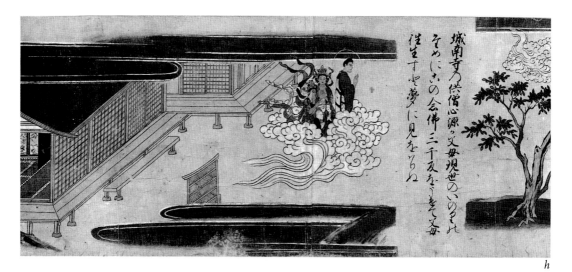

城南寺の供僧心源の父母現世のいのりも
そめにも六の念佛三千反をもて父母
往生すや夢に見をそん

h

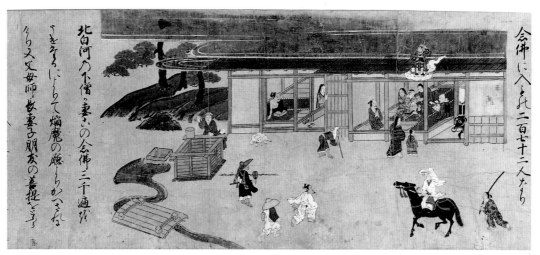

念佛に入をみ二百七十二人たち

北白河の下僧の妻六の念佛三千遍も
さをそろにもちて燭魔の廳にみかへ又を
そり父母師の敢妻子朋友の菩提をそそ

j

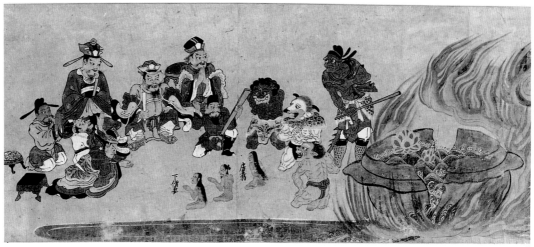

下僧妻　廣

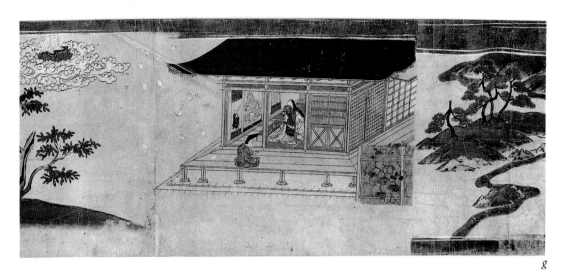

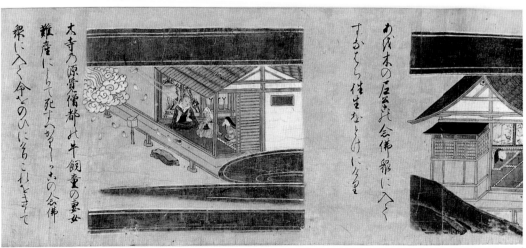

太寺乃源賢僧都は牛飼童の妻女
難産にちて死けるか此の念佛
衆に入く命をのひにをこれをききて

あめ末の石ざ乞念佛衆に入く
すゝちり往生なりけに多年

そひやをむそむ人いおれしく三者此名
宝成此悔まの芸っをらに念佛を
トやきハー自後は善根に同くをて廣大
乃功徳をえ地獄の中し蓮花らゝと見くう
天上にむまれ極楽に往生をて凡ろう
作勧進行者は功徳は経ゝい三世諸佛乃
浄業の正固たり地におつりこい粋まゝ龍節浄
本昿乃聖意にかおつれらゝ自身乃精進
をおり二人勧進まれゝ福徳無量なを
百千萬すむまいまへ此善薩をり刀
數小すゝおまには即足阿於随如来ゝ
こいり大唐代川房寄せいつゝめは
命綿ゝて夫魔乃廳ゝいそゝこれ
一人の老人をすゝめて念佛注せゝ
やゝろ人なりかすゝ净土にまゝて
とて実途ちかへゝれけるに
ゝろみゝ作を

召れ怪病をのすくいなとしてして龍といをす
とす光て幽田より引阿弥陀会佛とむ
へきとて番帳をうけて道場まへ貰ひ
かりて引苦なりとしまのくともをまを
よりこれ乃義に奥乃のくともを乆き
らしければを申て一切しをかくは是下面
其乃男女とを一切して引阿弥陀会佛とけ
佛前になふらく別阿弥陀会佛とけ
めふい義乃をけつけはへけり此はからう
志をなみ番帳へを校見をす一こんる
すなけち是をとすさにを疫神はをせらを
亀を結縷乃名まれ下さにに剗那と
かてのてこを我一人か忌女あり地帯て
めをとこいて疫神のらしてこ会佛と
小いまえくたを疫神れをとゆきさて
見て疫さをねをもに剗那ありいろほへ
実に名字をとて其乃をなるそに卆乃
亀を書換せつ一まおら家因乃老女く
にこより義にそうす家因乃老女く
かもをつ一なんほう地不にある鳥女式
痛そを終るめらき卆ろのてを番帳
な剗軍か引まらうに是術祇園訳
春属みな皆融通会佛乃結縷てまひ
を乃祇園訳をき失なと一るの番帳
てまへひ女敗ると一よを別乃を扱へると
はほ役は実敗れとう別乃なをふあこ子
る疫神也と主実に
たすきころろをとふてを囃日らり引阿弥陀会
会て番帳をまり日らり引阿弥陀会
佛と倍一信心乃誠をにあへれを

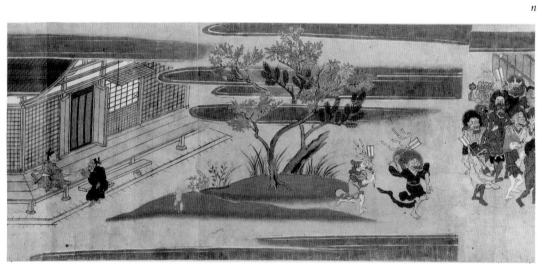

右本乾良恵上人融通会佛根本信條
住し注すること此本慚い良恵上人
歳賢上人に傳へしこのを
親鸞上人善永上人次第に相傳をちく
なる迷疫に注生すこ尺とり上人歓
云歓をくにいとまもなく僧森法海のまる
先躰な傳間語なむ道信伎会佛とけ
名帳に入給るを今まて一切乃失難を
てひにまにいかます注生まをいやく火
本月久詮右なのすことて一会し歓う
へすとこれ乃畵面にめくことしてて
直家乃男女に会佛注まの信心を増
進せしむろめ乃まの正和年三暦
仲冬上旬催記く

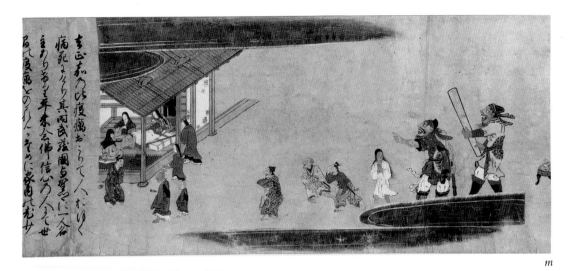

玄正和尚此疫癘おこりて人おほく
痛死々々々其間武羅圀をはじめに人各
まちあひを年来令佛信心人とて世
居し度癘とのべん。さゝに長岡氏光女

m

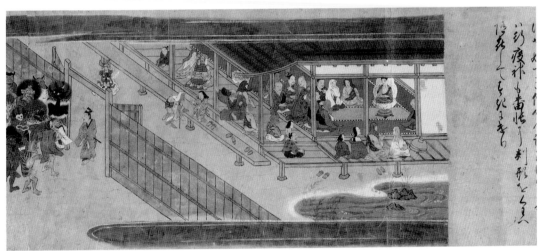

いやまじ三休らのうへ今おはく
新疫祚もも蕃師了判形をしるる
陰祚してもおひまより

o

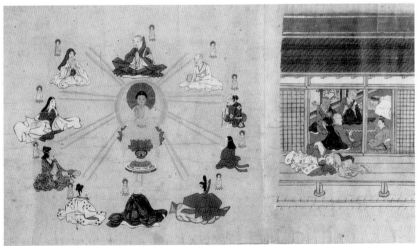

q

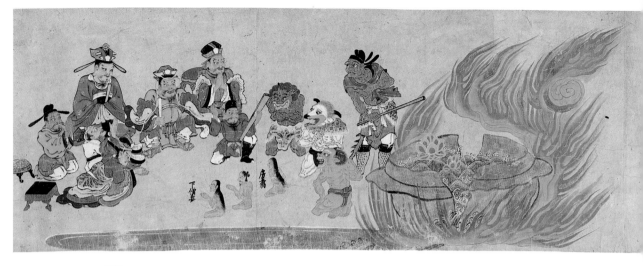

27a

In Tang China, a certain Fang Zhu of Daizhou was taken to the court of the King of Hell after he died. This Fang Zhu had once solicited an old man and had thus enabled him to be reborn in the Buddha's Land. It is said that he, therefore, was turned back from the underworld, being assured of his admission to the Pure Land.

In the painting the minuscule figures of the woman mentioned in the text and of Fang Zhu of Daizhou in China appear seated on the ground, surrounded by the enormous figures of Kings of Hell and demon attendants (fig. 27a). To the right is an enormous flaming cauldron with lotus flowers emerging from the boiling water. This detail symbolizes the saving of souls from hell through Buddhist faith, as explained in the text. There follows a scene showing the return of these figures to their everyday lives, accompanied by two enormous guardian figures wielding clubs.

The tenth text section relates events of the Shokā reign period (1257–1258), during which a pestilence occurred. To protect his family, a local official made the members of his household recite the name of Amida again and again. The text reads:

During the Shōka era (1257–1258), an epidemic broke out and took a heavy toll in victims. The village headman of Yono in Musashi Province who was a believer of the Yūzū Nembutsu sect for many years, hoping to escape the epidemic, advised his family, young and old, to begin a special Nembutsu service on the following day. Then he wrote their names in the book and left it in the recitation hall.

He dreamed that night about a company of demonic figures coming on foot, trying to force their way through his gate. He went out and told them:

"My family, men and women, is united. We are about to begin a special Nembutsu service which is to be attended by groups of two and three, taking their turns. The book inscribed with names is al-

ready placed before the Buddhas. Therefore, please remain outside the entrance."

"All that you say is correct—show me the book," demanded the God of Epidemics. As the village headman produced the book, the God of Epidemics looked well pleased, and he affixed his seal under the names of each group.

"I have a daughter," the village headman went on to say, "who is staying elsewhere. I, therefore, want to put her name in the book and to have her join the Nembutsu group." This was denied by the God of Epidemics as the dream ended.

Upon examining the book when morning came, it was seen that beneath each name was a seal. Some names were written over in ink of which the color resembled that of *Yaki-e* [designs obtained on paper with a heated rod].

As the village headman had dreamed, his daughter died of the epidemic elsewhere, though all other members of his family, young and old, were spared. As the story of this mysterious happening reached the ear of the Shōgun, the book with the names of the followers of the Yūzū Nembutsu sect was brought to the Shōgun's house.

All those who reside in the Jetavana-vihāra [the Buddha's favorite retreat in India; by analogy, the phenomenal world], including their relatives, are people united by dint of the Yūzū Nembutsu rite. Even the God of Epidemics who had accepted the Yūzū Nembutsu faith is not an exception. He is also a resident of the Jetavana-vihāra.

The family of the village headman displayed its devotion to the Yūzū Nembutsu by decorating the exercise hall and dedicating the book as preparation for the special Nembutsu service which was scheduled to begin on the following day. Seeing the faithful devotion of the village headman, even the God of Epidemics himself affixed his seal in the book and departed exultantly.

It is to be remembered that the Nembutsu believers with "three minds" need not be afraid of contracting disease. If the service is expected to last three or even seven days, it must be attended by small groups taking turns, as was demonstrated by the present one in which the superiority of the special Nembutsu service was self-evident.

Therefore, the Nembutsu believers should always observe a special service and if the service is prolonged, the participants should engage in it even more earnestly and enthusiastically.

The glory of Amida reaches all the people in the "world of ten directions" who recite the name of the Buddha; Amida receives people; never will he refuse them.

The painting begins with a scene in the man's household in which all the members of his family are shown reciting the name of Amida around a statue of this Buddha. Outside the gate of his house is the crowd of demons mentioned in the text. The man is

shown standing in the gateway while one of the demons adds his name to the Nembutsu registration book the man has compiled. The demons are very colorfully depicted and are as humorous as they are frightening. At the end of this painting is a scene of the death of the man's daughter, which follows the events related in the text.

The second handscroll ends with a depiction of the Buddha Amida on a lotus throne, surrounded by illustrations of different classes of society engaging in recitations of Amida's name. Eight golden beams of light emerge from the Buddha's head, terminating in small gilt images of Amida. Following this is the last section of text, which reads:

> This prayer was so interpreted as shown in the main book of the Yūzū Nembutsu of Ryōnin Shōnin.
>
> Following the transfer of this book from Ryōnin Shōnin to Ganken Shōnin, it was passed on to Myō-ō Shōnin, Kansei Shōnin, and Sonei Shōnin in that order, and the number of those who registered their names in this book came to 3,282, and all appeared to have been reborn in the Buddha's Land.
>
> After the death of Ryōnin Shōnin, people continued to come like "clouds and mists" up to the present time, seeking good fortune with high spirits. If both priests and laymen register their names in the book upon hearing these unprecedented happenings, they will be assured that they can avoid all the calamities in the present life and enter the Buddha's Land after death.
>
> The reason for representing this (the aspect of the Nembutsu faith) in these pictures is to promote the lay believers' desire, both men and women, for rebirth in the Buddha's Land by reciting the name of the Buddha. Hence, the present picture scrolls were produced early in the eleventh month of the third year of the Shōwa reign [1314].

1 John Rosenfield and Elizabeth ten Grotenhuis, *Journey of the Three Jewels: Japanese Buddhist Paintings from Western Collections* (New York: Asia Society, 1979), nos. 39, 40.

2 See *Hieizan to Tendai no Bijutsu* (Tokyo: Tokyo National Museum, 1986), no. 110; and Mosaku Ishida, *Japanese Buddhist Prints* (Tokyo and Palo Alto: Kodansha, 1963), pp. 82–84.

3 The following translations of the text are by T. Katsuki, and are included in Freer Gallery of Art folder files 58.11 and 59.13, Washington.

PREVIOUSLY UNPUBLISHED

PROVENANCE
Yamanaka and Company, Kyoto; Renee Halbedl, Honolulu.

SHINTŌ-BUDDHIST SYNCRETIC IMAGES

Kasuga Mandala

28

Nambokuchō period, 1336–1392
Hanging scroll; ink, colors, and gold on silk
102.4 x 55.7 cm
Gift of Mr. and Mrs. Philip E. Spalding, 1953 (1695.1)

This painting is an excellent example of a fourteenth-century syncretic Shintō-Buddhist shrine painting. It depicts the Kasuga Taisha, or Kasuga Shrine, in Nara. The shrine is shown from a bird's-eye view looking from west to east. The entrance to the precincts is shown at the bottom, where a tall *torii* gate stands at the entrance of a park. A path leads from this gate toward the enclosure itself, shown in the upper central part of the painting. Numerous shrine buildings appear throughout the park, with the primary buildings at the upper left in a courtyard surrounded by a covered gallery.

The primary buildings consist of four shrines built in the traditional Shintō method, with thatched roofs and crossed ornaments over the ridge beams. In the courtyard in front of these buildings are the Buddhist deities Shaka (Śākyamuni), Miroku (Maitreya), Yakushi (Bhaiṣajyaguru), Jizō (Kṣitigarbha), and Jūichimen Kannon (Eleven-Headed Avalokiteśvara), all dressed in gold robes and standing on open lotus flowers (fig. 28a). The depiction of the deities directly in front of the Shintō shrines is unusual among surviving Kasuga Shrine paintings. In the Buddhist beliefs of fourteenth-century Japan, these deities were seen as "original forms" (*honji*) of native Shintō gods, or *kami*. The primary Shintō deity of the Kasuga Shrine, Kasuga Myōjin, was believed to manifest itself at the shrine as the historical Buddha Shakā and in the form of the many deer shown here wandering about the shrine precincts.

In the upper background of the painting is Mount Mikasa, beyond which a gold sun rises into the blue-gray sky. Stylized white clouds and bands of mist appear throughout the scroll, painted in white *gofun* pigment, made from crushed shells. The painting, executed on two pieces of silk that have been sewn together, has suffered from some pigment loss and abrasion over the centuries, but is in generally excellent condition.

The Kasuga Taisha was founded during the Nara period in A.D. 709 by Fujiwara no Fuhito.[1] Located adjacent to the Kōfuku-ji, the shrine was originally an ancestral clan shrine, but it soon came to function as a national shrine. The precincts were moved to their present location under Mount Mikasa in 768. An annual festival held in the third month to celebrate the Shintō deities of the shrine was begun in the year 850. From very early times the shrine was patronized by the Fujiwara clan, and it is still one of the most

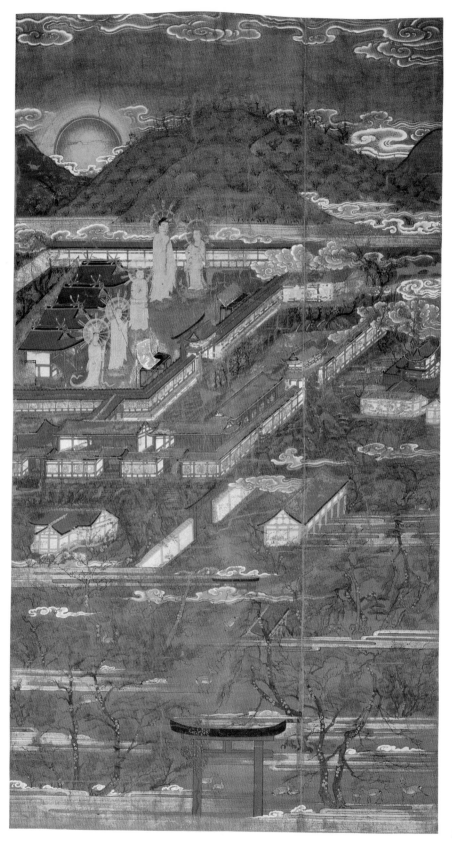

28

important Shintō shrines in Japan. The shrine buildings underwent extensive rebuilding in the years 1178–1179, in the Late Heian period.

As a genre of Japanese Buddhist painting, depictions of the Kasuga Shrine are significant as illustrations of the *honji-suijaku* theory. This theory, in which Shintō deities were seen as manifestations (*suijaku*) of Buddhist deities (*honji*), was developed as early as the ninth century.[2] These correspondences were clearly articulated in many Buddhist writings of the Late Heian period. The monk Jōkei (1155–1213) identified the principal *kami* of the Kasuga Shrine with the historical Buddha Shaka; for this reason, Shaka is the largest of the Buddhist deities depicted here.[3] Such correlations prevailed from the Heian period onward. *Honji-suijaku* concepts can be tied to beliefs that correlated sacred places on mountains in Japan with the divine paradises associated with certain Buddhist deities. The popularity in Nara of the bodhisattvas Kannon and Jizō can in particular be linked to the beliefs that as a sacred precinct the Kasuga Shrine was connected with Kannon's Fudaraku (Sk. Potalaka) Paradise, and that an entrance to hell could be found under Mount Mikasa (Jizō was seen as a savior of souls in hell). During the Late Heian period, many Shintō shrines and Buddhist temples were equated with Buddhist paradises. This is illustrated in the early fourteenth-century handscroll known as the *Kasuga Gongen Genki-e*, dated 1309, which ends with the following inscription:

> If the place where the heart is purified is a Pure Land,
> Our *kami* are already Buddhas.
> Isn't then the Shrine a Pure Land?
> Therefore (Yakushi's) Jōruri and (Shaka's) Ryōzen [Paradises] are already
> located in the inner shrine precincts.
> Nor is it necessary to search for (Kannon's) Fudaraku and (Monju's)
> Seiryōsan beyond the clouds and seas.[4]

As Darling has shown, in the Late Heian period, "Buddhist Pure Lands became equated with the purified realm of the Shintō shrines, with *kami* as their lords. Conversely, Shintō shrine settings began to assume more and more the appearance of Buddhist paradises, resplendent with vermilion and gold multi-towers and corridors set among flowering trees and meandering streams."[5]

Another example of this correspondence was the equation of Mount Kōya, the headquarters of the Shingon sect, with the Pure Land of Amida. By the Kamakura period, the Kasuga *kami* and the Buddhist deities with which they were associated were worshiped as protectors of the Japanese nation.

The earliest records of Shintō shrine paintings of the type exemplified by the *Kasuga Mandala* date to the late twelfth century. Most surviving examples, however, date to the thirteenth and fourteenth centuries (Kamakura, Nambokuchō, and Muromachi periods). The first literary reference to a Kasuga Shrine painting appears in the writer Kujō Kanezane's diary, *Gyokuyō* (*Leaves of Jade*), dated 1184, in which the worship of a painting depicting the Kasuga Shrine is mentioned.[6] The earliest use of the term *mandara* (Sk. *maṇḍala*) for such depictions appears in the *Kasuga Gongen Genki-e* handscroll of 1309.[7] An entry in the imperial diary of Emperor Hanazono, dated 1325, records that "for these three or four years, Kasuga mandalas (depictions of the 'scenes of the shrine compound' are

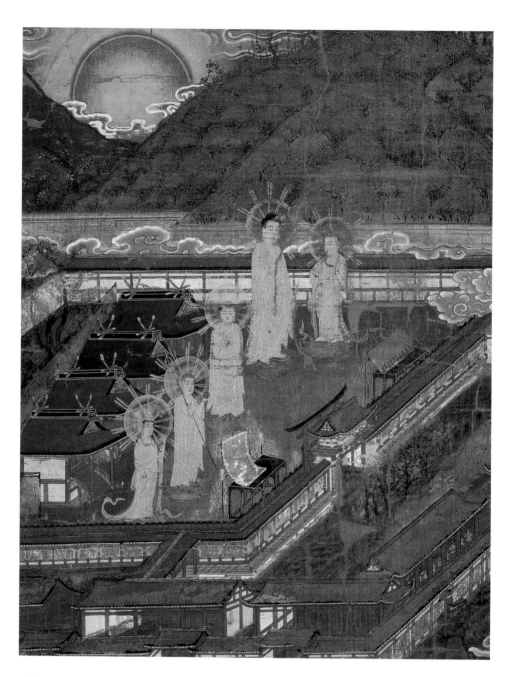

28a

called Kasuga mandala; in recent years everyone owns this kind of painting) are worshipped in all manner of ceremonies beginning with offerings of those performed at the shrine."[8]

The proliferation of Kasuga Shrine paintings from the thirteenth century onward has been linked to the spread throughout Japan of religious fraternities known as *kō*, in the ceremonies of which veneration of the Kasuga Shrine and its deities played a central role.[9] As Darling has shown, "a prerequisite of these Kasuga Mandalas . . . required that they accurately depict the shrine precincts because these paintings served in religious devotions as substitutes for the shrine itself."[10]

The majority of surviving Kasuga shrine paintings depict the shrine from the same angle as appears in the Academy's scroll. In general, however, the five Buddhist *honji* associated with the shrine are shown floating in disks in the sky above the precincts, or represented by Sanskrit *Siddham* characters in the same positions. It is rare to find the Buddhist deities standing directly in front of the main shrine buildings, as they do here.

The landscape elements and deer in the Academy's scroll are characteristically painted in a traditional *Yamato-e* mode. The stylized and rather mannered technique by which the white clouds are painted suggests that the scroll postdates the Kamakura period. The exceptionally fine *kirikane* (cut-gold) decoration in the deities' robes, and the refined, meticulous style of depiction of the shrine architecture suggest that the painting should be dated to the Nambokuchō period. The only visible retouching appears in the gold corona around the sun at the upper left; this painted gold wash partially covers some of the clouds in the background. Otherwise the painting is an extraordinarily well-preserved and beautiful example of an early Kasuga Shrine painting.

1 *Kodansha Encyclopedia of Japan.* 9 vols. (Tokyo: Kodansha, 1983), vol. 4, pp. 163–164.

2 On the development of the *honji-suijaku* theory in Japan, see Alicia Matsunaga, *The Buddhist Philosophy of Assimilation: The Historical Development of the Honji-Suijaku Theory* (Rutland and Tokyo: Charles E. Tuttle, 1969), pp. 211–230.

3 Leonard Bruce Darling, Jr., *The Transformation of Pure Land Thought and the Development of Shintō Shrine Mandala Paintings: Kasuga and Kumano* (Ph.D. dissertation, University of Michigan, 1983), pp. 9, 211–212, 225.

4 Ibid., p. 266.

5 Ibid., p. 118.

6 Ibid., p. 232.

7 Ibid., p. 239.

8 Ibid.

9 Ibid., p. 293.

10 Ibid., p. 239.

LITERATURE

F. Abbate, *Elite storia universale di tutte le arti* (Milan: Fratelli Fabbri Editori, 1966), pl. 69, p. 103.

Kami Gami no Bijutsu (*The Arts of Japanese Gods*) (Kyoto: Kyoto National Museum, 1974), no. 14.

PROVENANCE

Yamanaka and Company, Kyoto; Mr. and Mrs. Philip E. Spalding, Honolulu.

29 Niu Myōjin (Goddess of Kōya-San)

Nambokuchō period, 1336–1392
Hanging scroll; ink, colors, and gold on silk
106.7 x 38.1 cm
Purchase, 1986 (5484.1)

Niu Myōjin is a Shintō deity of particular interest in the history of Japanese Buddhism because she is the goddess of Mount Kōya on the Kii Peninsula, headquarters of the Esoteric Shingon sect of Buddhism. Niu Myōjin figures in syncretic Shintō-Buddhist mythology because her son, a hunter, gave the monk Kūkai (Kōbō Daishi, cat. no. 31) the use of two dogs, one white and one black, to help him find the sanctuary on Kōya-san. In rituals at the Kongōbu-ji and elsewhere, Niu Myōjin and her son were worshiped in conjunction with the Womb and Diamond mandalas respectively. A Kamakura-period hanging scroll in the Kongōbu-ji on Mount Kōya depicts the goddess in the guise of a Heian-period aristocrat.[1]

The Academy's hanging scroll depicts Niu Myōjin in flowing robes decorated with gilt scrolls and flowers. She wears an elaborate crown topped by a gold phoenix. In her hands she holds a gold fan. Her expression is calm, and the features of her face are painted in fine, delicate lines. The gold details of her crown, fan, and jewelry are painted in the raised *moriage* technique, suggesting that the painting should be dated to the Nambokuchō period.

This iconographic form of Niu Myōjin depicts the deity seated on a raised dais. Behind the figure is a beautiful folding screen painted with flowers on a white ground. In the background, pale lotus plants are painted in gold on a dark brown wall. At the top of the painting is an elaborate embroidered canopy decorated with phoenixes and flowers. A long staircase with banisters in the foreground leads up to the dais. On the platform at the top, on either side of the staircase, are two lions (*koma-inu*), the traditional protectors of Buddhism. The white and black dogs in the foreground at the bottom of the staircase are the ones that led Kōbō Daishi to the sacred mountain.

A noteworthy feature of the Academy's scroll is the presence of a gold phoenix in the goddess's crown. The phoenix in China was a well-known Daoist symbol of immortality, and was associated with Xiwangmu, the Queen Mother of the West. The phoenix, as a mythical bird, was closely associated with female deities, and its appearance in Niu Myōjin's headdress suggests an adaptation of a Chinese Daoist symbol in Shintō practice. It is well known that many Shintō deities in Heian and Kamakura times were portrayed with the attributes of Chinese figures.[2] Further, the name *Niu* was closely associated in Japan with the mining of mercury, while in traditional Chinese Daoist practice cinnabar, or mercuric sulphide (J. *tan*, Ch. *dan*), was the key ingredient in the most powerful elixers of immortality. It is conceivable that the Chinese-influenced images of Niu Myōjin in Japan were perceived with this association in mind.

Images of Niu Myōjin are relatively rare today, and the Academy's scroll is one

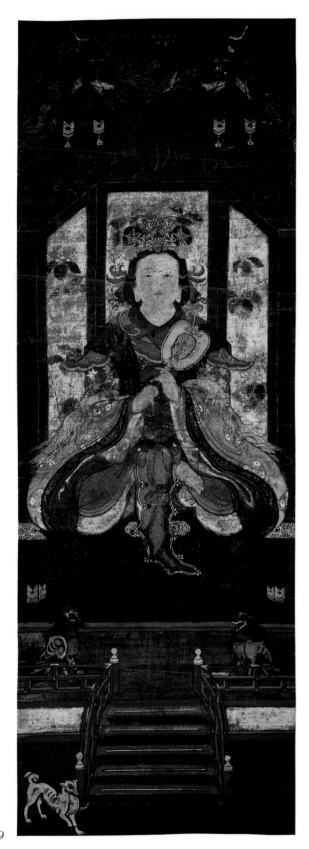

29

of very few known examples outside Japan. An early Muromachi painting in the collection of Mr. and Mrs. Jackson Burke, New York, depicts the goddess in a guise similar to that seen in the Academy's scroll (fig. 29a). Here the goddess appears as an aristocratic deity dressed in the style of the Chinese Tang Dynasty. The Burke painting depicts Niu Myōjin at the upper right, accompanied by her son, Kōya Myōjin, at the upper left. The two female deities in the lower half of the Burke scroll may represent the daughters of Niu Myōjin and Kōya Myōjin. In both the Academy and Burke scrolls, the deities are depicted on a raised dais with a staircase in the foreground, along with the Buddhist lions and the black and white dogs. Another variation on this theme is a Kamakura-period hanging scroll in the Kongōbu-ji, in which Niu Myōjin and Kōya Myōjin are depicted as subsidiary figures in a portrait of Kōbō Daishi.[3]

Fig. 29a.
Mandala of the Shintō Deities of Mount Kōya
Muromachi period, c. fifteenth century
Hanging scroll; ink, colors and gold on silk
Mary and Jackson Burke Collection, New York

1 Haruki Kageyama, *The Arts of Shintō*, trans. Christine Guth (New York and Tokyo: Weatherhill/Shibundo, 1973), pl. 74.
2 Ibid., pls. 69, 71, 76.
3 *Kōbō Daishi to Mikkyō Bijutsu* (Tokyo: Tokyo National Museum, 1983), pl. 5.

LITERATURE

Howard A. Link and Sanna Saks Deutsch, *The Feminine Image: Women of Japan* (Honolulu: Honolulu Academy of Arts, 1985), no. 5.
Honolulu Academy of Arts: Selected Works (Honolulu: Honolulu Academy of Arts, 1990), p. 77.

PROVENANCE

Harry Shupak, Honolulu; Mrs. L. Drew Betz, Honolulu.

Pilgrims at the Kumano Shrine

Muromachi period, sixteenth century
Handscroll; ink, colors, and gold on paper
31.1 x 565 cm
Gift of Robert Allerton, 1952 (1658.1)

This handscroll depicts pilgrims at the Kumano Shrine, located on the Kii Peninsula in Wakayama Prefecture. The shrine existed as early as the Heian period, and was visited by thousands of pilgrims every year. Like the Kasuga Shrine in Nara (cat. no. 28), Kumano was a major Shintō-Buddhist center. The twelve principal deities of the Kumano Shrine were *kami* (spirits) who came to be seen as manifestations of *honji*, or Buddhist deities. The key shrines at Kumano (Hongū, Shingū, and Nachi) are depicted in this handscroll. These were associated respectively with the Shintō deities Susano-o no Mikoto (*honji* Amida Nyorai) who was the brother of the Sun Goddess, Hayatama no Okami (*honji* Yakushi Nyorai), and Fusumi no Okami (*honji* Senju Kannon).

The Kumano Shrine was closely connected with the Buddhist Shugendō cult, which emphasized ascetic practices in mountain settings.[1] The sect was traditionally considered to have been founded by En no Gyōja (b. 634). The Kumano site, particularly the Nachi waterfall, was considered equivalent to Kannon's Fudaraku (Sk. Potalaka) Paradise. Emperors and commoners both made the pilgrimage to Kumano; one emperor, Go-Shirakawa (r. 1155–1158), visited the shrine thirty-three times during his life.[2] A visitor to the shrine was assured of well-being in this world and rebirth in paradise.

It is most likely that the Academy's handscroll was created as a souvenir for a pilgrim to the Kumano Shrine in the late Muromachi period. The execution of the scroll is somewhat heavy-handed, suggesting that it was one of many such paintings that were mass produced at the shrine for tourists and pilgrims. The scroll illustrates the main buildings of the shrine, which include both traditional Shintō structures and Buddhist subtemples. The scroll opens with the scene around the large *torii* gate at the entrance to the shrine precincts. An inscription appears on the gate reading "Nihon Dai-ichi" (First in Japan). A number of pilgrims and Shintō priests can be seen in the area surrounding the gate, while in the foreground a number of boats approach the shore. The pilgrims are much like those described in traditional accounts, who wore "white robes, hoods, silk undergarments, leggings, and straw sandals and carried staffs."[3]

As the scroll progresses, pilgrims are shown crossing a bridge and bathing in a shallow river. The central buildings of the shrine then appear within a forested enclosure. These buildings contain several clusters of traditional Shintō shrine buildings, with the sacred mirrors representing the home of the *kami* visible inside. At the far end of this enclosure is a long shrine building with pilgrims prostrating themselves in the courtyard facing it.

The next scene presents a vista of the famous Nachi waterfall, home of one of the principal *kami* of the Kumano Shrine (fig. 30a). In the stream below the waterfall, the

Heian period warrior Endō Moritō (b. 1120) is shown in his guise as the priest Mongaku Shōnin, being aided in his period of repentance by Seitaka and Kongara, the two youthful attendants of the Esoteric deity Fudō Myō-ō (cat. no. 34). To the left, two samurai approach the waterfall, their hands clasped in prayer as they view this miraculous scene.

The next section depicts another enclosed compound, and before it a three-story Buddhist pagoda and a bell tower. Within the enclosure are five Shintō shrines containing mirrors; one, however, displays a fan. In the courtyard at the far end of these buildings a man in clerical garb and three pilgrims kneel on the ground in prayer. The main figure here is the retired emperor Go-Shirakawa, who visited Kumano so often in the twelfth century.

Next we see a cluster of buildings situated just beyond a stream. These buildings include an open pavilion with a pine tree growing through the roof, as well as a bell tower, what appears to be an inn, and a small building connected to a pool of water for bathing. After this another complex of buildings is depicted, which includes a small cluster of three Shintō shrines and a large gateway built in traditional Buddhist style with two large sculpted guardian kings (*Niō*) visible on either side of the main entrance.

The scroll ends with scenes of scattered Shintō shrine buildings and a large structure built on stilts over rocks. On the veranda of this large building pilgrims and priests are shown praying, with Buddhist priests visible in the interior chanting *sūtras* aloud. The scroll ends rather abruptly, suggesting that some of the scroll may be missing. A rectangular seal on the mounting paper immediately following the scroll reads, "Suzuki shoshi."

Despite the bold and naive style of this handscroll, the depictions of the shrine buildings and of the actions of the pilgrims contain many specific details suggesting that the work was created by an artist active at the Kumano Shrine. The stylized portrayal of the rocks, trees, and architecture indicates that the painting is executed in the *Yamato-e* manner, although in a highly derivative mode. The handscroll is very close in style to a large hanging scroll entitled *Kumano Nachi Shrine Pilgrimage Mandala* in the Tōkei Shrine, Wakayama Prefecture.[4] The brush technique and coloring of the two scrolls are strikingly

30a

similar, suggesting that both paintings came from the same atelier. The number of pilgrims visiting the site each year would have guaranteed a certain demand for souvenir images, of which both paintings appear to be excellent examples. Many of the same buildings, shrines, and figures appear in both scrolls. In particular, the nearly identical handling of Go-Shirakawa's worship in the Honjū courtyard and the vision of Mongaku Shōnin with Seitaka and Kongara under the Nachi waterfall suggests a common origin for the two paintings. Most leading shrines and temples had studios either directly or indirectly attached to them that created souvenir images. Paintings of this kind typically depict the shrine buildings as they appeared at the time, pilgrims walking through the precincts, and both historical and mythical events that had occurred at the site.

1 Haruki Kageyama, *The Arts of Shintō*, trans. Christine Guth (New York and Tokyo: Weatherhill/ Shibundo, 1973), pp. 118–119.
2 Ibid., p. 129.
3 Ibid., p. 134.
4 Ibid., pl. 131.

LITERATURE
Honolulu Academy of Arts Bulletin (January 1953).

PROVENANCE
Mayuyama and Company, Tokyo; Robert Allerton, Kauai.

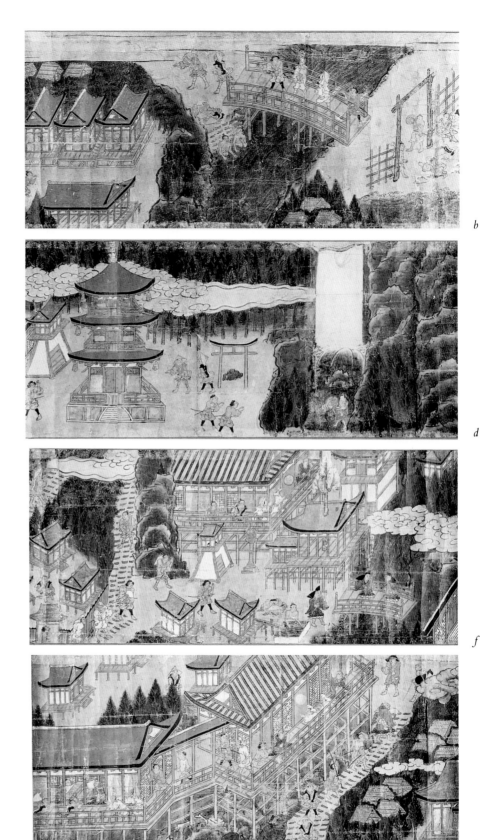

b

d

f

h

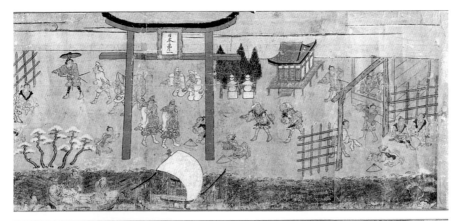

30

a

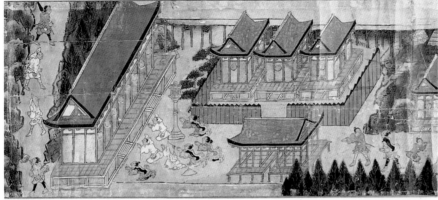

c

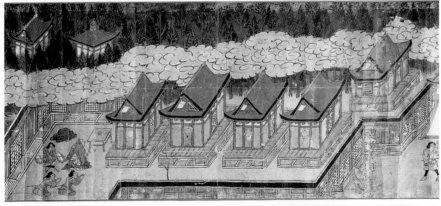

e

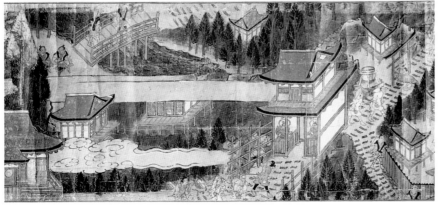

g

NARRATIVE SCROLLS AND IMAGES

31 *Kōbō Daishi Gyōjō Emaki:*
Events in the Life of Kōbō Daishi

Kamakura period, late thirteenth–early fourteenth century
Handscroll; ink and colors on paper
33 x 736 cm
Gift of Robert Allerton, 1952 (1689.1)

The Academy's painting, *Events in the Life of Kōbō Daishi*, is one of the best-preserved Kamakura-period narrative handscrolls in American collections. The scroll consists of three sections depicting key events in the life of Kūkai (Kōbō Daishi, 774–835), the founder of the Esoteric Shingon sect in Japan. In its original state the scroll included at least ten scenes; several of these are now in private collections in Japan. The fragments in the Academy's collection have been discussed by Toru Shimbo, who shows that the three scenes are the first, second, and tenth sections of the original handscroll.[1] The painting is executed in the classical *Yamato-e* technique.

Kūkai was born into an aristocratic family and was a precocious youth. As a young man he studied Buddhism, Confucianism, and Daoism, and at the age of seventeen he wrote a work entitled *Indications of the Three Teachings* in which he showed the superiority of Buddhism over the other two philosophies.[2] In 804 Kūkai sailed to China; upon arrival he went to the great Tang capital of Chang'an, where he studied Esoteric Buddhism with the master Huiguo (746–805). He returned to Japan in 806 and ten years later began the construction of a monastery on Mount Kōya (Wakayama Prefecture) that would become the headquarters of the Shingon sect. Kūkai introduced many of the key Esoteric texts and rituals to Japanese Buddhist practice.

The first section of the scroll begins with a text written in running script (*gyōsho*), which describes the miraculous circumstances under which Kūkai's mother conceived him:[3]

> Daishi, the founder of Kōya-san, was born in Byōbu-ga-Ura in the district of Tadō in the country of Sanuki,[4] in the fifth year of Hōki [774] during the reign of Emperor Kōnin. His father was Atai of the Saeki clan. In olden times when the Sun Goddess Amaterasu-ō-mikami shut herself up in the cave of Ama-no-iwa-to the Kami Ame-no-ko-yane-no-mikoto devised a plan whereby he would appease the angry Goddess

through offerings. The two Kami would open the door of the cave. It is said that the father of a servant of one of the two Kami who opened the door of the cave killed an enemy of the Kami, and as a reward was given some land.[5] Kōbō Daishi's mother, Atō, became pregnant when she and her husband dreamt that a Saint from the holy land of Tenjiku [India] entered her womb.[6] After twelve months, Kōbō Daishi was born.

In the characteristic manner of Kamakura-period narrative handscrolls, the text is followed immediately by an illustration. The first section of the painting opens with a landscape painted in the *Yamato-e* style. This brief landscape section depicts the shore of a river or lake, with rocks and plants on the bank and two boats tied up just offshore. Farther along is the entrance to an estate. This is the home of Kūkai's parents. The autumnal season of this scene is indicated by the red leaves of a tree just outside the gate; several leaves have fallen to the ground inside the enclosure. Above the gate is a guardhouse with roof and trap door, and a bow with a quiver of arrows stacked in one corner. Horses in a stable are being fed by two grooms, one of whom stretches energetically. The central house then appears, with a sleeping dog and two resting falcons outside the veranda. Inside a room two samurai guards are shown resting on *tatami* mats; their weapons and armor are on the floor nearby. In another room of the same house is Kūkai's mother, asleep. Above the roof the Indian saint mentioned in the text appears floating on a cloud. At the end of this scene is another tree with autumnal foliage, vigorously painted in the *Yamato-e* manner.

The second section of the Academy's scroll begins with the following text:

During the time Kōbō Daishi was five and six years old, he would often dream that he was sitting at the center of an eight-petal lotus blossom, floating in mid-air and conversing with several Buddhas. He never told anyone about this, not even his parents. His father and mother loved him dearly, and raised him with great care and reverence, as one would hold a precious gem in one's hands, always careful never to drop it or let it be damaged. His mother was always thinking of the events surrounding the birth of her son and the prophesy told to her by the Saint from Tenjiku [India], who had in the dream told her that her son would one day become a follower of Buddha. Kōbō Daishi, hearing of this, became overjoyed.

In the painting that follows this text, we see the women of the household asleep inside a large mansion. These women are depicted as Heian aristocrats. Just beyond the house the figure of Kūkai appears, seated on a lotus flower on the ground (fig. 31a). In front of him are three bodhisattvas painted in gold, also seated on lotus flowers. These deities hold their hands in various *mudrās* (gestures) as they speak with the young Kūkai. At the end of this section is a beautifully painted landscape, with trees and rocks on the shore of a lake. Three boats float offshore. The brilliant azurite and malachite pigments painted over the ink lines of the landscape elements and architecture are typical of the *Yamato-e* style. The blue and green colors, in addition to the occasional gold wash in the green rocks, ultimately hark back to the blue-and-green style of landscape painting popular in China during the Tang Dynasty (618–906).

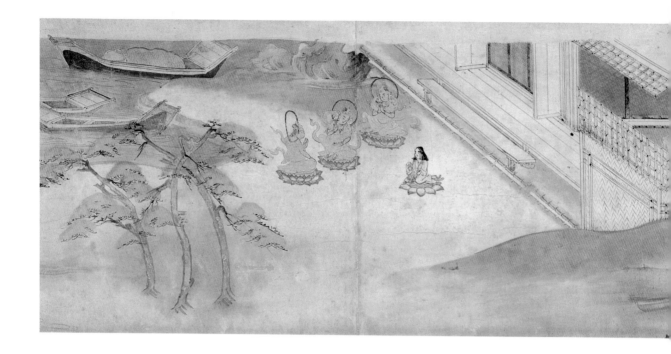

The last section of this scroll relates an event that occurred much later in Kūkai's life, after his return from China in 806. The text reads:

> After Kōbō Daishi returned from China he propagated the teachings of the True Word (Shingon) far and wide, sermonizing on the love of Buddha for all living beings and [teaching] that the welfare of the nation would be enhanced by this new religion. Priests of various sects, enraged by this activity, petitioned the emperor. Soon illustrious members of the Exoteric sects, as well as noblemen from various branches within the government were summoned to the Seiryōden in the imperial palace. There they discussed the righteousness of this new religion. Learned priests from the Five Natures [Hossō], Eight Negations [Sanron], Three Truths [Tendai], and Ten Mysteries [Kegon] sects each asserted their respective dogmas. Kōbō Daishi, like the flowing current of a mountain stream, unhesitatingly answered their questions with great skill and eloquence. Gradually the priests began to understand the profundity of the doctrine of the "Three Mysteries" [Body, Speech, and Mind]. As Kōbō Daishi was about to expound on the meaning of becoming a Buddha in this life, he turned to the south and making a secret hand *mudrā* of knowledge, began to chant. At that moment his body, word, and thought became one and he was suddenly transformed into a golden image of Dainichi Nyorai [Vairocana, the Supreme Buddha]. Atop his head rested the Crown of Five Wisdoms, and from it and the flesh and

blood of his body radiated brilliant rays of light. Slowly he rose above the dais and the assembled priests of the seven sects and the noblemen sitting below, who bowed in deep reverence to the holy figure floating in the air in front of them. At once Kōbō Daishi returned to his former appearance, and thus became a "Buddha in this body," unifying himself with the Buddha. From that day onward, those who had doubted the concept of "immediately becoming a Buddha," now understood, and the Way of the Mandala of the True Word was now established. The Hossō priest Gen'in [818–888],[7] the Sanron priest Dōshō [d. 875], the Tendai priest Gishin, and the Kegon priest Dōyū [d. 851] became his first followers. Together they preached the message of Buddha. In olden times, the sudden ascension to Buddhahood by the eight-year-old daughter of the Dragon King, and her entrance into the undefiled realm of Vimala, quieted the restive doubting hearts of Pratibhana and Sariputra,[8] so now Kōbō Daishi, in the palace of the emperor, by this act of transformation, startled the priests, all high-ranking clergy in the church hierarchy, into realization and abandonment of their quest for power and position. During the time of the preaching of the True Word, why is it that what should be thought mysterious is not thought to be? Because this is the period of *mappō*, when the world is corrupted in thought and action. Because of this, we are humbly grateful for the illustrious deed of Kōbō Daishi.

d

h

l

若道推人子弟子となりてすみしける

法化ますはたむり八歳の龍女
志垢果に速證むりの共香積方
お籠雞乃んまやむ今三宝礼祗說
清涼雨礼現成むるくくも絡義解
高僧滿拉礼軌跡と座の次彼八在世
乃說法の枘なわるむすむし礼り運み
出大坂る聖真夏昭雲塔の時
た妻車つくれむわやよけ聖
大殿礼釣化とうに西看巻る紀
玉脈

高野山根本大師者光仁天皇の御宇
寶龜五年に誕生す讃岐國多度郡
屏風ヶ浦なり御父は佐伯の
善氏と申まうす御母は天照大神あまてらすおほむかみあれば
いとやがて此くにもいでまさしめ
しや称へも又それに称へて
てすゝむ二人の神をまさりいで
くしも妻一神を申て吉事をなり
やぶりて給けり此父の夢なりけれ
御母も阿刀氏あとうぢの女母の夢に天皇の
御子をなけめして妻つる心
こゝろにくしもいまちて此くにあらはる
人ともいまちて此くにを十二月なりと
玉返申さしける事

大師御としと五六歳のほどを夢にて
小八葉の蓮花れんげにをなして法佛に
もろともの諸と志を御通せさせし
弟子志らかへ人も志ととさせる父母を
ろやかみへて人も志ととさすさせ父母を
のちかひしもてすこて天竺の聖人
たまひけれて仏をのちとなしもて見くり
きて來もよなるわてつてみかるへを
いみなるすたにもなつく志もも重城すう少
仏弟子とたなしくも重城すう少
よろふ御心あり

大師内證の後ち眞言秘教むなしき弦を
て仏祖れに應報こたへ國家の福を
さなくで養むまさせるを其詮
乃經經は末代のみを次期遠に計
にもつて顕宗ひ群美なす朝遠
宗殿せり高に藏む所論ろ計
此百官め志つてし所を謝て清
三輪十玄の顕ひ賢指論難ひ
ます皆眞念の許法を乃大師妻尋
宗詞義懸れへの徳にれ存れる
事をも三論盛れかつも乃現證をあれ
成佛の文理極成するふら南方なり

むろして秘卯むむすら夫喜志城頭
三蜜平ひ歌へ俳絵く紀盡頭恩
すにさは志とて筆をの此盧遮那仏
志り給合比皿顕のうへ志て眞念乃寶
剛まれ此皿肉素ゐる比もちゐ志富
乃皿のむをゝ川へ人廉なむ所法
皆果よ入へ所きれ之七宗れ語應れ
まこと稀謝志祥素万像をなるまこく
礼教ちすれを豈本縣小畫殿志も
生佛も二なれむとも其も志次加入構
持乃も龍うし白身頻惜れうてれ
日もとゝを志眞言論伽の志秘密
鲁茶盛れ道乃時顕立志乃法相の
源仁三輪の道昌天台に巖眞花巖
幕道雄人子弟子となわりて妻しける

n *m*

The painting depicts the miraculous transformation described in the text. The artist of this scroll chose to illustrate the precise moment when Kūkai changed into the brilliant gold image of the cosmic Buddha, Dainichi Nyorai (Mahavairocana). Kūkai is seated on a *tatami* mat in the Seiryōden, his hands in a mystical *mudrā*. Five courtiers dressed in black prostrate themselves on the veranda outside. In the foreground, four Buddhist monks clasp their hands together and bow in reverence. The fantastic event attracts the attention of other courtiers, guards, and court ladies, all of whom kneel on the ground. To the left is a gateway that leads to an outer courtyard. A number of subsidiary figures run toward this gateway and stumble to their knees as they enter the imperial compound.

The superb painting of this section is typical of some of the finest extant *Yamato-e* narrative handscrolls. Particularly noteworthy is the sharp contrast between the ink lines and geometric structures of the palace architecture, the opaque black costumes of the courtiers and Buddhist monks, and the almost electric blue, green, and gold pigments within the Seiryōden, echoed here and there among the figures in the courtyard. The composition overall is spare, and yet the details are precise and specific with regard to the narrative content of the painting.

1 Toru Shimbo, "The Academy's *Life of Kōbō Daishi* Handscroll," *Honolulu Academy of Arts Journal* 4 (1986), pp. 13–28; for the order of the original scroll and the remaining sections in Japan, see p. 21.

2 See William Theodore de Bary, *The Buddhist Tradition in India, China and Japan* (New York: Vintage Books, 1969), pp. 287–313. See also Yoshito S. Hakeda, *Kūkai Major Works: Translated with an Account of His Life and a Study of His Thought* (New York: Columbia University Press, 1972).

3 The translation of this scroll's text and the relevant footnotes are by Joseph Seubert. The text is transcribed in Shimada Shūjirō, ed., *Nihon Emakimono Zenshu* n.s. 1 (1980), p. 43.

4 Now in Kagawa Prefecture, Shikoku.

5 This story is taken from a famous episode in the seventeenth chapter of the first book of the *Kojiki*. Briefly told, the story relates that Ama-terasu-ō-mi-kami, indignant at the flagrant behavior of her brother Susa-no-o, hid herself in the "heavenly rock cave," Ama-no-iwa-to, thus throwing the world Takama-ga-hara into darkness. A congregation of Kami appointed one Kami to make a mirror and another to make a *magatama* (curved jade bead) while Ame-no-ko-yane-no-mikoto was asked

to perform divinations. Assembling in front of the cave, the Kami began to sing and dance. The Sun Goddess, curious as to why merriment instead of despondency should be coming from outside the cave, opened the door. At that moment, blinded by her own brilliance reflected in the mirror, the Sun Goddess was pulled out by one of the two Kami stationed near the door. Light was thus restored to the world. The question naturally arises as to why this story should appear on a scroll devoted to the deeds of the Master Kōbō. The Saeki clan was a branch of the famous Ōtomo clan, which traced its genealogy back to the deity Takamimusubi-no-kami, one of the two Kami appearing in the cosmological myth in the *Kojiki*. The father of one of the servants mentioned in the text is probably a descendant of this deity, a certain Michi-no-omi-no-mikoto. It is said that he fought with the legendary Emperor Jimmu in his campaigns in the East. For his bravery, Michi-no-omi-no-mikoto was given grants of land. The earliest text to include this genealogy is the *Kōbō Daishi Gyōjō Yō Shū*, dating to c. 1374. The inclusion of this story in illustrated handscrolls thought to be as much as a century earlier in date, however, suggests an earlier origin for this family tree.

6 There is a noteworthy similarity between the tale of the miraculous birth of Kōbō Daishi and that of the Buddha Śākyamuni.

7 An error is evident in the fact that the events here portrayed supposedly occurred in 806, whereas Gen'in was not born until 818. The error cannot, however, simply be attributed to the calligrapher of the Academy's scroll, for the tradition of including Gen'in as one of the original followers of Kōbō Daishi dates from an early twelfth century work entitled *Kōbō Daishi Gyō Den*. Furthermore, in the *Himitsu Deshu Taiyo Bun*, dated to the third quarter of the eleventh century, Gen'in is designated the eighteenth patriarch of the Shingon sect, while Kōbō Daishi is addressed as the eighth patriarch. Why such an erroneous tradition should arise in the face of such evidence, and why it should continue to be transmitted, is unknown. For a brief biography of Gen'in, see *Nihon Bukka Jinmei Jisho*.

8 This is a paraphrase of the story in the twelfth chapter of the *Lotus Sūtra*.

LITERATURE

Junkichi Mayuyama, ed., *Japanese Art in the West* (Tokyo: Benrido, 1966), pl. 141.

Academy Album (Honolulu: Honolulu Academy of Arts, 1968), pp. 119–120.

Shimada Shūjirō, ed., *Zaigai Hiho*, vol. 1: *Bukkyo Kaiga, Yamato-e, Suibokuga* (Tokyo: Gakken, 1969), text vol., pp. 86–87.

Howard A. Link, "Japanese Buddhist Art," *Apollo* 109, (204) (February 1979), pl. 23.

Zaigai Nihon no Hihō, vol. 2: *Emakimono* (Tokyo: Mainichi Shimbunsha, 1980), pls. 102–103.

Shimada Shūjirō, ed., *Nihon Emakimono Zenshu* n.s. 1 (1980), pls. 1–2, 8–14.

Howard A. Link and Sanna S. Deutsch, *The Feminine Image: Women of Japan* (Honolulu: Honolulu Academy of Arts, 1985), no. 19.

Toru Shimbo, "The Academy's *Life of Kōbō Daishi* Handscroll," *Honolulu Academy of Arts Journal* 4 (1986), pp. 13–28.

Honolulu Academy of Arts: Selected Works (Honolulu: Honolulu Academy of Arts, 1990), p. 76.

PROVENANCE

Hisamatsu Collection: Yamanaka and Company, Kyoto; Robert Allerton, Kauai.

32

Section of the *Hōnen Shōnin E-den Emaki*

Kamakura period, thirteenth–early fourteenth century
Handscroll fragment; ink and colors on mica-coated paper
31.8 x 36 cm
Gift of Mrs. Theodore A. Cooke, 1955 (2111.1)

This fragment comes from an important Kamakura-period handscroll depicting the life of the famous Heian period monk Hōnen (1133–1212). Known today as the founder of the Jōdo, or Pure Land, sect, Hōnen was one of the most important figures in the history of Japanese Buddhism. He taught that in the age of *mappō* (the decline of the law, or *Dharma*), the best hope for human salvation was the recitation of the name of Amida, Buddha of the Western Paradise. In his text entitled *Senchaku Hongan Nembutsu-shū* (*Collection of Passages on the Original Vow of Amida, in Which the Nembutsu Is Chosen above All Other Ways of Achieving Rebirth*), Hōnen taught that there was a more direct means to emancipation than conventional religious practices.[1] By effectively denying the reliability of traditional means, Hōnen incurred the wrath of the authorities of the Tendai sect on Mount Hiei, the sect in which he had begun his career as monk.

Hōnen was deeply influenced by Shandao's *Guanjing Su* and by Genshin's *Ōjōyōshū*, and he had a particular sympathy for individuals who had committed grave crimes such as murder.[2] He wrote the *Senchakushū* in 1198 in Kyoto. In 1207, he was exiled to Shikoku because of the widespread popularity of his teachings. In 1211, he was allowed to return to Kyoto, where he died the next year. Hōnen and his followers taught that the recitation of Amida's name on one's deathbed would guarantee rebirth in the Pure Land. A depiction of Hōnen on his own deathbed, contained in the *Hōnen Shōnin Eden* handscroll in the Kōshō-ji, Hiroshima Prefecture, shows the priest holding a rope tied to a statue of Amida as he chants the *nembutsu*.[3]

On Hōnen's way into exile in 1207, he stopped briefly at a place called Takasago, a port town on the mouth of the Kako River. After preaching to the fishermen who lived there, he moved on to another port called Muro-no-tomari. It was there that the scene depicted in the Academy's painting took place:

> When he arrived at Muro-no-tomari in the same province [Harima], a
> small boat drew near carrying a woman of ill fame, who said to Hōnen,
> "I heard that this was your boat, and I have come to meet you. There are
> many ways of getting on in the world, but what sin could have been com-
> mitted in a former life of mine, to bring me into such an evil life as this,
> which I seem fated to lead. What can a woman who carries a load of sin
> like mine do to escape, and be saved in the world to come?"
> Hōnen compassionately replied,
> "Your guilt in living such a life is surely great, and the penalty indeed
> incalculable. If you can find another means of livelihood, give this up at
> once, but if you cannot, or if you are not yet ready to sacrifice your very

life for the true way, begin just as you are, and call on the sacred name; for it is for just such sinners as you, the Amida Nyorai made that wonderfully comprehensive Vow of His. So put your sole trust in it, without the least misgiving. If you rely upon his Original Vow and repeat the Nembutsu, your Ōjō [Rebirth] is an absolute certainty."

Thus kindly taught, the woman wept for joy, and later Hōnen said of her, "She is a woman of strong faith. She is sure to attain Ōjō [Rebirth]."

When afterwards he was on his way back to the capital, he called at this place and inquired about her. He found that from the time he had instructed her, she had retired to a village near the mountains in the neighbourhood, and had been living there, devoting herself assiduously to the practice of the Nembutsu. A short time after, as death drew near, it was with great mental composure that she safely accomplished her Ōjō [Rebirth]. On being told this, he said, "Yes, it is just as I had expected."[4]

In the Academy's fragment, painted in ink and colors on mica-coated paper, Hōnen is shown seated not in a boat but on a level outcropping by the sea. Another priest is seated in the foreground, and behind both figures are tall rocks and trees. The lady described in the story is shown in a boat nearby with two attendants. The rocks are painted in thick lines of pale ink, with overlays of green, brown, and blue pigment. The two priests are shown with gray robes, and their skin is painted in ocher. The women in the boat are dressed in Heian-period attire, with pink, blue, white, and green pigments in their robes. The water is painted in pale blue wash. There are clear traces of pentimenti immediately to the left of and partially overlapping the figure of Hōnen; apparently the artist changed the figure's location well after the design had been completed. The painting is in good condition, with several small patched holes.

Although the original handscroll from which the Academy's fragment comes was split up in the 1950s, the original composition was fortunately published as a whole in 1950. From the published photographs it is possible to determine that the Academy's fragment was the fourth scene in the overall composition.[5]

1 William Theodore de Bary, ed., *The Buddhist Tradition in India, China and Japan* (New York: Vintage Books, 1969), pp. 327–329.
2 Jōji Okazaki, *Pure Land Buddhist Painting*, trans. Elizabeth ten Grotenhuis (Tokyo and New York: Kodansha, 1977), pp. 20–21.
3 Ibid., pl. 7.
4 Harper Havelock Coates and Ishizuka Ryugaku, *Hōnen, The Buddhist Saint: His Life and Teaching* (Kyoto: Chion-in, 1925), pp. 611–612.
5 Umezu Jiro, "On the Picture-Scrolls of Priest Hōnen," *Kokka* 705 (December 1950).

LITERATURE

Umezu Jiro, "On the Picture-Scrolls of Priest Hōnen," *Kokka* 705 (December 1950).
Junkichi Mayuyama, ed., *Japanese Art in the West* (Tokyo: Benrido, 1966), pl. 139.
Shimada Shūjirō, ed., *Zaigai Hihō*, vol. 1: *Bukkyo Kaiga, Yamato-e, Suibokuga* (Tokyo: Gakken, 1969), text vol., p. 89.

Zaigai Nihon no Hihō, vol. 2: *Emakimono* (Tokyo: Mainichi Shimbunsha, 1980), pl. 106.
Howard A. Link and Sanna Saks Deutsch, *The Feminine Image: Women of Japan* (Honolulu: Honolulu
Academy of Arts, 1985), no. 21.

PROVENANCE
Mayuyama and Company, Tokyo; Mrs. Theodore A. Cooke, Honolulu.

Fragment of the *Jin'ō-ji Engi Emaki* 33

Late Kamakura or Nambokuchō period, fourteenth century
Handscroll section; ink and colors on mica-coated paper
34.6 x 56.5 cm
Gift of John Gregg Allerton, 1961 (2824.1)

This painting is a section of a narrative handscroll that tells the story of the founding of
the Jin'ō-ji, a Buddhist temple located southwest of Ōsaka in southern Izumi Province.
The temple was founded by the monk En-no-Gyōja in the seventh century and became
the center of the Buddhist Shugendō cult of *yamabushi*, or "monks who sleep in the
mountains." The original painting of which this is a fragment consisted of two handscrolls,
which are now divided into smaller sections scattered among several collections.[1] The
Academy's fragment comes from the first of the two scrolls, one that illustrates episodes
in the life of En-no-Gyōja, the founder of the temple and the traditional founder of the
Shugendō sect.

The Academy's section—the sixth scene in the original handscroll—depicts the
monk in an encounter with a Buddhist guardian deity named Hōshō Gongen. The scene
takes place in the Korean kingdom of Silla, to which En-no-Gyōja was dispatched by the
Shintō *kami* (spirit) of the Jin'ō-ji site (Jinushi Myōjin).[2] The hermit is shown soliciting
aid in founding the temple; in the succeeding scene, now in the Mary and Jackson Burke
Collection, New York, Hōshō Gongen appears in the air at the Jin'ō-ji.[3]

In the present painting, En-no-Gyōja, dressed in a robe of vines, meets with
Hōshō Gongen in a pavilion. The hermit sits on a tiger-skin mat and faces the guardian
deity, who is dressed in armor and flowing robes. A flaming halo appears behind Hōshō
Gongen's head, and his hands are clasped in a *mudrā* (mystic gesture). En-no-Gyōja holds
a *vajra* (thunderbolt) and a *shakujō* (staff). Outside the pavilion six attendants are seated on

33

the ground; two are dressed as Chinese civil officials, and the other four are demons. The supernatural figures are identified in the painting by names inscribed in gold ink on small strips of blue paper which have been pasted onto the surface of the scroll. The two demons at the right are En-no-Gyōja's assistants, one of whom holds a crutch. Another blue paper label inscribed in gold ink identifies these figures as "two demon spirits."

The painting is extraordinarily well preserved; its brilliantly colored blue-and-green landscape provides an appropriate setting for the meeting between the human priest and the Buddhist deity with his attendants. The painting of the figures, architecture, and landscape elements is executed in the classical *Yamato-e* style, characterized by free and sketch-like brushwork and the use of bright mineral pigments. The harmonies of blue, green, and brown in the landscape painted in thick washes of color over the ink drawing present a series of resonant color patterns in the background.

The image of En-no-Gyōja presented in this detail from the Jin'ō-ji scroll corresponds closely to the popular image of this priest in the fourteenth century. An early Muromachi hanging scroll in the Metropolitan Museum of Art, New York, depicts the hermit as a *yamabushi* in a mountain landscape.[4] He is accompanied in that painting by the same two demons that appear in the Academy's scroll. En-no-Gyōja was also depicted in sculpture; an example dating to the Kamakura period is in the Ishiuma-dera, Shiga Prefecture.[5]

1 Terukazu Akiyama, "The Identification and Reconstruction of the Illustrated Scroll Known as the 'Kōnin-Shōnin-eden'" (paper delivered at the International Symposium on the Arts of Asia, Asian Art Museum of San Francisco, 1966).

2 John Rosenfield and Elizabeth ten Grotenhuis, *Journey of the Three Jewels: Japanese Buddhist Paintings from Western Collections* (New York: Asia Society, 1979), p. 145.

3 Ibid., no. 42.

4 Metropolitan Museum of Art, no. 29.100.442.

5 Alicia Matsunaga, *The Buddhist Theory of Assimilation: The Historical Development of the Honji-Suijaku Theory* (Rutland and Tokyo: Charles E. Tuttle, 1969), pl. 11.

LITERATURE

Junkichi Mayuyama, ed., *Japanese Art in the West* (Tokyo: Benrido, 1966), pl. 137.
Academy Album (Honolulu: Honolulu Academy of Arts, 1968), p. 121.
Zaigai Nihon no Hihō, vol. 2: *Emakimono* (Tokyo: Mainichi Shimbunsha, 1980), pl. 88.

PROVENANCE

Yamanaka and Company, Kyoto; John Gregg Allerton, Kauai.

34　The Tale of Zegaibō the Tengu

Late Nambokuchō or early Muromachi period, late fourteenth–early fifteenth
century
Handscroll; ink and colors on paper
26.9 x 692.7 cm
Gift of Mrs. Philip E. Spalding and Mrs. Theodore A. Cooke, 1954 (1925.1)

This remarkable handscroll illustrates the tale of the *tengu* goblin Zegaibō. In medieval
Japan *tengu* were believed to be goblins that were half-man and half-bird; some *tengu* had
beaks and some long noses. The term *tengu* literally means "heavenly fox," and according
to Alicia Matsunaga, "This mythological creature had its origin in China where it was
used as the name for a falling star, comet or meteor. The long glowing tail of the comet
or falling star to the Chinese was reminiscent of a fox, hence they named it Tianhu."[1]

Although this belief was eventually transmitted to Japan, the *tengu* was ultimately
seen there as an evil, mischievous creature that had wings, could fly like a bird, and lived
deep in mountains.[2] *Tengu* were often shown dressed as Buddhist priests holding a fan,
and thus the name came to mean "a conceited priest." *Tengu* became an integral part of
folk beliefs in Japan by the Heian period.

The story depicted in this scroll has its origins in the twelfth century or earlier,
and is recorded in the late Heian compendium of folktales entitled *Konjaku Monogatari-shū*.[3]
In the original tale the principal *tengu* is named Zhiluo Yongshou, or Chira Yōjū in
Japanese. This story runs as follows:[4]

STORY OF THE LONG-NOSED GOBLIN NAMED CHIRA YŌJŪ FROM SHINDAN [CHINA] THAT CAME TO THIS COUNTRY

A long time ago there was a strong *tengu* from China. His name was Chira Yōjū and he
came to Japan. There he met a Japanese *tengu*.

The Chinese *tengu* said:

"There are many bad priests in my country, but my power is greater than theirs so
I can do as I want. I came to this country (Japan) because I heard there were powerful
priests here. I want to compare my power with theirs. What do you think?"

The Japanese *tengu* listened. He thought what the Chinese *tengu* said was interest-
ing. The Japanese *tengu* said:

"I am more powerful than the Japanese priests. If you want to harm them, do what
you want. I will tell you which priests to hurt. Follow me."

Then both *tengu* left. The Japanese *tengu* flew away first, followed by the Chinese
tengu. They went to Mount Hiei and stopped near a stone stele with religious writing near
Otake. Both *tengu* sat down on the path that led up to the shrine. The Japanese *tengu* said:

"I'm famous in this area so it isn't good to show myself. I'll hide in the bushes
down in the gully. Change yourself into an old priest so you can hurt the people passing by."

Then the Japanese *tengu* hid in the bushes and began to watch. The Chinese *tengu* changed into an old priest and sat down next to the stele. The Chinese *tengu*'s eyes gave off a fearful look. This gaze gave the Japanese *tengu* confidence that the Chinese *tengu* would do very well. The Japanese *tengu* felt both happiness and contentment.

After a while a person named Yokiyo Ritsushi came down from the mountain, traveling towards the capital [Kyoto]. He was in a palanquin. The man was a famous priest. The Japanese *tengu* said, "I wonder how the Chinese *tengu* is going to hurt the priest." It made the Japanese *tengu* feel good to think about what the Chinese *tengu* was going to do. The priest passed the tablet. The Japanese *tengu* said, "What is the Chinese *tengu* going to do?" He started to look for the old priest, but he had disappeared. Yokiyo Ritsushi passed the tablet. He had many students and followers with him. The Japanese *tengu* wondered why the Chinese *tengu* had disappeared. He started to look for him. Then the Japanese *tengu* found the Chinese *tengu* hiding with his rear end up and his face down over in the south gully. He went to him, and the Chinese *tengu* asked, "Who was that priest who passed by?" The Japanese *tengu* said:

"That was Yokiyo Ritsushi, a very powerful priest. He was on his way to pray in Kyoto. I thought you were going to hurt him. I'm disappointed you didn't do anything."

The Chinese *tengu* responded,

"When I saw that noble-looking priest I became happy that I would hurt him. I was going to jump in front of him, but when I looked up I saw a fire above the priest's palanquin. I became afraid to go near, otherwise I would be burned. So I let him pass."

After hearing the story the Japanese *tengu* laughed:

"You come from China which is far away and yet you let the priest pass. How did you get into this mess? Next time make sure you stop the person and hurt him."

The Chinese *tengu* said, "You are right—look at what I'm going to do next." He went back to the tablet and sat down. As before, the Japanese *tengu* went down into the gully and hid in the bushes. After a while, he heard voices approaching, so people were coming. It was Jinzen Sōjō from Iimuro. About nine hundred meters in front of Jinzen Sōjō's palanquin a boy with frizzled hair, carrying a pole, was clearing people out of the way and off the path. The Japanese *tengu* was watching and thinking. He said, "I wonder what the old priest will do."

The boy came to the old priest and started to hit him repeatedly, and chased him away. While running away the old priest held his head. He was unable to get closer to the palanquin. The Chinese *tengu* was beaten, and Jinzen Sōjō and his group passed on.

Afterwards, the Japanese *tengu* went to where the Chinese *tengu* was hiding and shamed him as he had done before. The Chinese *tengu* said:

"You are telling me really bad things. The boy's face told me I would be unable to get close to him. I thought he would break my head. So I ran away. Even though I could fly quickly from China to Japan, that boy looked stronger than I. That is why I went and hid. It wasn't necessary to fight."

The Japanese *tengu* listened to the explanation. He said:

"Let's do it again. Make sure you attack the next person. Since you came it would be embarrassing to return to China without accomplishing anything."

Again the Japanese *tengu* went to hide and watch. After a while he heard many voices and saw people coming up the mountain path. In front of them, a priest wearing a

red robe was clearing the path of people. A young priest followed him carrying a box with three priestly garments in it. Next came a priest riding in a palanquin. His name was Jiedai Sōjō, and he was from Yokawa. While the Japanese *tengu* watched, he was wondering whether the Chinese *tengu* would attack the priest. Twenty or thirty boys were walking next to and on both sides of the palanquin. The old priest disappeared. Again he was hiding.

One of the boys said, "There is a bad person hiding in the area and he's trying to do something bad—let's spread out and look for him." The boys started to walk on both sides of the path, vigorously swinging wooden staffs in front of them. The Japanese *tengu* said:

"So I went down into the gully and hid in the bushes. Then I heard the boys' voices coming from the southern gully."

One of the boys said, "There's an old priest hiding—he seems strange." Another boy said, "Catch him! Don't let him go!" The boys ran after and tried to attack the old priest. Then a bad thing happened: the *tengu* of China was caught. The Japanese *tengu* said:

"I became afraid. I put my head into the bushes and hid. Watching from my hiding place, I saw about ten boys drag the old priest over to the stele. They were hitting and kicking him. The old priest was screaming for help loudly, but no one would help him. A boy who was hitting the old priest said, 'Tell us who you are.' He responded, 'I am a *tengu* from China. I was here waiting and watching people pass by. The first person who came by was Yokiyo Ritsushi. I saw fire above his palanquin. What could I do? I ran away so I wouldn't be burned. Next the priest from Iimuro came. He used magic. He had a boy who carried an iron staff. Who could attack that kind of person? He used religious scripture and prayers. Because of that, he had no fear. I was too close to him and didn't hide myself well. That's why I was attacked and caught.' The boys said, 'He doesn't look like a person who has committed a serious crime; let's forgive him and let him go.' Then everyone stepped on his lower back and left. The old priest screamed in pain."

After the group had left the Japanese *tengu* left his hiding place in the gully and went to where the old priest was sitting. The Japanese *tengu* said, "How did it go?" The Chinese *tengu* responded:

"Stop talking that way. Don't say any more bad things. I came from far away. I expected your help. While I was here you didn't bother to teach me the correct way to do things. You let me attack the priests who were actually living gods. Finally, my back was stepped on and broken."

The Chinese *tengu* was now crying. The Japanese *tengu* said:

"You are right, but I thought a *tengu* from such a large country could defeat priests from a small one. I'm sorry your back was broken."

The Japanese *tengu* took the Chinese *tengu* to Unohara [in the Kitayama District of Kyoto] so that his back could be healed in the hot baths. He would then send him back to China. While the Chinese *tengu* was healing in the bath, a woodcutter from Kyoto was passing through Unohara. He noticed smoke coming from the bathhouse and decided he wanted to stop and take a bath. He put down his load of wood outside the bathhouse. Inside, he found two old priests taking a bath. One of them was lying low in the water to help his back. The Chinese *tengu* asked, "Who are you?" The woodcutter said:

"I've come from the mountains. I've been cutting wood. This bathhouse smells bad!"

Then the woodcutter's head began to hurt. He became afraid. He left without

taking a bath. Later the Japanese *tengu* changed and entered another man's body. He then told others the story of the Chinese *tengu*. The woodcutter heard the tale and realized that the date was the same as he remembered from Unohara. He told others about the two priests he met in Unohara. So this is a story which came directly from a Japanese *tengu* who had entered the body of an average person. This is where the story comes from.

This extraordinary tale appears in the twentieth book of the *Konjaku Monogatari-shū*, a section entirely devoted to tales of *tengu* goblins. Although the story forms the basis for the depiction in the Academy's handscroll, the names are changed in the painting. In the handscroll the Chinese *tengu* is called Zegaibō, and his Japanese counterpart Nichirabō. The story is also more elaborate. In the Kamakura period, the story was believed to have taken place in the year 966, in the reign of the Heian emperor Murakami.[5] As an evil *tengu*, Zegaibō aimed to lead the clergy of Japan astray from their devotion to Buddhism.

In Japan he meets with Nichirabō, grand *tengu* of Mount Atago; their meeting takes place at Sagarimatsu in Sakamoto near Mount Hiei, the headquarters of the Tendai sect of Buddhism. This is the first scene depicted in the Academy's handscroll. The two *tengu* are shown in a clearing, with their names clearly inscribed next to them: Zegaibō on the right and Nichirabō on the left. When asked where the most pious monks of Japan could be found, Nichirabō tells Zegaibō that the monks of the Enryaku-ji on Mount Hiei are "the most hateful." Zegaibō then disguises himself as an elderly priest and makes his way to Mount Hiei. In the painting, Zegaibō's three encounters with monks are compressed into two encounters.

There Zegaibō encounters the cleric Yokei Risshi (Yokiyo Ritsushi) as the latter, abbot of the Senko-in, descends the mountain with his entourage. In the Academy's scroll, however, this cleric is labeled "Ryōgen Daishi," actually the third priest Zegaibō encounters. The cleric is shown en route to the imperial palace in Kyoto. Yokei, realizing that the old monk was actually a *tengu*, intoned a sacred fire-spell, causing a flaming *cakra* wheel to descend from the sky over Zegaibō's head. The *tengu* is shown panicking and running away from the fiery wheel. Just beyond this, Nichirabō is shown hiding in a mountain ravine, as described in the original text.

After recovering from this ordeal, Zegaibō encounters the high cleric Iimuro Gon-no-Sōjō (Jinzen Sōjō in the original story, here labeled "Ichirin Daishi"), named Zenju, son of the aristocrat Fujiwara Morozane. Zegaibō sets out to attack Zenju, who is shown in a tall palanquin accompanied by a retinue of monks. Zenju, however, like Yokei Risshi, is a devotee of the Esoteric deity Fudō Myō-ō (see cat. no. 16), and he calls upon Fudō's young attendants Seitaka-dōji and Kongara-dōji for help. These two figures fly down from the sky and attack Zegaibō; the *tengu* desperately flees as Seitaka beats him with a rod and Kongara wields a *vajra* (thunderbolt). Zegaibō's disguise falls apart as he runs away.

Undeterred, Zegaibō finally encounters the priest Ryōgen, abbot of the Enryaku-ji on Mount Hiei and head of the Tendai sect. Entranced by the handsome young pages in Ryōgen's entourage, Zegaibō is discovered, tied to the ground, and mercilessly beaten by the priest's divine attendants. Having succumbed to this attack, Zegaibō is carried off on a stretcher in a long procession of *tengu*. These figures carry, among other things, a mallet, a huge *daikon* radish, a gourd tied to a bamboo stalk, a bow and arrow, and lotus

c

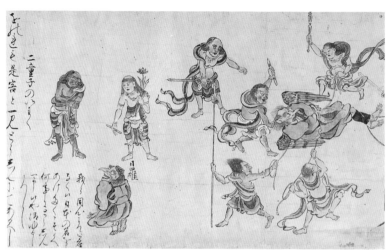

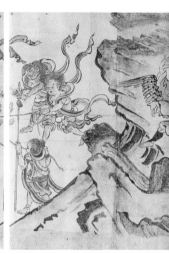

f

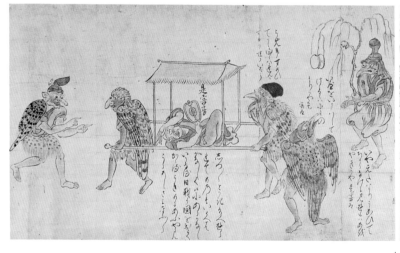

i

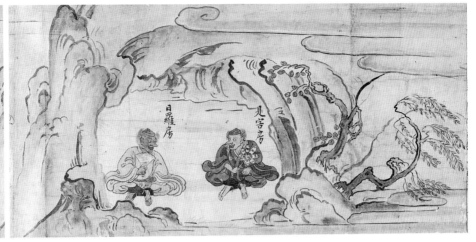

b a

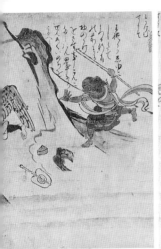
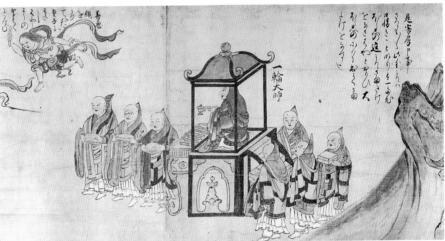

e d

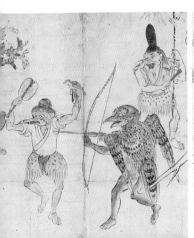
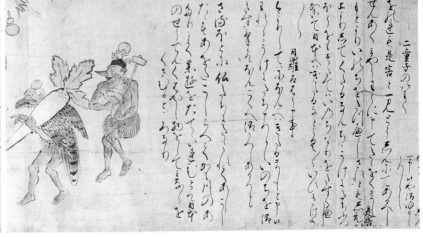

h g

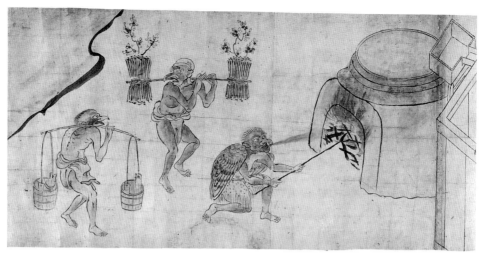

k

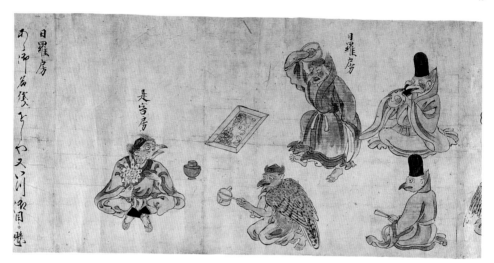

日羅房

れ〳〵御若後を
や又八川
御用に懸

是宮房

日羅房

m

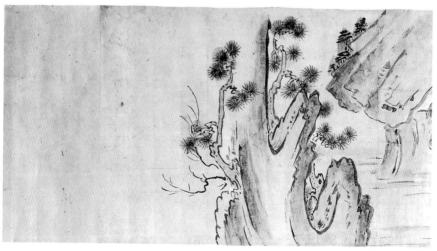

o

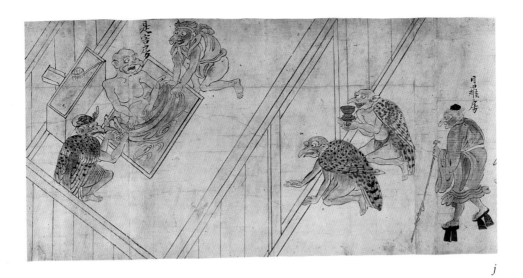

是害房　日羅房　開是害房

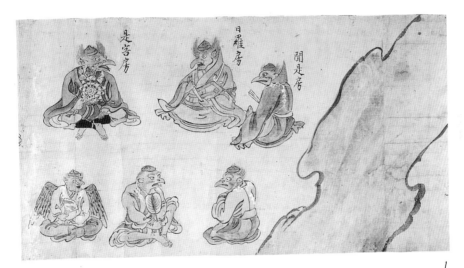

l

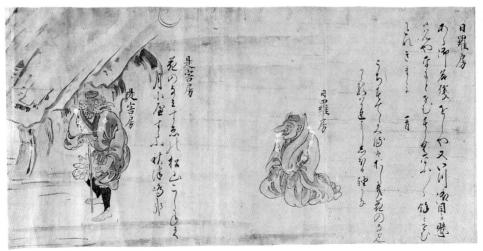

n

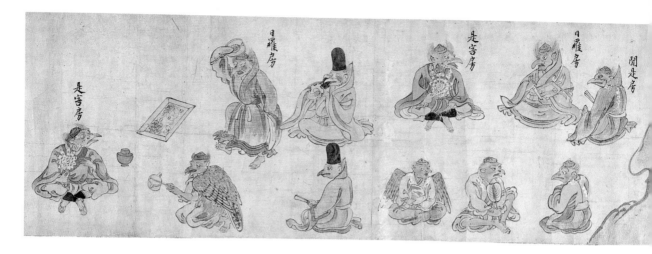

34a

flowers. The Japanese *tengu* then give Zegaibō a hot bath on the banks of the Kamo River in Kyoto. Zegaibō expresses his desire to stay in the bath a little longer, but he is admonished by Nichirabō, who cautions him to avoid excesses. In the handscroll the hot bath is depicted in some detail, with two *tengu* covering Zegaibō's private parts with a towel while another blows on the fire under a tank of water. Just beyond this is the Kamo River.

After seven days the *tengu's* recovery is complete. The contrite Zebaibō resolves to return to China, and he is given a farewell poetry party by Nichirabō, the *tengu* Monzebō and others. In this section of the painting the *tengu* are shown in the guise of Buddhist clerics, having apparently now been taught the superiority of Buddhism as a philosophy (fig. 34a). Zegaibō appears seated on the ground, enjoying a meal of sake and shellfish. In the last section of the painting, Zebaibō takes his leave of Nichirabō and returns to China.

Aside from being an entertaining depiction of a *tengu* story, this scroll is very likely an allegory in which the meaning of *tengu* as "a conceited monk" plays a key role. The eventual superiority of the righteous Tendai clergy over the nefarious Zegaibō may allude to ethical shortcomings within the Japanese Buddhist clergy. In this light the painting can be related to a series of handscrolls entitled *Tengu-zoshi*, which relate tales of corrupt and degenerate priests.[6]

Other versions of the Academy's painting survive in Japanese collections, the best known of which is a pair of handscrolls in the Manshu-in, Kyoto.[7] In the Manshu-in version, the first scroll includes the episodes from Zegaibō's arrival in Japan to his beating at the hands of Ryōgen's entourage, while the second scroll depicts Zegaibō's recovery and departure. This second scroll, which also includes sections of text, ends with three colophons, written in the same hand as the text on the painting. The first is dated 1308, but is probably copied from an earlier, lost original. The third colophon is dated 1354 and may indicate the actual date of the Manshu-in painting. From this documentation it appears that the subject of Zegaibō's visit to Japan first appeared as a handscroll in the Kamakura

period, only to be copied in several versions in the Nambokuchō and Muromachi periods.[8]

The style of the Manshu-in and Academy scrolls is derived from the classical *Yamato-e* manner of the thirteenth century, with freely painted figures and vigorously rendered landscape elements. The painting of the Academy scroll is, however, more refined in its details than that of the Manshu-in version. The figures in particular are rendered with greater variety, animation, and humor in the Academy scroll. Despite the bold and sketchy handling of the landscape elements, the brushwork, calligraphy, and overall condition of the Academy painting suggest a date in the late fourteenth century. This painting is the only known version of the "Tale of Zegaibō" outside Japan, a rarity that crosses the boundaries between traditional Buddhist teachings and popular folk beliefs. The subject is also significant as one of the few tales from the twelfth-century anthology *Konjaku Monogatari-shū* to have been interpreted artistically in the form of a narrative handscroll.

1 Alicia Matsunaga, *The Buddhist Theory of Assimilation: The Historical Development of the Honji-Suijaku Theory* (Rutland and Tokyo: Charles E. Tuttle, 1969), p. 257.

2 Ibid., p. 258.

3 On the *Konjaku Monogatari-shū*, see Marian Ury, *Tales of Times Now Past* (Berkeley: University of California Press, 1979), pp. 1–23; W. Michael Kelsey, *Konjaku Monogatari-shū* (Boston: Twayne Publishers, 1982); and W. Michael Kelsey, "*Konjaku Monogatari-shū*—Toward an Understanding of Its Literary Qualities," *Monumenta Nipponica*, 30 (1975), pp. 121–150.

4 I am indebted to Mr. Ron Tessler of Honolulu for the translation of this story. For the original text, see *Konjaku Monogatari-shū* (Tokyo: Iwanami Shoten, 1963), pp. 144–149.

5 The following synopsis is based on that in Jiro Umezu, "Tengu-zoshi and Zegaibō-e," *Nihon Emakimono Zenshu* n.s. 27 (1978), pp. 2–4, 13–14.

6 Umezu, "Tengu-zoshi," pp. 1–2.

7 Ibid., pls. 89-102; see also *Mount Hiei and the Art of Tendai Buddhism* (Tokyo: Tokyo National Museum, 1986), no. 105.

8 The different copies are discussed in ibid., p. 4; and in *Zaigai Nihon no Hihō*, vol. 2: *Emakimono* (Tokyo: Mainichi Shimbunsha, 1980), no. 11.

LITERATURE

Archives of the Chinese Art Society of America 9–12 (1955–1958), p. 85.

Richard Lane, "Ukiyo-e and Before," *Asia Scene* (August–September 1966), p. 43.

Junkichi Mayuyama, ed., *Japanese Art in the West* (Tokyo: Benrido, 1966), pl. 145.

Zaigai Nihon no Hihō, vol. 2: *Emakimono* (Tokyo: Mainichi Shimbunsha, 1980), no. 11.

PROVENANCE

Mayuyama and Company, Tokyo; Mrs. Philip E. Spalding and Mrs. Theodore A. Cooke, Honolulu.

ZEN IMAGES

35 Byaku-e Kannon (White-Robed Kannon)

Kanō Kōi (Kanō Sadanobu, c. 1569–1636)
Hanging scroll; ink on paper
89.5 x 26.8 cm
Gift of Aileen Miyo Ichijo, 1982 (5009.1)

The image of the white-robed Kannon (Sk. Avalokiteśvara), the bodhisattva of Compassion, was particularly popular in the Zen sect, and appears to have been introduced in Japan from China in the tenth century.[1] The white of the figure's robe symbolizes the pure, enlightened mind. Kāno Kōi's painting depicts the bodhisattva as an androgynous figure dressed in a white robe, seated on a rock next to the ocean. This setting recalls Kannon's traditional home on Mount Potalaka (Fudaraku) in the Eastern Ocean. The deity has a benign expression and wears a single piece of jewelry on its chest.

The scroll is executed in a style of ink painting derived from Zen painting of the Muromachi period. In this style the figure is painted in quick, loose lines of pale ink, with the details of the face, hair, and jewelry added in darker, more precise lines. In contrast to the figure, the rocks are painted in bold strokes of ink which blend into loosely handled ink washes. Rough dots of ink in varying tonalities are added among the rocks to suggest moss. The lines depicting waves at the base of the rocks are very pale and fluid, and echo the lines of the figure's robe. The painting bears a signature written in standard script at the lower right, reading "Hōkyō Kōi Hitsu." This is followed by a rectangular seal of the artist.

[1] Jan Fontein and Money L. Hickman, *Zen Painting and Calligraphy* (Boston: Museum of Fine Arts, 1970, p. 47); for further discussion see John Rosenfield and Elizabeth ten Grotenhuis, *Journey of the Three Jewels: Japanese Buddhist Paintings from Western Collections* (New York: Asia Society, 1979), no. 52.

LITERATURE
Howard A. Link and Sanna Saks Deutsch, *The Feminine Image: Women of Japan* (Honolulu: Honolulu Academy of Arts, 1985), no. 13.

PROVENANCE
Aileen Miyo Ichiyo, Honolulu.

36

The Three Vinegar Tasters (The Three Teachings) 36

Kanō Isen'in (Kanō Naganobu, 1775–1828)
Hanging scroll; ink and light colors on paper
44.5 x 56.5 cm
Gift of George H. Kerr, 1958 (6156.1)

This hanging scroll depicts a favorite theme among Zen artists in both China and Japan. The three figures in the painting represent the Buddha Śākyamuni, Confucius, and the Daoist sage Laozi. They are gathered around a large vat of vinegar. Each dips a finger into the vinegar, tastes it, and puckers up his mouth because of the sour taste. This illustrates the Zen doctrine to the effect that all three teachings are but different means to the same end.[1] The fact that each of the figures reacts to vinegar in the same way implies that Buddhism, Confucianism, and Daoism were all of equal significance.

This subject first appeared in Chinese painting of the Song Dynasty. The theme appears to have been even more popular during the Muromachi period in Japan; the earliest known depiction of the Three Vinegar Tasters is by the fifteenth-century painter Reisei.[2] In Kanō Isen'in's painting, the three figures are tightly grouped within a circle, the lower half of which is lightly sketched on the paper. The painting is executed primarily in ink, with red pigment added in the Buddha's robe and pale red added in the faces and hands. The brushwork is sketchy and spontaneous, befitting a painting in the Zen tradition. The scroll is signed at the lower left, "Isen Hōgen Hitsu." "Hōgen" was a Buddhist title granted to the painter by the emperor and which he used between 1802 and 1816. The square seal following the signature reads "Naganobu," the artist's alternate name.

1 For an excellent discussion of this theme, see John Rosenfield, "The Unity of the Three Creeds," in John W. Hall and Toyoda Takeshi, eds., *Japan in the Muromachi Age* (Berkeley: University of California Press, 1977), pp. 205–225.
2 Ibid., fig. 3.

PREVIOUSLY UNPUBLISHED

PROVENANCE
George M. Kerr, Honolulu.

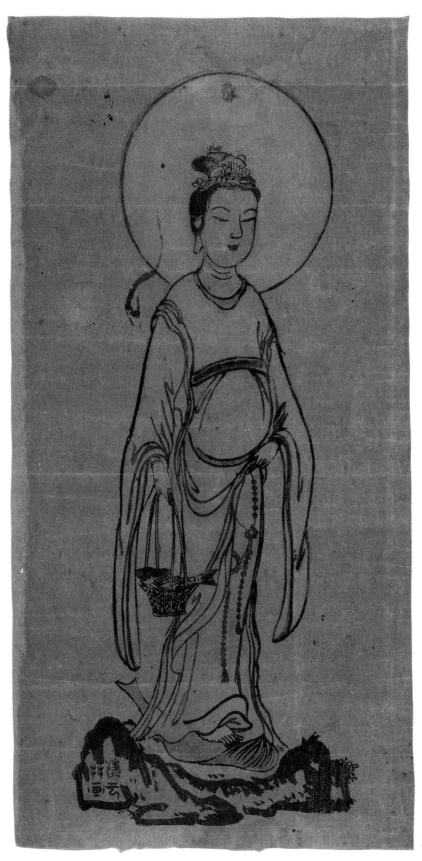

Lingzhao as the Bodhisattva Kannon 37

Muromachi period, c. sixteenth century
Hand-colored woodblock print; ink and colors on paper
25.6 x 13.4 cm
Purchase, 1954 (13,433)

This print depicts the Chinese figure Lingzhao, daughter of the Buddhist Pang Yun. Pang Yun, who lived in the Late Tang Dynasty (ninth century), was a favorite figure in Zen mythology, for he was an enlightened layman.[1] His actions and outrageous sayings were recorded and transmitted at the end of the Tang Dynasty. Pang Yun's daughter, Lingzhao, appears often in the anecdotes related to Pang, and later tradition conceived of her as a manifestation of Kannon, the bodhisattva of Compassion. The standard depiction of Lingzhao with a basket refers to the fact that both she and her father sold bamboo baskets to support themselves:

> During the Yuanhe era [806–820] the Layman [Pang] traveled northward to Xianghan, stopping here and there. His daughter Linghzao sold bamboo baskets for their morning and evening meals. The Layman had these verses, which say:
>> When the mind's as is, circumstances also are as is;
>> There's no real and also no unreal.
>> Giving no heed to existence,
>> And holding not to non-existence—
>> You're neither saint nor sage, just
>> An ordinary man who has settled his affairs[2]

Images of Lingzhao holding a basket appear often in Zen painting in China and Japan; numerous examples survive from the Yuan Dynasty and the Muromachi period. A Chinese Yuan Dynasty hanging scroll in the Yale University Art Gallery (fig. 37a) bears the following inscription by the monk Yu'an Zhiji:[3]

> In antiquity Lingzhao was enlightened to the hidden machinations [of reality],
> How did [this] dark woman ascend [to be] a divine consort?
> She only hid her female nature, but never let it go,
> Respecting her teacher and honoring study, by nature she knew her faults.

Despite what appears to be a chauvinistic stance in this poem, the author acknowledges that Lingzhao was a fully enlightened woman. "Knowing one's faults" was a virtue in traditional Chinese society.

In the Academy's woodblock print Lingzhao is shown standing on a lotus petal which rests on a rock. Behind her head is a large halo, and she wears orange-colored robes. A small, clearly spurious, inscription on the rock reads: "Respectfully painted by Pang Yun."

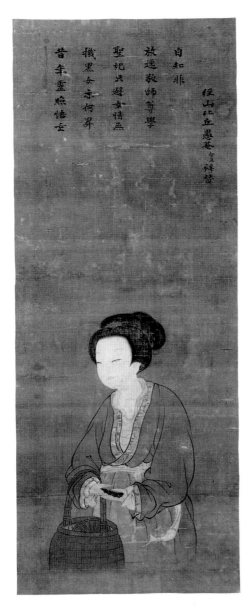

Fig. 37a.
Portrait of Lingzhao
Inscribed by Yu'an Zhiji
China, Yuan dynasty, fourteenth century
Hanging scroll; ink and colors on silk
Yale University Art Gallery, gift of Mr. and
Mrs. Fred Olsen, Mr. and Mrs. Laurens Hammond,
and Mr. and Mrs. Knight Woolley, B.A. 1917

1 Jan Fontein and Money L. Hickman, *Zen Painting and Calligraphy* (Boston: Museum of Fine Arts, 1970), pp. 38, 44–45.

2 Ruth Fuller Sasaki et al., trans., *The Recorded Sayings of Layman Pang: A Ninth Century Zen Classic* (New York and Tokyo: Weatherhill, 1971), p. 74.

3 Published in Mary Gardner Neill, *The Communion of Scholars: Chinese Art at Yale* (New York: China Institute, 1982), no. 50. The poem on this painting is written from left to right in a style often seen in Zen inscriptions.

PREVIOUSLY UNPUBLISHED

PROVENANCE
Raymond E. Lewis, San Francisco.

A PORTRAIT AND TWO PARODIES

Portrait of Prince Son'en

38

Nambokuchō period, c. 1350
Hanging scroll; ink, colors, and gold on silk
93 x 51.9 cm
Gift of Mrs. Carter Galt, 1959 (2600.1)

The imperial prince Son'en (1298–1356) was a son of the emperor Fushimi (1265–1317) and one of the most influential calligraphers in Japanese history. Two of his brothers, Go-Fushimi (r. 1299–1301) and Hanazono (r. 1308–1318), became emperors. The prince received the Buddhist name Son'en in 1311, and became abbot of the Shoren-in, an imperially sponsored temple in Kyoto, the same year. He was later appointed to the post of abbot of the Tendai sect headquarters of Enryaku-ji on Mount Hiei.[1]

In the Academy's sensitive portrait, Son'en is depicted as a high-ranking Tendai cleric, seated in a formal pose and wearing a gold-embroidered robe. He holds a *vajra* (thunderbolt) in his right hand. The portrait follows a characteristic mode of depicting aristocrats, military leaders, and even Shintō deities, established in the Heian period. The prince has the same domed cranium and heavily lidded eyes as his brother Hanazono, as shown in a portrait of the latter in the Chōfuku-ji, Kyoto, by the artist Gōshin, dated 1138.[2]

Son'en is renowned in the history of Japanese calligraphy as the founder of the Shoren-in school of calligraphy. This school stressed the study and transmission of classical models, both Chinese and Japanese. Son'en himself was the author of an influential treatise on the practice of calligraphy, the *Jubokushō*, completed in 1352 and presented to Emperor Go-Kogon of the Northern Court.[3] As Gary DeCoker has pointed out, this treatise incorporates ethical and religious (specifically Buddhist) elements in its rhetoric. Son'en stresses the spiritual cultivation of the individual calligrapher and writes that "the shape of a character is, in a manner of speaking, a person's appearance, and the vigor of the brush is the expression of the workings of his heart. Ultimately, the study of any Way is a labor of the heart. If you base your study on the heart of the classic calligraphers and study the Way thoroughly, you will naturally master its mysteries."[4]

Serious practice and the transmission of the "secrets" of calligraphy through oral discourse provide a link between the Shoren-in lineage of calligraphy as established by Son'en and the discipline of Esoteric Buddhism founded by Kōbō Daishi (ninth century), himself a calligrapher much admired by Son'en.

1 Gary DeCoker, "Secret Teachings in Medieval Calligraphy," *Monumenta Nipponica* 43 (2) (Summer 1988), p. 203.

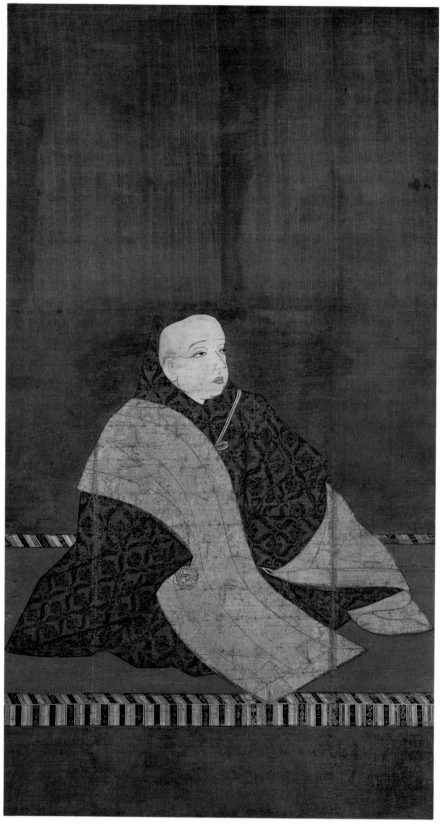

2 Sherman E. Lee, *Reflections of Reality in Japanese Art* (Cleveland: Cleveland Museum of Art, 1983), no. 57.

3 Translated in DeCoker, "Secret Teachings."

4 Ibid, p. 213.

LITERATURE

Mori Toru, *Kamakura Jidai no Shozo-ga* (Tokyo, 1971), pp. 143–159.

Shimada Shujiro, ed., *Zaigai Nihon no Shihō*, vol. 2 (Tokyo, 1980), pl. 114.

Komatsu Shigemi, *Nihon Shoryu Zenshu*, A, p. 306.

Yoshiaki Shimizu and John Rosenfield, *Masters of Japanese Calligraphy, 8th–19th Century* (New York: Asia Society, 1984), pl. 25.

Gary DeCoker, "Secret Teachings in Medieval Calligraphy," *Monumenta Nipponica* 43 (2) (Summer 1988), p. 204.

Honolulu Academy of Arts: Selected Works (Honolulu: Honolulu Academy of Arts, 1990), p. 73.

PROVENANCE

Mrs. Carter Galt, Honolulu.

Copy of the Kōzan-Ji Chōjū Giga (Frolicking Animals) Scroll

39

Kanō Tan'yū (1602–1674)
Two sections of a handscroll; ink on paper
30.5 x 812.1 cm; 30.5 x 155.2 cm
Gifts of the Robert Allerton Fund, 1954 (1951.1) and Jiro Yamanaka, 1956
(2212.1)

This painting consists of two sections of a handscroll originally mounted as a single scroll. The composition is a copy of a famous Heian-period painting in the Kōzan-ji, Kyoto, entitled Chōjū Giga.[1] The Kōzan-ji scroll depicts hares, monkeys, and frogs in the guise of human beings. Throughout much of the painting the animals are shown frolicking and playing; toward the end of the scroll the animals are depicted as pilgrims attending a Buddhist ceremony in an outdoor setting. The original Heian painting has attained great fame as a satirical commentary on human activities executed in a Buddhist context.

The Academy's handscroll was painted in the seventeenth century as a copy of the Kōzan-ji composition. Before the scroll left Japan in the 1950s, it bore the signature of the great master Kanō Tan'yū (1602–1674); the scroll was published with its original signature in 1941 in the journal *Bijitsu Kenkyū*.[2] The original signature, now removed from the scroll, read "This one scroll is the brush of Tosa Sōgen; copied by Tan'yū." The Kōzan-ji painting, however, is attributed to Toba Sōjō (1053–1140). This artist, a Buddhist monk, is also known by the name Kakuyū. On the other hand, nothing is known about

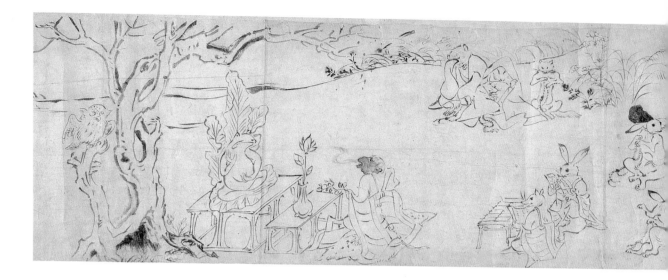

39a

Tosa Shōgen. Kanō Tan'yū is known to have painted many copies of this type after handscrolls of the Heian and Kamakura periods. Many of his sketches exist today in the Kyoto National Museum.

The painting in the Academy's collection is a copy of the second half of the Kōzan-ji original. Painted in fluid, deft brushwork, it opens with a depiction of a wrestling match between a frog and a hare. The animals and the landscape elements in the background are both painted with great vitality and are very faithful to the original. The next section illustrates a belching contest between a frog and a hare, with an audience of three frogs laughing hysterically. Beyond this is a lengthy section that survives only in Tan'yū's copy, having disappeared from the original scroll. This section depicts monkeys and hares engaged in a variety of games and sporting events. First a hare and monkey are shown playing a game of *go*. The hare appears to be taking a long time to make up its mind, and the other hares and monkeys watching the game appear to have dozed off in boredom. Beyond this a monkey and a frog are engaged in a tug of war, with a long cloth wrapped around their necks. At the end of this section hares and monkeys are both engaged in a high jump, using bamboo poles as the obstacle.

As a commentary on Buddhism, the next section is of great interest. Here we see monkeys, hares, frogs, and foxes taking part in an elaborate Buddhist ritual. The focal point of the ceremony takes place under a tree, where an altar with a frog Buddha has been set up on a platform (fig. 39a). The officiating priest is a monkey who emits hot vapors from his mouth as he chants. Behind him, at a low table, a hare and a fox, dressed as Buddhist monks, chant *sūtras*. Behind these two figures frogs, hares, foxes, and monkeys attend the ceremony. Some of the figures have rosaries in their paws, and one, a monkey, props up his head as he sleeps. In a parody of a Buddhist pilgrim, a frog with a lotus leaf for a hat brings up the rear. This section of the scroll has long been interpreted as a satirical commentary on the Buddhist clergy of the Late Heian period. It is particularly significant that such an irreverent sketch is believed to have been created by a Buddhist monk.

The Academy's handscroll ends with a section that no longer survives in the original Kōzan-ji painting. Here we see hare and frog aristocrats bringing offerings to the Buddhist ceremony, while a monkey cleric observes their actions. In the detail a hare presents a sacred deer to a monkey; beyond this a frog brings a large boar as an offering. As the scroll progresses, a hare is shown chasing a monkey as he prepares to beat it with a long reed. Farther on, a group of hares and frogs gather around a single frog who appears to have collapsed in exhaustion. At the end of this section, four frogs are shown dancing wildly as one beats on a drum; they are being observed closely by a frog and a cat dressed as Heian aristocrats, and by a group of foxes and hares with their children. The painting ends with the section that originally bore Kanō Tan'yū's signature. This begins with a scene of frogs dancing, followed by a procession of frogs, monkeys, and a hare. At the left end of this procession five frogs gesticulate wildly as they run away from a large venomous snake which appears from behind a rock at the end of the scroll.

The Chōjū Giga handscroll in the Kōzan-ji collection apparently held great interest for Kanō Tan'yū; another copy of the same scroll survives among the Tan'yū sketches preserved in the Kyoto National Museum.[3] The Kyoto sketch is on a smaller scale and is even looser in technique.

1 *Treasures of Kōzan-ji Temple* (Kyoto: Kyoto National Museum, 1981), pl. 1.
2 Tanaka Kisaku, "On a Newly Found Copy of the Kōzan-ji Cartoon, Handed Down in the Sumiyoshi Family," *Bijitsu Kenkyu* 116 (August 1941), pl. 10.
3 *Sketches by Tan'yū,* 2 vols. (Kyoto: Kyoto National Museum, 1976), vol. 1, pls. 61–64.

LITERATURE
Tanaka Kisaku, "On a Newly Found Copy of the Kōzan-ji Cartoon, Handed Down in the Sumiyoshi Family," *Bijitsu Kenkyū* 116 (August 1941), pl. 10.
Miya Tsugio, ed., *Nihon Emakimono Zenshu* n.s. 4 (1976), pls. 95-104.

PROVENANCE
Nagao Collection; Yamanaka and Company, Kyoto; Robert Allerton, Kauai.

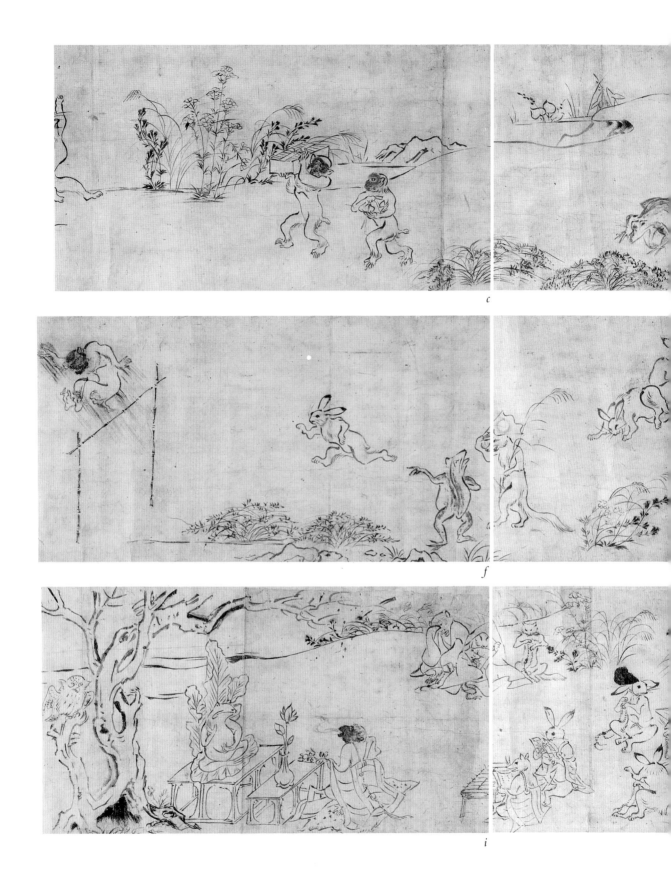

c

f

i

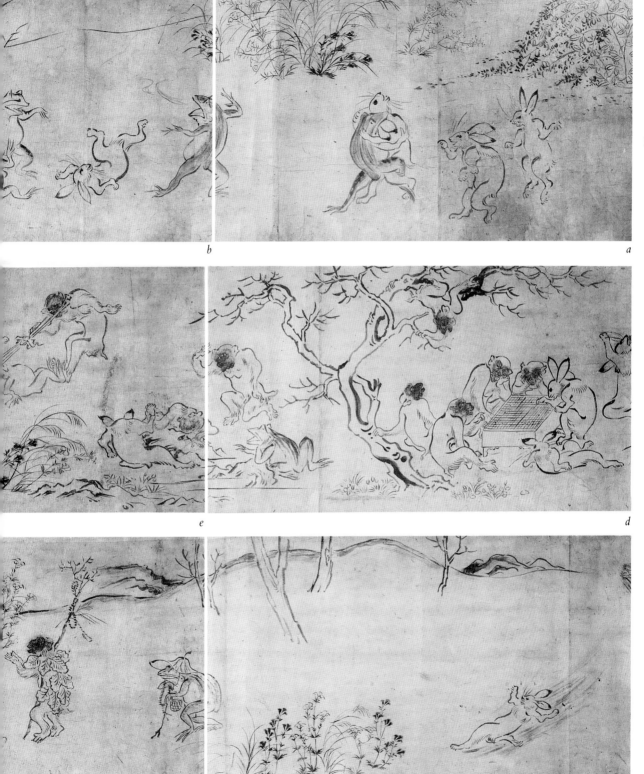

b

a

e

d

h

g

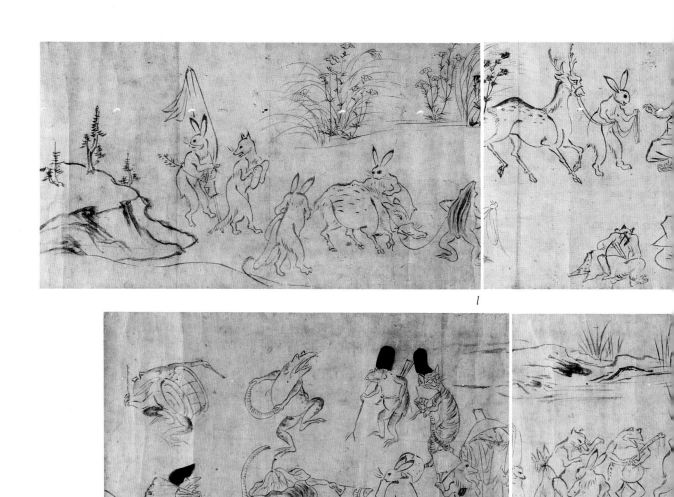

1

o

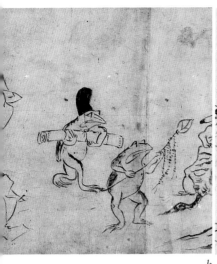

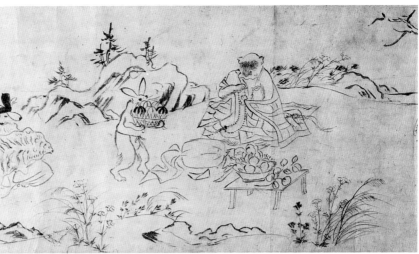

k

j

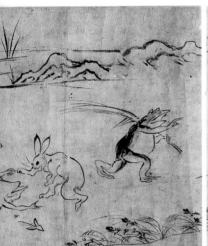

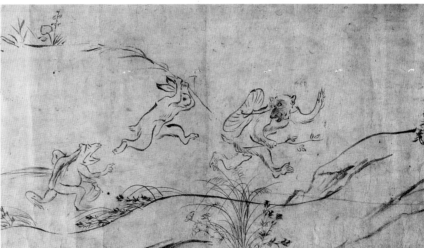

n

m

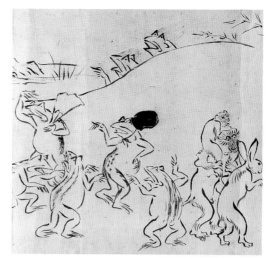

b

d

a

c

40 Nehan Mitate (Parody of the Death of the Buddha)

Shibata Zeshin (1807–1891)
Hanging scroll; ink and colors on paper
137.5 x 69.2 cm
Gift of James Edward and Mary Louise O'Brien, 1977 (4598.1)

Like the Kanō Tan'yū copy of the famed *Chōjū Giga* handscroll (cat. no. 39), this painting by Shibata Zeshin is a parody of Buddhist beliefs. The painting depicts the *Parinirvāṇa*, or the Buddha Śākyamuni's final entry into *Nirvāṇa*. The subject was one of the central scenes in the Buddha's life and was often depicted in both paintings and prints (cat. nos. 5, 6). In this scroll, the Buddha Śākyamuni is depicted in the guise of a large *daikon* radish laid out on a stone couch. The mourners, normally represented by monks, deities, and animals, are here shown in the guise of fruits and vegetables which crowd around the couch. Among the many vegetables are pumpkins, mushrooms, and an eggplant. The *daikon* radish was often associated with the frugality of monastic life, and is thus an appropriate symbol for the Buddha.[1] The image itself, however, is ridiculous and the satiric intent obvious. The painting is executed largely in color, with loose brushwork and rapidly applied washes. The theme of the "vegetable *Parinirvāṇa*" appears to have been common in the late Edo period; it was also painted by the eighteenth century artist Itō Jakuchū.[2]

1 Pratapaditya Pal et al., *Light of Asia* (Los Angeles: Los Angeles County Museum of Art, 1984), no. 66.
2 Tsuji Nobuo, *Life and Works of Itō Jakuchū* (Tokyo: Bijutsu Shuppan-sha, 1980), pl. 81.

LITERATURE
Howard A. Link, *The Art of Shibata Zeshin* (Honolulu: Honolulu Academy of Arts, 1979), pl. 5.
Pratapaditya Pal et al., *Light of Asia* (Los Angeles: Los Angeles County Museum of Art, 1984), no. 66.

PROVENANCE
Mr. and Mrs. James E. O'Brien, San Francisco.

Chronology

		
A.D. 552		
	Asuka	
646		
	Nara	EARLY NARA 646–710
		LATE NARA 710–794
794		
	Heian	EARLY HEIAN 794–897
		LATE HEIAN 897–1185
1185		
	Kamakura	
1336		
1392	*Nambokuchō*	
	Muromachi	
1568		
1615	*Momoyama*	
	Edo	
1868		
1912	*Meiji*	

Glossary

Aizen Myō-ō　愛染明王
Ama-no-iwa-tō　天岩洞
Amaterasu-ōmikami　天照大神
Ame-no-ko-yane-no-mikoto　天兒屋命
Amida　阿彌陀
Amida-kyō　阿彌陀經
Aoki　青木
Ashita　阿氏多
Ashuku　阿閦
Asuka　飛鳥
Atago　愛宕
Atō　阿刀

Bajarahotara　伐闍羅弗多羅
bakufu　幕府
Banabashi　伐那婆斯
Batsudara　跋陀羅
Beijing　北京
bijin　美人
Binzuru batsuradaja　賓頭盧跋羅馱闍
Bishamon-ten　毘沙門天
biwa　琵琶
Bonten　梵天
Budong mingwang　不動明王
Bussetsu-jūichimen-Kanzeon-jinju-kyō　佛說十一面觀世音神咒經
Butsugen　佛眼
Butsumyō-e　佛名會
Butsumyō-kyō　佛名經
Byaku-e Kannon　白衣觀音
Byōbugaura　屏風ケ浦
Byōdō-ō　平等王
Byōdō Shinō-in　平等心王院

Caishan　蔡山
Chan　禪
Chang'an　長安
Chang E　嫦娥

chiken-in　智拳印

Chira Yōjū　智羅永壽

Chiten　地天

Chōfuku-ji　長福寺

Chōjū Giga　鳥獸戲画

Chōshō　長承

Chūdahantaka　注茶半託迦

Chūson-ji　中尊寺

Da a luohan Nandimiduoluo suo shuo fazhu ji　大阿羅漢難提密多羅所說法住記

daikon　大根

Dainichi Nyorai　大日如來

Dainichi-kyō　大日經

Daizhou　代州

Dakura　諸矩羅

Daotai　道泰

Daruma　達磨

Dicang　地藏

Dōgen　道元

Dōshō　道昌

Dōyu　道雄

Dunhuang　敦煌

Edo　江戶

Emma-ō　閻魔王

Emma-ten　閻魔天

Endō Moritō　遠藤盛遠

Ennin　圓仁

En-no-Gyōja　役行者

Enryaku-ji　延曆寺

Enyū Nembutsu　円融念佛

Fang Zhu　房翥

Faxian　法顯

Fazhuji　法住記

Foshuo shiyimian Guanshiyin shenzhou jing　佛說十一面觀世音神咒經

Fudaraku　補陀羅

fude-maki　筆卷

Fudo Myō-ō　不動明王

Fugen　普賢

Fujiwara Morozane　藤原師實

Fujiwara no Fuhito　藤原不比等

Fujiwara no Hidehara　藤原秀衡

Fukukenjaku-jimpen-shingon-kyō　不空羂索變真言經

Fushimi　伏見

fusuma 襖
futai 風帯

gampi 雁皮
Ganken shōnin 嚴覧上人
Gaten 月天
Gen'in 源仁
Genkaku 源覺
Genshin 源信
Gi'ō 義應
Gi'ō shi shō 義應之章
Gion 祇園
Gishin 義真
go 碁
Godōtenrin-ō 五道轉輪王
gofun 胡粉
Go-Fushimi 後伏見
Gokan-ō 五宮王
Go-Kōgon 後光嚴
Gonkyō 權教
Gōshin 豪信
Go-Shirakawa 後白河
Guanjingsu 觀經疏
Guanxiu 貫休
Guo Xi 郭熙
Gyokuyō 玉葉
gyōsho 行書

Han 漢
Hanazono 花園
Handaka 半諾迦
Hanju-sammai-kyō 般舟三昧經
Harima 播磨
hassō 八宗
Hayashi 林
Hebei 河北
Heian 平安
Henan 河南
Henjōkō-in 遍照光院
Hensei-ō 變成王
hensō 變相
Hiei-zan 比叡山
hiragana 平仮
Hiraizumi 平泉
Hiroshima 広島

Hisamatsu　久松
Hōki　寶亀
Hōkongō-in　法金剛院
Hōkyō Kōi　法橋興以
Hōnen shōnin　法然上人
Hōnen shōnin eden　法然上人絵伝
Hongū　本宮
honji　本地
Honshū　本州
Hōshō Gongen　寶勝權現
Hossō　法相
Hua ji　畫繼
Huiguo　慧果
hyōshi　襟紙

Ichiji Kinrin　一字金輪
Ichiyō Kannon　一葉觀音
Iimuro　飯室
Iimuro Gon-no-sōjō　飯室權僧正
Inkatsuda　因揭陀
Isen Hōgen hitsu　伊川法眼筆
Ishana-ten　伊舍那天
ishizuri-e　石摺絵
Itabashi Sadatoki　板橋定時
Itō Jakuchū　伊藤若冲
Iwate　岩手
Izumi　和泉

Jiedai Sōjō　慈惠大僧正
Jimmu　神武
Jimyō-in　持明院
Jin　金
Jingo-ji　神護寺
Jin'ō-ji　神於寺
Jin'ō-ji engi emaki　神於寺縁起絵卷
jinushi myōjin　地主明神
Jinzen Sōjō　深禪僧正
Jishoki　時処軌
Jitsukyō　實教
Jizō　地藏
Jizō-bosatsu-hon-gan-kyō　地藏菩薩本願經
Jōdo　浄土
Jojo　如如
Jokei　貞慶
Jōnan-ji　地南寺

Jōruri　浄瑠璃

Josetsu　如拙

Jubaka　戌博迦

Jubokushō　入木抄

Jūichimen Kannon　十一面觀音

Jūji　十地

Jūni-bunkyō　十二分經

Jūni-ten　十二天

Jū-ō-kyō　十王經

Jūroku zenjin　十六善神

Jūsambutsu mandara　十三佛曼荼

Kadakka Batsuridaja　迦諾迦跋釐馱

Kadakkabassa　迦諾迦伐蹉

Kaei　嘉永

Kagawa　香川

Kakogawa　加古川

Kakugen　覺嚴

Kakuyū　覺猷

Kamakura　鎌倉

kami　神

Kammūryō-ji　觀無量寺

Kammūryōju-kyō　觀無量壽經

Kamo　賀茂

Kannon　觀音

Kannon-kyō　觀音經

Kanō Isen'in　狩野伊川院

Kanō Kōi　狩野興以

Kanō Tan'yū　狩野探幽

Kansei shōnin　觀西上人

Kanzeon　觀世音

Ka'ō　可翁

Karika　迦哩迦

Kasuga　春日

Kasuga gongen genki-e　春日權現驗記繪

Kasuga Myōjin　春日明神

Kasuga Naishōzū Motomitsu　春日內匠頭基光

kebutsu　化佛

Kegon　華嚴

Kengyō　顯教

Kennin-ji　建仁寺

kesa　袈裟

Ki-dera　木寺

Kii　紀伊

kirikane　切金

Kita Shirakawa　北白川

Kitayama　北山

kō　講

kōan　公案

Kōbō Daishi　弘法大師

Kōbō Daishi gyōjō emaki　弘法大師行狀絵卷

Kōbō Daishi gyōjō yo shu　弘法大師行狀要集

Kōfuku-ji　興福寺

Kojiki　古事記

Kokūzō　虛空藏

koma-inu　狛犬

Kongara-dōji　金迦羅童子

Kongō zuishin bosatsu　金剛隨心菩薩

Kongōbū-ji　金剛峯寺

Kongōkai　金剛界

Kōnin (emperor)　光仁

Kōnin shōnin　光忍上人

Konjaku monogatari-shū　今昔物語集

Konshi-kinji-kyō　紺紙金字經

Kōryū-ji　廣隆寺

Kōshō-ji　興正寺

koto　琴箏

Kōya-san　高野山

Kōzan-ji　高山寺

Kujō Kanezane　九條兼實

Kūkai　空海

Kumano　熊野

Kurama-dera　鞍馬寺

Kyōōgokoku-ji　教王護国寺

Kyoto　京都

Li Cheng　李成

Li Gonglin　李公麟

Liang　梁

Liang Kai　梁楷

Lingzhao　靈照

Liu Songnian　劉松年

Lu Lengjia　盧稜伽

luohan　羅漢

magatama　勾玉

Manshu-in　曼殊院

mappō　末法

Marishi-ten　摩利支天

Michi-no-omi-no-mikoto　道臣命

mikaeshi　見返
Mikasa　三笠
Mikkyō　密教
Minchō　明兆
Miroku　彌勒
Missei sō　密正宗
mitate　見立
Mohe sengzhi lü　摩訶僧祇律
Mongaku shōnin　文覺上人
Monju　文殊
Monzebō　聞是房
moriage　盛上
Mudō-ji　無動寺
Muqi　牧谿
Murakami　村上
Muromachi　室町
Muro-no-tomari　室泊
Muryōju-kyō　無量壽經
Musashi　武藏
Myō-ō shōnin　明應上人

Nachi　那智
Naganobu　榮信
Nagao　長尾
Nagasaina　那伽犀那
Nambokuchō　南北朝
namu　南無
Nara　奈良
Nehan　涅般
Nembutsu go ro　念佛吾廬
Nenjū gyōji　年中行事
Nichirabō　日羅房
Nihon Dai-ichi　日本第一
Nijūgo-bosatsu-wasan　二十五菩薩和讃
nin-in　壬寅
Ninji　仁治
Ninnō-gokoku-hannyo-haramitakyō-dōjō-nenjugiki　仁王護国般若波羅密多經道場念誦儀軌
Niō　仁王
Nishimura Shigenaga　西村重長
Niten　日天
Niu Myōjin　丹生明神
Nyoin　女院
Nyoirin Darani-kyō　如意輪陀羅尼經
Nyoirin Kannon　如意輪觀音
Nyoraidō　如來藏

Ōhara　大原
Ōjōyōshū　往生要集
Ōsaka　大阪
Ōtake　大嶽
Ōtomo　大伴

Pang Yun　龐蘊

Qi　齊

Ragora　羅怙羅
raigō　來迎
rakan　羅漢
rokudō　六道
Ru dacheng lun　入大乘論
Ryōgen　慈惠
Ryōnin shōnin　良忍上人
Ryōzen　良全
Ryūjo Jōdobun　龍舒淨土文

Sadanobu　定信
Saeki　佐伯
Saimyō-ji　西明寺
Sakamoto　坂本
samurai　侍
Sanko-sanzen-butsumyo-kyō　三切三千佛名經
Sanron　三論
Sanuki　讚歧
Sefuku　雪復
Seiryōden　清涼殿
Seiryō-san　清涼山
Seitaka-dōji　制多迦童子
semui-in　施無畏印
Senchaku-hongan-nembutsu-shū　撰擇本願念佛集
Shaka　釋迦
shakujō　錫杖
Shandao　善導
Shaolin　少林
Shibata Zeshin　紫田是真
Shikoku　四国
Shindan　震旦
shingai　辛亥
Shingen　心原
Shingon　真言

Shingū　新宮
Shinkō-ō　泰廣王
Shintō　神道
Shōgun　將軍
Shōjō　小乗
Shoka　正嘉
Shokō-ō　初江王
Shōmu　聖武
Shōren-in　青蓮院
Shōtoku　聖德
Shōwa　正和
Shūbun　周文
Shugendō　修驗道
shuheishimbō　主兵神
shuzōshimbō　主藏神
Sohinda　蘇頻陀
Sonei shōnin　尊永上人
Son'en　尊円
Song (dynasty)　宋
Song (Mount)　嵩
Sōtei-ō　宋帝王
Sōtō　曹洞
Sugiura　杉浦
Sui　隋
suijaku　垂迹
Suiten　水天
Sumiyoshi Hironao　住吉廣尚
Sumiyoshi Hirotsura　住吉弘貫
Sumiyoshi Hiroyuki　住吉廣行
Susa-no-o　須佐之男
Suzan　蘇山
Suzuki shoshi　鈴木荘司

Tado　多度
Tai ji　太極
Taima Mandara　當麻曼荼
Taima-dera　當麻寺
Taishaku-ten　帝釋天
Taizan-ō　太山王
Taizōkai　胎藏界
Takama-ga-hara　高天原
Takamimusubi-no-kami　高皇産靈神
Takasago　高砂
Takuma Shoga　宅磨勝賀

tan　丹

Tang　唐

tatami　畳

Tendai　天台

tengu　天狗

Tengu-zōshi　天狗草紙

Tenjiku　天竺

tianhu　天狐

Toba　鳥羽

Toba Sōjō　鳥羽僧正

Tōgaku　等覺

Tō-ji　東寺

Tokugawa　德川

torii　鳥居

Tori-ten　忉利天

Tosa　土佐

Tosa Shōgen　土佐時監

Toshi-ō　都市王

Tsurao　貫雄

Ue Gukei　右惠愚谿

Ukiyo-e　浮世絵

Unohara　鵜原

Wakayama　和歌山

Wu Daozi　吳道子

Xiangtang shan　響堂山

Xiwangmu　西王母

Xuanzang　玄奘

yaki-e　燒絵

Yakushi　藥師

Yakushi-kyō　藥師經

yamabushi　山伏

Yamato-e　大和絵

Yan Hui　顏輝

yang　陽

yin　陰

Yokei Risshi　餘慶律師

Yokiyo Ritsushi　余慶律師

Yokohagi no Ōtodo　横佩大臣

Yokawa　槇川

Yono　與野

Yuan 元
Yuanhe 元和
Yu'an Zhiji 愚菴智及
Yūzū Nembutsu 融通念佛

Zegaibō 是害房
Zen 禪
Zhiluo Yongshou 智羅永壽
Zhou 周
zuzō 圖像

Bibliography

Akiyama Terukazu. *Japanese Painting*. Lausanne: Skira, 1961.

——. "The Identification and Reconstruction of the Illustrated Scroll Known as 'Kōnin-Shonin-eden'." Paper delivered at the International Symposium on the Arts of Asia, Asian Art Museum of San Francisco, 1966.

Anesaki Masaharu. *Nichiren, The Buddhist Prophet*. Gloucester, Mass.: Peter Smith, 1966.

Brinker, Helmut. *Zen in the Art of Painting*. Trans. George Campbell. London and New York: Arkana, 1987.

Ch'en, Kenneth. *Buddhism in China: A Historical Survey*. Princeton: Princeton University Press, 1964.

Ching, Heng, trans. *Sūtra of the Past Vows of the Earth Store Bodhisattva*. New York: Institute for Advanced Studies of World Religions, 1974.

Coates, Harper Havelock, and Ishizuka Ryugaku. *Hōnen, The Buddhist Saint*. Kyoto: Chion-in, 1925.

Conze, Edward, trans. *Buddhist Scriptures*. Harmondsworth: Penguin, 1969.

Cultural Relics from Dunhuang and Turfan. Hong Kong: Art Gallery, Chinese University of Hong Kong, 1987.

Darling, Bruce. *The Transformation of Pure Land Thought and the Development of Shintō Shrine Mandala Paintings: Kasuga and Kumano*. Ph.D. dissertation, University of Michigan, 1983.

de Bary, William, ed. *The Buddhist Tradition in India, China and Japan*. New York: Vintage Books, 1969.

DeCoker, Gary. "Secret Teachings in Medieval Calligraphy." *Monumenta Nipponica* 43 (2) Summer 1988.

Edwards, Richard. "Ue Gukei—Fourteenth-Century Ink-Painter." *Ars Orientalis* 7 (1968).

Exhibition of Japanese Paintings from the Collection of Museum of Fine Arts, Boston. Tokyo: Tokyo National Museum, 1983.

Fontein, Jan, and Money L. Hickman. *Zen Painting and Calligraphy*. Boston: Museum of Fine Arts, 1970.

The Freer Gallery of Art, II: Japan. Tokyo: Kodansha, 1972.

Getty, Alice. *The Gods of Northern Buddhism*. Oxford: Clarendon Press, 1914.

Gulik, Robert Hans van. *Siddham: An Essay on the History of Sanskrit Studies in China and Japan*. New Delhi: International Academy of Indian Culture, 1956.

Hakeda, Yoshito S. *Kūkai, Major Works: Translated with an Account of His Life and a Study of His Thought*. New York: Columbia University Press, 1972.

Hakin, J., et al. *Asiatic Mythology*. New York: Crescent Books, 1963.

Hall, John W., and Toyoda Takeshi, eds. *Japan in the Muromachi Age*. Berkeley: University of California Press, 1977.

Haruki, Kageyama, and Christine Guth Kanda. *Shintō Arts: Nature, Gods, and Man in Japan*. New York: Japan Society, 1976.

Hieizan to Tendai no Bijutsu (Mount Hiei and the Art of Tendai Buddhism). Tokyo: Tokyo National Museum, 1986.

Illustrated Catalogue of Tokyo National Museum: Buddhist Paintings. Tokyo: Tokyo National Museum, 1987.

Ishida Hisatoyo. *Esoteric Buddhist Painting*. Trans. E. Dale Saunders. Tokyo and New York: Kodansha, 1987.

Ishida Mosaku. *Japanese Buddhist Prints*. Tokyo and Palo Alto: Kodansha, 1963.

Kageyama, Haruki. *The Arts of Shintō*. Trans. Christine Guth. New York and Tokyo: Weatherhill/Shibundo, 1973.

Kami Gami no Bijutsu (The Arts of Japanese Gods). Kyoto: Kyoto National Museum, 1974.

Kannon no Kaiga (Exhibition of Kannon Paintings). Nara: Yamato Bunka-kan, 1974.

Kasuga Taisha Miho Ten (Hidden Treasures of the Kasuga Shrine). Nara: Kasuga Taisha, 1968.

Kelsey, W. Michael. *Konjaku Monogatari-shū*. Boston: Twayne, 1982.

Kōbō Daishi to Mikkyō Bijutsu (Kōbō Daishi and the Art of Esoteric Buddhism). Tokyo: Tokyo National Museum, 1983.

Kodansha Encyclopedia of Japan. Tokyo: Kodansha, 1983.

Kōzan-ji Ten (Exhibition of Kōzan-ji Treasures). Kyoto: Kyoto National Museum, 1981.

Lee, Sherman E. *A History of Far Eastern Art*. London: Thames and Hudson, 1964.

Lee, Sherman E., et al. *Reflections of Reality in Japanese Art*. Cleveland: Cleveland Museum of Art, 1983.

Levi, Sylvain, and E. Chavannes. "Les seize arhat protecteurs de la Loi." *Journal Asiatique* (1916), pp. 5–50, 189–304.

Link, Howard A. "Japanese Buddhist Art." *Apollo* 59 (204) (February 1979).

Link, Howard A., and Sanna S. Deutsch. *The Feminine Image: Women of Japan*. Honolulu: Honolulu Academy of Arts, 1985.

Masterpieces of Japanese Prints—From the Origin to the Emergence of Nishiki-e. Machida: Machida City Museum of Graphic Arts, 1987.

Matsunaga, Alicia. *The Buddhist Philosophy of Assimilation: The Historical Development of the Honji-Suijaku Theory.* Rutland and Tokyo: Charles E. Tuttle, 1969.

Murase, Miyeko. *Japanese Art: Selections from the Mary and Jackson Burke Collection.* New York: Metropolitan Museum of Art, 1975.

Neill, Mary Gardner. *The Communion of Scholars: Chinese Art at Yale.* New York: China Institute, 1982.

Ninna-ji no Meihō (Treasures of the Ninna-ji). Tokyo: Tokyo National Museum, 1989.

Okazaki, Jōji. *Pure Land Buddhist Painting.* Trans. Elizabeth ten Grotenhuis. Tokyo and New York: Kodansha, 1977.

Pak, Young-Sook. "Kṣitigarbha as Supreme Lord of the Underworld." *Oriental Art* 23 (7) Spring 1977.

Pal, Pratapaditya. *Light of Asia: Buddha Śākyamuni in Asian Art.* Los Angeles: Los Angeles County Museum, 1984.

Roberts, Laurance P. *A Dictionary of Japanese Artists.* Tokyo and New York: Weatherhill, 1976.

Rosenfield, John. "The Unity of the Three Creeds." In John W. Hall and Toyoda Takeshi, eds., *Japan in the Muromachi Age.* Berkeley: University of California Press, 1977.

Rosenfield, John, and Elizabeth ten Grotenhuis. *Journey of the Three Jewels: Japanese Buddhist Paintings from Western Collections.* New York: The Asia Society, 1979.

Sasaki, Ruth Fuller, et al. trans. *The Recorded Sayings of Layman Pang: A Ninth Century Zen Classic.* New York and Tokyo: Weatherhill, 1971.

Sawa Takaaki. *Art in Japanese Esoteric Buddhism.* Trans. Richard L. Gage. New York and Tokyo: Weatherhill/Heibonsha, 1972.

Seattle Art Museum. *A Thousand Cranes.* San Francisco: Chronicle Books, 1987.

A Selection of Japanese Art from the Mary and Jackson Burke Collection. Tokyo: Tokyo National Museum, 1985.

Shaolin si Shike Yishu Xuan. Beijing: Wenwu Chubanshe, 1985.

Shimbo, Toru. "The Academy's Life of Kōbō Daishi Handscroll." *Honolulu Academy of Arts Journal* 4 (1986).

Shimizu, Yoshiaki, and John Rosenfield. *Masters of Japanese Calligraphy, 8th–19th Century.* New York: Asia Society, 1984.

Sirén, Osvald. *Chinese Painting: Leading Masters and Principles.* 7 vols. London, Lund Humphries, 1956–1958.

Sketches by Tan'yū. 2 vols. Kyoto: Kyoto National Museum, 1976.

Soothill, William E. *A Dictionary of Chinese Buddhist Terms.* Rpt. Kaohsiung: Fo Kuang Press, 1962.

Shūjirō, Shimada, ed. *Nihon Emakimono Zenshu.* Tokyo: Kadokawa Shoten, 1980.

Tanabe, Willa J. *Paintings of the Lotus Sūtra.* New York and Tokyo: Weatherhill, 1988.

Tanaka Ichimatsu. *Japanese Ink Painting: Shubun to Sesshu.* New York and Tokyo: Weatherhill, 1972.

ten Grotenhuis, Elizabeth. *The Revival of the Taima Mandala in Medieval Japan.* New York: Garland, 1985.

Tōdai-ji Ten (Exhibition of Tōdai-ji Treasures). Tokyo: Tokyo National Museum, 1980.

Umezu Jiro. "On the Picture-Scrolls of Priest Hōnen." *Kokka* 705 (December 1950).

Ury, Marian. *Tales of Times Now Past: Sixty-two Stories from a Medieval Japanese Collection.* Berkeley and Los Angeles: University of California Press, 1979.

Visser, M. W. de. *The Arhats in China and Japan.* Berlin: Oesterheld. 1923.

———. *Ancient Buddhism in Japan.* 2 vols. Leiden: E. J. Brill, 1935.

Zaigai Nihon no Hihō, vol. 2. *Emakimono.* Tokyo: Mainichi Shimbunsha, 1980.

Zanie, Carla M. "Ryōzen: From Ebusshi to Ink Painter." *Artibus Asiae* 40 (2/3) (1978).

Index